Surrealism

S U R R E

JACQUELINE CHÉNIEUX-GENDRON

A L i s m

Translated by Vivian Folkenflik

COLUMBIA UNIVERSITY PRESS NEW YORK

Columbia University Press wishes to express its appreciation of assistance given by
the government of France through le Ministère de la Culture in the preparation
of this translation.

COLUMBIA UNIVERSITY PRESS
NEW YORK CHICHESTER, WEST SUSSEX
Copyright © 1990 Columbia University Press
Le Surréalisme copyright © Presses Universitaires de France, 1984

Library of Congress Cataloging-in-Publication Data

Chénieux-Gendron, Jacqueline.
[Surréalisme. English]
Surrealism / Jacqueline Chénieux-Gendron;
translated by Vivian Folkenflik.
p. cm. — (European perspectives)
Translation of: Le surréalisme.
Includes bibliographical references.
ISBN 0-231-06810-7
ISBN 0-231-06811-5 (pbk.)
1. French literature—20th century—History and criticism.
2. Surrealism (Literature)—France.
I. Title. II. Series.
PQ307.S95C4813 1990
840.9'1—dc20 89-28959
 CIP

Contents

Acknowledgments

I would like to thank Robert Mauzi, without whose encouragement this book would never have seen the light of day.

I am also grateful to Mme José Vovelle and José Pierre for their testimony about the pictorial aspects of Surrealism, and to Etienne-Alain Hubert, who read the book in manuscript.

Jacqueline Chénieux-Gendron

Translator's Preface

This book presents a number of challenges to the translator. Jacqueline Chénieux-Gendron's prose is often allusive; I have sometimes felt it necessary to provide English-speaking readers with a context for these allusions in the text. In my notes, I have identified the many poets and artists mentioned in the text, explained technical terms, and intepreted Surrealist puns and wordplay. Wherever possible, I have supplied page references and dates that might be helpful to readers.

I have used the standard English translations of the major texts, not for my own convenience—I would often have preferred to translate crucial passages myself—but as a way of enabling readers to make further explorations of this material. The notes thus offer English-speaking readers access to some English translations not listed in Chénieux-Gendron's bibliography.

I am very grateful for the generous help I was given in the course of this work by a number of people. Robert Folkenflik provided valuable references as well as steady encouragement and interest. David Folkenflik gave willing help at a crucial time. Dickran Tashjian cheerfully offered his expertise and a careful reading of the manuscript. Renée Riese Hubert made several useful suggestions. Jennifer Crewe of Columbia University Press helped me solve various procedural problems. Karen Mitchell, also of Columbia, once again proved to be a thoughtful editor, sensitive to the demands of both text and reader. I would like to thank them all.

Vivian Folkenflik
Laguna Beach, California

Surrealism

1

Prohibition and Meaning

Three great systems of exclusion and division allow the human word to lay claim to purity: the play of prohibitions, the strongest of which is the prohibition of desire; the division between reason and madness; and the will to truth.

> We know perfectly well that we are not free to say just anything, that we cannot simply speak of anything, when we like or where we like; not just anyone, finally may speak of just anything. We have three types of prohibition, covering objects, ritual with its surrounding circumstances, the privileged or exclusive right to speak of a particular subject; these prohibitions interrelate, reinforce and complement each other, forming a complex web, continually subject to modification.[1]

These prohibitions certainly surround the act of speech in a very powerful way. Moreover, added to them is the obligation to say *only* what is reasonable, and according to the codified modes of "non-madness." If pre-nineteenth-century Europe sometimes discerned signs of lucidity and marks of portent in the speech of the mad, this was another way of reinvesting that speech through reason, of denying its absolute *difference*. More subtly, too, as Michel Foucault shows, the very opposition between true and false defines a constraint on truth involving *power*. "Certainly, as a proposition, within a discourse, the division between true and false is neither arbitrary, nor modifiable, nor institutional, nor violent." But there *is* a will to truth, which takes different forms according to the various historical periods in the West, and which tends to exercise on other discourses, such as literature, or on other forms of expression, "a sort of pressure, a power to constrain."[2] If we just think about the references to "verisimilitude" in Western art and literature until the naturalist period and probably beyond, we can measure its indirect force.

From the time of its foundation in France in 1919, Surrealism responded to these games of division by revolting against them. Surrealists saw these divisions with a lucidity and a violence sharpened by the postwar despair and a sense of there being no reason to go on living. After the rupture and bloodshed of World War I, in opposition to the clear conscience of Europe, which was reshaping and healing itself, the movement launched a wave of global contestation and wove a network of *other* differences. In its most far-reaching projects, Surrealism claims to mingle desire with human speech, and eros with human life—not just to tell, or to describe, desire and eros. It claims to abolish the notion of incongruity or obscenity, to let the subconscious speak, and to simulate different pathologies of language. It claims to overturn the quest for the probable in art by making an astounding bet on the imagination, presented as the central power of the human mind, from which emerges a whole life-in-poetry. In this life-in-poetry the improbable, the extraordinary, the incongruous would grow in abundance; sincerity would no longer have an absolute referential value; what would be sought for its own sake would no longer be truth but living, living *otherwise* than in everyday mediocrity, living *outside* the track to which society assigns each of us.

This displacement of the system of moral and intellectual values on which centuries of Western culture were based has been and still is sometimes perceived as a perversion, or a biasing of human activity: an antihumanism.

Now that we can define it more clearly, differentiating it from other poetic movements that arose in Europe at the same time, the French Surrealist project once again makes possible and legitimizes all sorts of of behaviors and practices which are not completely *new*, but which had tended to become marginalized or encysted in the tissue of social life and poetic practice. Surrealism preaches the reversal of this tendency and the totalizing assumption of responsibility for all human behavior. Human violence had indeed been marginalized and neutralized by social life, by the norms of bourgeois capitalist society, but still rose up unpredictably and found an outlet in wars: in the example of the "just" war, as the French saw it, that was the butchery in Europe from 1914 to 1918. Surrealism proposes a recognition and a taking of responsibility for human violence in *revolt*, in every sense. It is on this very general if not symbolic level that we should understand the proclamation of André Breton's *Second Manifesto of Surrealism:*

> one can understand why Surrealism was not afraid to make for itself a tenet of total revolt, complete insubordination, of sabotage according to rule, and why it still expects nothing save from violence. The simplest Surrealist act consists of dashing down into the street, pistol in hand, and firing blindly, as fast as you can pull the trigger, into the crowd.[3]

But also, and without any contradiction, Surrealism tried to channel this potential energy, until then burning away "in the open air," into an action at once inventive and concerted:

> Once again, the question here is the whole problem of the transformation of energy. To distrust, as people do out of all proportion, the practical virtue of imagination is to be willing to deprive oneself at any cost of the help of electricity, in the hope of bringing hydroelectric power back to its absurd waterfall consciousness.[4]

Also marginalized were eroticism and the powers of love in French society of the late nineteenth and early twentieth century. Surrealism struggled constantly against the ruling hypocrisy on the double front of eroticism and the recognition of love. An article on "research into sexuality" appears in the eleventh issue of *La Révolution Surréaliste* (1928); daringly, clinically accurate for a time when Robert Desnos and Kra, his publisher, were brought into

court for supposedly pornographic passages of *La liberté ou l'amour!* (1927). And there was a recognition of love's power to disturb the mind in the same issue of the review (no. 12, 1929) in which appear the answers to a "Questionnaire on Love," written in a tone of intense but unidealistic urgency. In the sixties, with no contradiction, Breton discounted "sex education" as a force for liberation in order to preserve love's power to disturb (Jean-Claude Silbermann, 1964, *Le surréalisme et la peinture*). Marginalized, too, were the practice of automatic writing and the use of dreams as the springboard of "inspiration"—both of which had fostered the writing of all sorts of great texts (from Horace Walpole's dream to Mallarmé's resonant obsession, "The penultimate is dead"), but neither of which had ever been explicitly advocated as a systematic exercise. In twentieth-century society, all sorts of magical behavior was veiled which the Surrealist group was to concentrate on exhibiting.

Surrealism therefore presents itself to us as a machine for *integration*—having refused the cultural divisions we have discussed, even the division between true and false, that have been the basis for language in the West since the nineteenth-century industrial and scientific revolution. This movement of integration implies a reversal in the manifestation of a function hitherto marginalized both in social life and in literary and philosophical tradition: I am referring here to the imagination. All Platonic philosophy shows the human being as a chariot guided by the intellect and carried along by the will, while imagination, the lead horse, tries to make the team run off its course. Before Surrealism, the "classical" and rationalist philosophical tradition in France, while insisting on the infinite character of will and its primary importance in defining human liberty, had thrust imagination to the side of life, of animation, of warmth, of vivacity, and thus "prepared our minds to recognize the primacy of the imagination, from the moment when life appears no longer as a secondary fact, but as a primary, primitive fact and as an indivisible energy."[5] The meaning of the Romantic revolution (to which Surrealism is connected, from this point of view) was to give imagination a *cognitive* function.

But Romantic philosophy is a philosophy of being, in which imagination can rediscover paradise lost. The implicit philosophy of the French Surrealists, playing on the level of existence and not of essence, of beings and not of being, gives imagination a leading role: not to *recognize* something that

had previously been veiled, but to give existence to its own unprecedented forms. The power of (poetic) imagination becomes, by definition, practical. The play on words *must* become its own object (Duchamp), dreamed forms *must* be materialized in a tangible object (Breton, *Introduction au discours sur le peu de réalité*.)[6]

But if Surrealism is a machinery for integration, it is also, in the same impulse, or perhaps from another point of view, a machinery for negating. Surrealism negates everything implied by the divisions and prohibitions on which the majority cultural structure is founded: negating ready-made "orders," denying the pertinence of codes (social, but also stylistic, linguistic, and even logical). Surrealists therefore suspect everything that organizes the sense of things, the *direction* of things, in space and in time, especially any kind of taxonomy and any presentation of evidence that has *signification* for us. Various games take shape: one consists of trying to capture the meaning of time, or of space, or of language, in the moment of their arising—in a kind of original space, with mythical evidence. The practice of automatic writing or drawing is a response to this intention: "to create a universe of words [or of forms, I should add] in which the universe of our practical and utilitarian perceptions will be completely disoriented."[7] Is this a question of *either* refusing ready-made meanings *or* creating the conditions for the epiphany of a new meaning? What we have here is rather the two intentions at the same time, the first being the reverse side of the second. Another game (Bataille's own game, but, at one time, also André Masson's or Hans Bellmer's and the particular form eroticism takes in them) consists of negating the meaning of space and of the human body, by the introduction of all possible meanings in a dionysiac investment of space, even at the price of tearing apart and scattering the human body.[8] The absence of "meaning" can also be seen in the practice of exhibiting as equivalent the two sides of things and of manifesting the plurality of meanings of signs: as if one had to show that "meaning" could be transparent, or that things and signs had the same value as their opposites. This is Marcel Duchamp's enterprise. For example, the *Female Fig Leaf* is the printed stamp, the "negative" of a feminine sexual organ, so that hiding the masculine organ—the role of the fig leaf in classical statuary—or exhibiting the feminine organ amounts to the same thing. In the realm of signs and letters, this is also the enterprise of Robert Desnos. And to this practice we must add the use Surrealism makes of the reverse of cultural content. I am thinking not only of Paul Eluard and Benjamin Péret's collection of updated proverbs (*152 proverbes mis au goût du*

jour), but also of the reversal of the content of myths. In *Au château d'Argol*, Julien Gracq turns the myth of the Savior into a myth of the ambivalence of the mediator. Savior? Perhaps, but condemner as well.[9]

This is a great attempt to demolish the sense of reality, stigmatized in 1947 by Jean-Paul Sartre, who put Surrealist thought in the same class as the (eternal) current of scepticism, emphasizing certain manifestations which he interprets as idealist. According to him, the Surrealists preach, particularly through automatic writing, the dissolution of the individual consciousness and also, by the symbolic annulment of "object-witnesses," the dissolution of the objectivity of the world.

But Surrealism responds to this threatening spread of idealism steadfastly with two firebreaks. One is political action, whose sparks we will see fly with some regularity in the historical part of this work; the other is the attempt, in the very heart of practical activity (ethical *or* artistic), to make *another* sense emerge, discovered by some people in and through pleasure and by others in and through the seizure of a projective desire (that is "objective chance"). Pleasure on one side, in which the body rediscovers its sense and sensibility rediscovers its comforts; on the other side, a new ethic of desire, in which time rediscovers an undeniable orientation.

Thus, the massive denial of prohibition, as it functions in Surrealism, is also a game of *displacement*. The aim—to take back the move that implicates human conduct and language in prohibitions and power structures—is turned upside down and becomes an immense confidence in "pure" desire, in "absolute" revolt, in the powers not of society but of the word. Now on the one hand this involves mythical terms ("pure" desire, "absolute" revolt), which function as the horizon of an ever-disappointing quest, or as its completely fictional premises. But more especially, in the order of speech, this voice, which the Surrealists originally gave in its full strength to *everyone* ("Secrets of the Surrealist Magical Art," in the first *Manifesto*), has been appropriated by a *few*. Is this the necessity of experimentation or the displacement of prohibitions? It is the ineluctable ambiguity of Surrealism finally to have reinforced the privileged right of the speaking subject within an already privileged group. Surrealism has reinvented, in fact, as the privileged place in which the "miracle" arises, the *group* constituted around a dominant personality. This elective constellation reproduces, with its rites of initiation, exclusion, and rehabilitation, the characteristics of a micro-society ruled by magical thinking:

The group never presents itself here as the picture of an open community, swollen with uncontrolled contagion; on the contrary, it is rather the idea that seems to have imposed itself on Breton from the beginning: the idea of a closed, separate *order*, of an exclusive companionship, of a phalanstery which tends to be shut in by vaguely magical walls (the significant idea of a "castle" is hovering about somewhere nearby).[10]

Membership in the group, in what Jules Monnerot calls the *Bund*, is a central condition of Surrealist life in its French definition: the place in which sensibilities are exacerbated and creativity exalted. Thus the Surrealist word sometimes becomes collective, or impersonal, and does not depend on the power of the speaking object. It replaces this power by that of Surrealism.

Is this displacement of "divisions" and cleavages a perverse effect of preaching liberation, or is it the necessary means? The Surrealist reply is obviously the latter. Moreover, it would be inaccurate to see this displacement as parallel, or the various called-for prohibitions as symmetrical. The prohibitions linked to the functioning of the group life are explicit and artificial. The prohibitions denounced by Michel Foucault, which eternalize their own everyday immediacy, are implicit and even repressed by the communal consciousness. A language and behavior that refuse the division between reason and folly, as between truth and error, in favor of imagination, analogy, and desire are words and behaviors that insert within their process an awareness of their relativity. Their intoxicating liberty and the preciosity of their discoveries are bought by an awareness of their precariousness, which is no doubt very hard to maintain without the structuring, securing interplay of *other* divisions.

The origin of new hierarchies and new differences thus lies not only in group life but in certain Surrealist "values": the search for eros, the search for political and social liberty, the search for poetry. But the functioning of these "values" is quite different from what can be seen in a morality of prohibition. It involves, by repeated transgression, reinventing a certain orientation of the world. To be exact, for Michel Leiris, we must reinvent the sacred by transgressing the taboo, "a limit in regard to which things abandon the unoriented, amorphous character of the profane and polarize themselves into left and right."[11] And Breton, after having incriminated Judeo-Christian religion as both "blood-curdling and congealed," cannot help but subscribe to Francis Ponge's suggestion: "Perhaps the lesson we

7

must learn is to abolish all values the instant we discover them."[12] Value, poetic and practical, is discovered in the same moment in which it is transgressed.

We must therefore be wary of the oversimplified image of Surrealism as the breaker of prohibitions, a word on which Pierre de Massot puns when he calls his homage to Breton "Breton le septembriseur," the revolutionary:[13] as a "pure" movement, free from any compromise with what has been repressed. But it is also too simple to see in Surrealism, as was fashionable in the criticism of the sixties, a locus for stubborn, confusional idealism, for the celebration of some sorts of vaguely conceived transgression—or, as those who are nostalgic for Dadaism believe, the proud fortress of a coercive morality whose high priest was supposedly André Breton. Some people think that the "fringe" figures and fellow travelers of Surrealism (expressions they use, as I do, in the least uncomplimentary way possible, to refer to figures like Georges Bataille and Antonin Artaud)[14] should be relocated at the heart of the adventure of the avant-garde, lived by them in a *more* revolutionary way. Others believe that Bretonian hypocrisy must be unmasked, and authenticity tracked down amid the make-believe. Critical distance today permits us to relate the projects of some Surrealists to others without automatically establishing hierarchies and demarcating boundaries within and outside the historical group: in short, to weigh the differences with passion but without projecting preconceived schemas upon them.

2

A Promethean and Totalizing Enterprise

The Surrealists seem to have always perceived their own movement as referring to something beyond their experience, so that they possess both great ancestors and a master plan that transcends individual achievements. Everything happens as if there were a *Surrealist idea*, a spirit of Surrealism, whose demands were absolute. Expressions such as the apparently mysterious phrase, "a system in which I believe, to which I slowly adapt myself, like Surrealism";[1] the peremptory formulation, "Were there to remain not a single one, from among all those who were the first to measure by its standards their chance for significance and their desire for truth, yet would Surrealism continue to live";[2] the whimsical title of no. 12 of *La Révolution Surréaliste*, "The Surrealist Millennium (929: Death of Charles the Simple)"[3] —these all express the fact that Surrealism responds to a fundamental

intuition which we must keep on making open and clearer, which language should keep delimiting more and more closely, which should be tested by facts.

Nevertheless, Breton gives signs of a marked historical relativism in defining the role of Surrealism, different in the 1920s from what it may have become in the 1950s.[4] There is thus a complex interplay between a "Surrealist idea," its recurrent manifestations (which define a perceptible climate and certain life choices), and the modalities of its role.

Another kind of complexity emerges when it is a question of defining the exact quality of Surrealism as a movement: is it philosophical? psychological? literary and artistic? Jean-Louis Bédouin, in 1961, rejected all these qualifications in turn:

> However syncretic we may think Surrealism is, there is absolutely no reason to suppose it is a philosophy, just because it may proceed on the philosophical level of Hegelian dialectic; or because it may have recognized, on the level of traditional knowledge, a few of the major sources of hermetic philosophy; or because at some point in its development it may have subscribed to the basic principles of Marxism-Leninism.
>
> Nor is it a psychology, although Freud's discoveries and theories greatly contributed to setting it on its path.
>
> Even less is it a literary and artistic school. . . . Surrealism is born of a consciousness of the derisory condition allotted to the individual and his thought, and a refusal to accommodate oneself to it.[5]

Surrealism therefore wills itself to be a philosophy, but a "philosophy of life," a way of living and thinking, a madness of living and thinking which, refusing the world as it is—since the "real" is often only habit—proposes both to "transform the world" (Marx) and to "change life" (Rimbaud), in a political and poetical rebellion.[6] Refusing a priori logic, Surrealism recommends exploring the resources of disorder, insofar as disorder may arise from a confidence in all our instincts and in the emergence of the id. Surrealism invites us to explore "objective chance," by examining signs which, objectifying our desire, orient our life plan. The active exaltation of elective love gladly depends on such signs of chance. But meanwhile humor, as Jacques Vaché understands it—"a sense of the theatrical (and joyless) uselessness of everything"—undermines this lyrical behavior without gain-

saying its impulse.[7] Humor manifests another form of the rebellion of the mind against death and injustice: a "superior rebellion" that tends to include all the others. In Surrealism, then, "knowledge passes reason by, action surpasses it," as Maurice Nadeau says. Surrealism defines itself by what it seeks: a possibility that would always encroach on the impossible. There is no foundation for human prudence. Breton agrees with the formulation of Saint-Pol Roux: "Man seems to me to live in a mere fairyland of vague indications, slight provocations, faraway longings, enigmas."[8] In Surrealism, the provocation is not slight but sharp: enigmas are confronted, human affinities and everyday fantasies are constantly tracked down and claimed in all their consequences. To go beyond the limits of the possible involves courting dangerous risks.

The Promethean dimension of the Surrealist project can be measured by comparing it with other movements—such as Romanticism, Symbolism, even Expressionism—which, while neither exclusively pictorial nor exclusively literary, involve an opening both on the world and on a diversity of means of expression. But there is no profound relationship between Surrealism and exclusively pictorial movements such as Impressionism, Neoimpressionism, Fauvism, or even Cubism; or exclusively literary movements such as the "new novel." There are certainly perceptible historical connections between Cubist technique and certain Surrealist or Surrealistic painters. André Masson, in the early 1920s, offers striking examples of this conjunction in *Les constellations* (1925). Historical connections are possible between the "new novel" and Surrealism, although their projects go in diametrically opposite directions (Julien Gracq talks about "those curious zinc novels, which seem dedicated to some kind of glorification of the reflecting mirror, the Pigeon lamp, and the spat button").[9] Such a relationship can be seen in the way Nathalie Sarraute and Alain Robbe-Grillet read and reread the violently antinovel pages in Breton's *Manifesto*, from which they borrow certain arguments. But these relationships are created by criticism, and do not involve the definition of Surrealism itself.

The recurrent gaze that Surrealism casts over past modes of expression is of Promethean amplitude. Little by little this glance fixes its values, however —and we should not confuse the following picture with the "sources" of Surrealism at its origin. On the other hand, its essential characteristic is to establish *differences*. Surrealism recognizes a precursory "surrealist" quality in certain poets, prose writers, painters, currents of civilization and thought:

a comparable sensibility, or a line of inspiration. In his 1924 *Manifesto*, Breton declares Jonathan Swift Surrealist for his "maliciousness," and Chateaubriand for his "exoticism."[10] In this retrospective and theatrical attribution of a characteristic, there is an unprecedented move toward annexation made by none of the European forms of Romanticism or Symbolism. Surrealism affirms equally its radical newness and a ramified, subtle genealogy that is almost impossible to outline. In these choices and their motivations, at any rate, we see projectively defined the coefficients of a sensibility and the persistence of an essentially participatory way of thinking.

Selective Glances at European Literature and Art

The eighteenth century, in which the first roots of the various "Romanticisms" take hold, is a century on which the Surrealist gaze lingers:[11] above all on the figure of the Marquis de Sade, in whom the Surrealists believe they see the model of an absolute political liberty, linked incontrovertibly to a total liberty of behavior. As Eluard said,

> Because he tried to give back to civilized man the power of his primitive instincts, because he tried to rescue the erotic imagination, and because he struggled desperately for absolute justice and equality, the Marquis de Sade was locked up for most of his life in the Bastille, Vincennes, and Charenton.[12]

It is not clear that Sade tended toward a total liberation of behavior, and Surrealist homage is taking chances if it makes Sade the precursor of Freud. But in the last analysis what Surrealism is paying homage to is a dark shadow, a "humor," what Breton calls a "black sun"; a "tragic humor, still in the process of definition."[13] Next to Sade, the figure of Jean-Jacques Rousseau is comparatively hazy. Breton does not deny the opposition between their messages,[14] but Surrealism assumes this double admiration: the political, educational, and poetic thought of Rousseau is admired insofar as it refuses metaphysics: "I will even say that it is on this branch—for me the first which grows at a human level—that poetry was able to bloom."[15]

The "roman noir," or Gothic novel, which arose in the eighteenth century, particularly in England, rode a great wave of success in both France

and England in the nineteenth century, but by the 1920s it had become completely unfashionable. This "ultra-Romantic," "high fiction" literature nevertheless is the only thing that redeems the genre of the novel. It is full of marvelous elements which arouse fascinating mental images; moreover, these novels are published in illustrated editions which give "a tangible value to what, as far as appearance goes, would remain spectral without them."[16] Their theme exacerbates human ambivalence toward taboos. In the process of our reading, we measure in them the power of emotion, which throws us, bound hand and foot, on the mercy of symbols and myths, overturning all the defenses we have set up on a logical level. The Surrealist gaze covers this whole line from beginning to end. In England it goes from Walpole to Maturin and beyond; in France, under the sway of the "frenetic" movement, it goes from Nodier, who adapted Maturin's *Bertram* in 1921, to Théophile Gautier and his *Morte amoureuse* (1836), from Pétrus Borel (*Contes immoraux*, 1833) to Xavier Forneret, and we can still see traces of it in Lautréamont. We may include in this same "Gothic" tradition the work of Johann Heinrich Füssli, an artist haunted by the literary work of Shakespeare, Milton, and Dante, whose monstrous beings he reinscribes in his paintings.[17] Surrealists expect painting and poetry to reveal what is hidden in us or around us. Both must enlarge the field of our awareness.

As we have just seen with French Romanticism and pre-Romanticism, Surrealism enjoys the game of In and Out. How about Lamartine, Musset, Vigny? No, they are Out, from the first questionnaire of *Littérature* (no. 18, March 1921) to the "Open up?" survey in *Médium* ("Ouvrez-vous?" no. 1, November 1953). For Hugo or Chateaubriand, the response is much more positive. Surrealism lingers on the "minor Romantics" or in the "frenetic" movement which corresponds so well, in France, to the English Gothic novel. Aloysius Bertrand is put on the same level as Gérard de Nerval (*Entretiens*, p. 58) and quoted as the equal of Swift, Young, Chateaubriand, and Hugo in the *Manifesto*. The Surrealists certainly contributed to rescuing Pétrus Borel from oblivion. All German Romantics receive universal admiration, and are never déclassé. Achim d'Arnim and Heinrich von Kleist are recognized as inspirations: Arnim is praised by Breton for denying the existence of a boundary between the imaginary and the real,[18] whereas Kleist rediscovers perfect grace beyond the most lucid, or the most arbitrary, invention. Julien Gracq translates Kleist's *Penthesilea*. But the Surrealists also find models in Jean-Paul, Novalis, Hölderlin, Büchner, and Christina Dietrich Grabbe. Among the English Romantics, Surrealist favor falls

on the great "inspired" artists, those who proclaimed the transcendence of this inspiration: Samuel Taylor Coleridge, who said that he had heard the verses of *Kubla Khan* in a dream, and of its sequel, which he then forgot; Keats and Shelley; in painting, J. M. W. Turner, whose enormous production seems to have been accomplished in a state of trance; William Blake, artist and poet whose visionary automatism is a Surrealist point of reference. As for the European painters, in the Romantic realm, we note the Surrealist admiration for Goya, only a little younger than Füssli and inspired by him, and for all the painters who exalt inspiration, such as Caspar David Friedrich, of whom it is said that he *saw* his picture with his eyes closed, then reproduced the forms as conceived in their smallest details. Hugo's drawings and washes are highly praised, and he even takes an important place in the pedigree of automatism and paranoiac-critical interpretation that begins with Leonardo da Vinci. Let us recall his "lace impressions": a fragment of lace impregnated with ink is applied to a sheet of paper, and the print is interpreted. We will "open up" to Géricault, or even, with some reservation, to Chassériau; but not to Delacroix.[19]

Symbolism

The poetical and pictorial current of Symbolism provided the guiding lights of the emerging Surrealist movement. Baudelaire's theory of correspondences was retained as an inadequate but functioning link with the esoteric tradition; after Baudelaire's death, then, poets could fall into agreement on a fundamental principle:

> Language can and should be rescued from the misappropriation and the tarnish that come from its function as a basic means of exchange; in it are included possibilities for much closer interpersonal contact than the laws presiding over such an exchange usually imply. A systematic cultivation of these possibilities would lead to nothing less than the recreation of the world. . . . The two roads I have been talking about diverge the instant the poet *decides whether he is going to be the master or the slave of such arrangements.* Lautréamont, Cros, Rimbaud, Nouveau,[20] Corbière, Jarry—Maeterlinck . . .—are among those who

have submitted to these arrangements manacled hand and foot, without trying to find out where they were being taken by the sphinx whose talons were deep in their flesh, or trying to trick their way out. As for the others, the heavy Mallarmean thinkers. . . .[21]

To this list should be added Saint-Pol Roux, the "master of the image," and Marcel Schwob, the creator of Monelle.[22] By referring to Gustave Moreau's painting "Oedipus and the Sphinx," in the superb metaphor of the sphinx dragging the poets away, her talons "deep in their flesh," Breton emphasized a personal debt to Moreau dating from his own adolescence; he referred to this painter whenever there was any question of evoking spellbinding women, and devoted a 1960 preface to his work. Odilon Redon, the other French beacon of Symbolist fantasy, inspired André Masson and Yves Tanguy[23] as well as Breton, but his already overrecognized merits were not stressed by the Surrealists, who were more likely to see the softer side of his characteristic traits. What really fascinated Surrealists was the work of Arnold Böcklin, the Swiss painter whose "Isle of the Dead" canvases were a decisive influence on Chirico and Dali, and the work of Max Klinger, who claims to be revealing every detail of the phantasmagoria of half-sleep, and whose series "Paraphrase on the Discovery of a Glove" (1881) shows a disturbing fantastic element emerging from one engraving to the next.

Finally, the cosmic ambition of Symbolism, every time it is demonstrated with some force by a poet or painter, had to awaken the Surrealist gaze. This is the case of Paul Gauguin or, more modestly, Charles Filiger; interest in Gauguin reawakened after World War II, at an exposition in the Orangerie in 1949. The 1897 painting "D'où venons-nous? Que sommes-nous? Où allons-nous?" ("Where do we come from? What are we? Where are we going?") led Breton to show that the "line that starts with Novalis and Nerval . . . goes through Gauguin, as well as Rimbaud": it tends to "give man back to the primordial feeling he had of himself, which has been corrupted by positivist rationalism."[24]

On the other hand, the Surrealist gaze does not seem to take any special notice of the presence of the other great Symbolist painters (such as Gustav Klimt and Fernand Khnopff), or of the English Preraphaelites, whom Salvador Dali is the only Surrealist to mention (*Minotaure*, no. 8, 1936).

In the end, instead of turning toward what Odilon Redon called "dimwitted" Impressionism, the Surrealist gaze turned toward German Expres-

sionism, admiring Munch's "The Cry" and its cosmic pessimism, fascinated by the drawings of Alfred Kubin and his novel *Die andere Seite*.[25]

We can already see the orbits in which Surrealist taste travels, and the ancestors it invokes: men of the wide open spaces, poets with cosmic ambitions, painters who hint at an anguished or lyrical questioning of the relationship of humanity to what it may become. And occasional adventure novels or children's stories have given us a furtive foretaste: stories which "delighted us when we were children, while already beginning to furrow our hearts with disappointment," as Breton says *(Il y aura une fois)*. Let us recall, Aragon suggests, "the intoxication, the lost foothold of the whole romantic atmosphere, when the sailor in the Arabian Nights tarries at the foot of the magnetic monster that has torn all the nails out of his boat, or the fleur-de-lis simply appears on the shoulder of Milady de Winter." It is true that Aragon adds, "I don't need this detour to find that intoxication."[26]

We have also seen the play of a sort of promotion of works forgotten or in conflict with their own times. Forgotten, neglected—Aloysius Bertrand or Xavier Forneret, and even Pétrus Borel or the painter Filiger. Forgotten after a period of excessive popularity, which creates its own problems: the Gothic novels and thrillers. Conflicting with their own time: no better example than Sade, whose works, between the two world wars, could still not be reprinted in their entirety, so demonic did their teaching appear, so terrifying the humiliation of the very concept of virtue.

Nevertheless, the great visionaries and direct sources of inspirations of Surrealism do not fall into the category of Symbolism, or indeed any other oversimplified classification—Nerval, Rimbaud, Jarry, Lautréamont.

Nerval, so close to Novalis, and "whose soul slips from Mallarmé to Apollinaire to reach us," had an occult and central influence on all Surrealism (see "Caractères de l'évolution moderne et ce qui en participe," 1922, *Les pas perdus*). Nerval's Aurélia is reborn in Michel Leiris's Aurora. The very meaning of the Surrealist quest is that dreams and myths must stimulate daily life to give it the dimension of destiny: Surrealism will use different names for this quest, and give it sometimes a tangential meaning, but not another inspiration. And if Nerval is Surrealist in his madness, Rimbaud is Surrealist in his silence. One of Rimbaud's advantages is that he knew how to keep quiet. (Similarly, if Valéry was admired by the young Breton, it was because he seemed to be following this path, becoming, little by little, Valéry's Monsieur Teste). Thus, affirms the first *Manifesto*, it is "in the way

he lived and otherwise" that Rimbaud is Surrealist.[27] Nerval's teaching is fulfilled in the " 'I' is another" and the practice of an immense and deliberate disordering of all the senses. Nerval's madness has its correspondence in Rimbaud's "reason": Surrealists tend toward this obstinate disordering, this unreasoning, irrational reasoning. They do not foster the "whatever;" they speak of chance, but of objective chance, a "second" reason which engulfs unreason and is won at the cost of a great effort over oneself. And then, Rimbaud's text certainly resists intellectual apprehension better than any other: "You will never really know Rimbaud."[28]

Obscurity is not a virtue in itself; what may be a virtue is the resistance of a text in which several meanings coexist. In this respect Lautréamont multiplies the enigmas: the violence of absolute derision and revolt, which is then, in the *Poésies*, itself derided; the cultural game of collages, in the *Chants de Maldoror*, played in the key of the great rhetoric of Romanticism; in short, a lyricism founded on ambiguity. And if the Surrealists were not the only ones to rediscover Lautréamont, the publication of the *Poésies* in the first Surrealist review signaled a debt that no one ever refused to acknowledge.

Finally, with Alfred Jarry, modern humor and absolute cultural denial were introduced to the literary scene. This was a denial that Jacques Vaché, Breton's friend during a few crucial years, tried to live, until the refusal of memory (implied, at its limit, by the total denial of culture) led him to suicide. If Nerval and Rimbaud permitted Surrealism to invent "objective chance," Lautréamont and Jarry provided the first elements of a henceforth continual reflection on black humor. Between these two poles, whose relationship is not altogether self-evident, the whole Surrealist movement burst into bloom.

Revelation Outside Europe and Beyond the Norms

It is in the art of "foreign" countries rather than in their literature (often inaccessible because of a language barrier or a lack of written records) that Surrealism could most easily recognize the signs of the revelatory beauty that arises from the artist's consciousness of participation in the cosmos. Such recognition helped change a whole segment of the art market, subverted by this new criterion.

The first revelation was that of Oceania. Since Cubism had already sung

the praises of African sculpture, this interest continues in the Surrealists and those around them, but with no great passion. In *Minotaure*, which was not a completely Surrealist review, particularly in its early days, the Dakar-Djibouti mission had published documents and mosaics bearing witness to a way of life full of enigmas and an exceptional artistic sense. André Masson's words may best express the Surrealist reaction:

> For me, as for many of the companions of my youth, black art no longer had anything to offer us. Confronting it had been a crucial shock for our elders; for us, there was merely an affectionate comprehension and a due homage rendered.[29]

Between Picasso, Matisse, Juan Gris, on the one hand, and Masson and Breton on the other, there is a generation gap.

But in June 1926, in *La Révolution Surréaliste* (no. 7), the Surrealists published a photograph of Melanesian masks "illustrating" a wonderful poem by Soupault; and in March 1926 the inaugural exposition of the Jacques Callot Gallery had presented pictures by Man Ray accompanied by "objects from the Islands."[30] It is to Melanesia that the Surrealists remained faithful, though Polynesia, especially the art of Easter Island, also held a strange fascination for them. Some remarkable examples of this have been studied by Micheline and Vincent Bounoure (see *La Brèche*, no. 5, October 1963; *L'Archibras*, no. 2, October 1967); Breton had celebrated a volcano on Easter Island with a poem in *Xénophiles*, 1948. Oceania is perceived as a privileged place in which the "dualism of perception and representation" is abolished, in a synthetic movement where we can find "the greatest immemorial effort to realize the interpenetration of the physical and the mental."[31] Imagination would thus find there its original unity, doubled by the rational demands between perceptive consciousness and imaging consciousness. In *Main première* (1962), Breton makes us understand the force of the appeal that drew Paul Gauguin to the Marquise Islands and Karel Kupka to the Australian aborigines. Why there? "Only the fact of painting, Kupka tells us, the very act of creation counts for them." And Breton adds, "These paintings . . . bear witness to the same generative principle as the other, initiatory paintings which, under the seal of secrecy, propagate the myths that belong to the tribe."[32] These paintings are thus clearly magical, since they are linked to the mythic systems of these tribes. To contemplate them, to read the book that Kupka devotes to them, is "to go back to what may be

the pin of the fan" of knowledge. If it is characteristic of magical art to be contagious, it seems that Breton's suggestion concerns us directly, to rebalance the effect of disjunction and separation toward which our rationalist mentality draws us.

Henceforth, starting in 1948, the opposition between Africa and Oceania was marked as the one that exists between abstraction and the magical spirit, between the metonymic reduction of exterior qualities, in a gesture of purification, and metaphoric synthesis:

> On one side of the barricade (in my opinion) there are the endless variations on the outer appearances of men and animals, which can naturally achieve *style* through a gradual purification of these appearances (but the themes remain heavy, material; the structure remains attributable to physical being—face, body—fertility, domestic work, horned beasts). On the other hand, the greatest effort in time immemorial is being made to realize the interpenetration of the physical and the mental, to triumph over the dualism of perception and representation, to go beyond the bark and reach the sap (and the themes are airborne, the most spiritually charged I know, the most poignant, too). . . .[33]

This text recalls the opposition established by Breton between the respective projects of James Joyce and those of automatic writing in *Du surréalisme en ses oeuvres vives*:

> In opposition to the illusory stream of conscious associations, Joyce will present a flux and try to make it gush forth from all directions, a flux that in the last analysis tends to be the closest possible *imitation* of life (by means of which he keeps himself within the framework of *art*, falls once again into *novelistic* illusion, and fails to avoid being placed in the long line of naturalists and expressionists).[34]

For what characterizes the "Cubist" use of African masks and statues is that it turns them away from their original ritual function. African art was certainly "discovered" by both Vlaminck and Matisse toward 1905–6: as Jean Laude says, before 1914 "Black art is taken as an exotic source by Vlaminck, Derain, the Expressionist painters of the 'Bridge' group, and Nolde," who all restrict themselves to "effects." And "African art is taken as

a visual reference point by Matisse, Picasso, Braque and Gris."[35] But exactly what were the Cubists looking for in the figures sculpted by the peoples of the Sudan, of Dahomey, of Gabon? Diagrams, and the way they fit together; the arrangement of volume; the structure of their forms. The Surrealists, on the other hand, interrogated the Oceanic masks in their very *function*.

North and South American Indians were also valorized. The second exposition of the Surrealist Gallery, in May 1927, presented Yves Tanguy's canvases together with "objects from America": from British Columbia, New Mexico, Colombia, Peru. In October 1927, *La Révolution Surréaliste* illustrated a Hopi Kachina doll (no. 9–10). We know that in 1945 Breton went to a Hopi reservation in Arizona and New Mexico, living among the Pueblo Indians of the American Southwest. Leonora Carrington went to stay with the Chiapas Indians, in the north of the Maya country, before painting the great fresco "The Magic World of the Mayans" for the anthropological museum of Mexico. Kurt Seligmann relates his conversations with a Tsimshian Indian (*Minotaure*, no. 12–13, 1939).[36] Wolfgang Paalen visited American Northwest Indians on the Pacific coast. And all the Surrealists living in New York during their years of wartime exile went through the wonderful rooms of the Museum of Natural History, described by Claude Lévi-Strauss in *La Gazette des Beaux-Arts* (September 1943):

> There is in New York a magic place where all the dreams of childhood hold a rendezvous, where century-old tree trunks sing or speak, where indefinable objects lie in wait for the visitor with an anxious stare; where animals of superhuman gentleness press their uplifted little paws, clasped in prayer for the privilege of constructing for the chosen one the palace of the beaver, of guiding him into the realm of the seals, or of teaching him, with a mystic kiss, the language of the frog and the kingfisher.[37]

The ritual objects of the Northwest Indians, found in New York shops by Max Ernst in 1941, were really "discovered" by the Surrealists. These objects may have already been in the Museum of Natural History, but they had not been recognized as works of art.

But ultimately, within Europe, and as a counterweight to the ever-menacing influence of Greek art, what was valorized by Breton's group in its last stage was Celtic art. Their attention was attracted by Lancelot

Lengyel's work, *L'art gaulois dans les médailles* (1954). Georges Bataille had already used the example of the horse on Gallic coins to show that the "crazy" Gallic imitations of Greek coins "drew our attention not to any technical fault so much as to a positive extravagance, consistently carrying to the most absurd conclusions a schematic interpretation" (*Documents*, no. 1, 1929). What Bataille sees here is corporeal distortion carried to the level of a positive value. Lancelot Lengyel shifts the emphasis of this valorizing interpretation:

> The Celtic rhythm, an innovation in the world's art, represents itself and envisages a dynamic universe, with its moving space, in which humanity no longer occupies a privileged position. The Greek form is born of an anthropomorphic vision of the world that freezes movement and crystallizes emotion.

And Breton marvels at the disproportion of Celtic art, for example, when it uses a die too large for the coin being struck.[38]

On the borders of continents, the boundaries of normality. Starting in the 1920s, along with a minority of doctors and a few brilliant autodidacts like Hanz Prinzhorn, the Surrealists discovered the artistic value of the drawings of the mad, especially schizophrenics.

They also rediscovered the function of the "madman" in primitive society. Jules Monnerot says, in *La poésie moderne et le sacré*:

> To satisfy a powerful drive—for the advantage of the group—we see these savage communities reclaim the deviant, whose peculiarly precarious condition they believe to be privileged and revelatory. Society thus does not crush him like a tombstone, but instead carries him like a wave, finding a place within itself for this supremely asocial being—far from keeping him at a distance and driving him to crime or insanity.

And Mircea Eliade explains from his own standpoint how the shaman's vocation often comes from an illness or an epileptic fit. The social function of the shaman makes a positive value out of a lack, a deficiency, a sickness.

But Surrealism was also moving in the same direction as a whole evolution of mainstream medical and social mentality with respect to "institution-

alized" insanity. German-speaking Swiss psychiatry took a much less coercive attitude from the 1920s on. In 1921 Dr. Walter Morgenthaler was able to publish *Un aliéné artiste*, on the "mad" artist Adolf Wölfli (1864–1930), which not only emphasizes the draftsman's virtues of artistic invention but states that the morbid behavior of this aged child (who had been deprived of all affection from the age of eight) should be "supported" in order to strengthen an equilibrium which would be precarious without it. Readers of this monograph included Lou Andréas-Salomé, Rilke, and Dr. Hans Prinzhorn, who used it for a comprehensive study published in Berlin in 1922: *Bildnerei der Geisteskranken (Artistry of the Mentally Ill)*. Apparently Hans Arp and Max Ernst made the Surrealists aware of this book very quickly. José Pierre gives great weight to the spread of this work among the French Surrealist group: abundantly illustrated, the book could well have convinced a number of them, just after the collapse of Dada, that the resources of the unconscious were well worth exploring through visual means: in other words, that Surrealism also involved painters and sculptors, which, in 1922, was not self-evident.[39] Shortly thereafter, the eccentric, anomalous compositions of the mentally disturbed began to play their part in the birth of Surrealist objects and of Breton's "poem-objects." In 1924 Dr. Jean Vinchon's *L'art et la folie* appeared in France, praising the drawings of schizophrenics. Already, in 1907, Marcel Réja's *L'art chez les fous* had objected to the belief that the "sickness" of such drawings relegated them to a position "beyond the frame, unrelated to the norm." Thus the "Letter to the Medical Directors of Insane Asylums," written chiefly by Robert Desnos for an issue edited by Artaud of *La Révolution Surréaliste* (no. 3, April 1925) was less audacious for its content than for Desnos's own characteristic tone when it called the mentally ill the "galley slaves of sensibility." In 1928, Aragon and Breton's commemoration (in *La Révolution Surréaliste*) of the Fiftieth Anniversary of Hysteria belongs to the same tendency to consider hysteria "a supreme mode of expression." From this came the beginning of an attempt to invent in order to understand—Breton and Eluard's experiment of the five "Essays in Simulation": mental deficiency, acute mania, general paralysis, interpretive delirium, and dementia praecox.

Surrealist admiration of the artistic expression of "madmen" centered on Adolf Wölfli, Aloïse, and Friedrich Schröder-Sonnenstern, the first discovered before World War II, the two others afterward. Surrealist reviews bear steady witness to this interest, in daring terms. Breton writes: "I have no fear in making the statement, paradoxical only at first glance, that the art of

those we call mentally ill constitutes a reservoir of mental health" *(L'art des fous, la clé des champs).* It is not a question of denying the pain of madness, nor its irreversible effects, but of acknowledging in the "marginal" people of the art world the right to exist, and in their works the power to enlarge our awareness of the world.

"Naïfs" and "mediums" constitute two other categories of painters noticed and valorized by the Surrealists, categories that are sometimes no easier to distinguish from each other than to distinguish from that of madmen. When the "Company of Brute Art" was founded in October 1948 around André Breton and Jean Buffet (including Jean Paulhan, Charles Ratton, Michel Tapié, and Henri-Pierre Rouche), the very name they chose for the group allowed the regrouping of works done by "madmen," mediums, and naïfs.

Of course, "the autodidacts we call "naïfs,' " in Breton's phrase, whether famous names like Henri Rousseau (the "Customs Inspector") and Ferdinand Cheval ("the postman") or lesser-known figures such as Morris Hirshfield, Demonchy, and Miguel G. Vivancos, made no claim that their impulse to paint was dictated by some kind of spirit. On the other hand, Hector Hyppolite, a Haitian inspired by voodoo, painted the divinities of the cult and scenes of the rituals invoking them; the Scotsman Robert Wilson (known as "Scottie"), painted under the hallucinatory effect of very fine parallel lines which slowly ordered themselves, "an open birdcage" (George Golfayn, *Médium*, no. 4, 1953); while Joseph Crépin received a revelation, his hand refusing one day in 1938 to continue copying music and beginning to draw little sketches. These drawings, done in colored pencil on notebook paper, were then enlarged and copied on canvas, all to obey a mysterious voice guiding him. As for Augustin Lesage, he attributed the merit of his painting to his sister Marie, dead at the age of three. And so forth.

In fact, Surrealists tried not to make unnecessarily sharp distinctions among these categories, because of assertions of the painters themselves. Isn't the main thing these painters have in common the fact that they all avoided academic training, and gave themselves to their art as if to answer a necessity of life—like the need to paint that plagues some schizophrenics? So the Surrealists saw no need to connect "mediumistic" painting to the stream of thought arising in the mid-nineteenth-century Industrial Revolution, with its spiritualist implications and what Breton called its "nauseating terminology." For the Surrealists, the important thing was to trace the ways in which this painting suddenly comes into being: the motivating impulse

may produce graphs or letters and lead either to drawing or to writing. This impulse may also have an essentially "sensory" quality, in that "the products of the vision and the internal auditory experience are exteriorized so as to assume the quality of quasi-perception" (F.W.H. Myers).[40] Whether or not automatic passivity is a fiction, so that the origin of this pictorial or written activity is a false problem, is a question left open by Surrealism; as is the question of whether "naivety" involves powerful reveries of possession of the world, as studies now seem to indicate.

This simple survey of the "forerunners" to whom Surrealists consistently refer, and the kinds of works that they saw as models, has already cut a wide path. We still have not considered, however, the whole vein of inspiration generally called hermetic or esoteric, in the sense that it designates doctrines restricted to certain individuals and hidden from the eyes of the profane. The esoteric tradition, as we know, presents itself as one transmitted down through the ages by a chain of masters and disciples, a *philosophia perennis* for all time, the content of which is the order of knowledge: a gnosis, an intuitive, suprarational, transcendent understanding through which humanity could reconstitute a universal metaphysics. This involves all kinds of propositions which, if they were defined with any precision, could not coincide with those of Surrealism. For Breton, the word "tradition" rhymes with suppression.[41] And the transcendence implied by the idea of metaphysics cannot coincide with the resolutely immanent projects of Surrealism ("Le message automatique," in *Point du jour*). Surrealism cannot possibly be a link in the chain of traditional esotericism. Nevertheless, the Surrealists were fascinated by all kinds of ideas and cultural objects connected to esotericism: the idea that intuition is a privileged and primordial form of knowledge, from which rational cognition detaches itself only secondarily in human history; that the horizons of knowledge should be ambitiously extended far beyond the limits of what we know today (in esoteric tradition, the goal is a total and absolute knowledge). But we can also see that at this degree of generality such propositions could be claimed by the most banal anthropology as easily as by a thoughtful epistemology. The originality of Surrealism lies in its claim to keep these certainties in mind at the *very moment* when we are making the most ordinary decisions or looking at the most unimportant objects. Such a frame of mind may or may not create new frontiers of science, but it has a good chance of remarkably enriching our lives and the way we look at things.

Within esotericism, Surrealism tends to find affinities in Gnostic tradi-

tions, once it has freed them from their dated imagery, their basic dualism, and their metaphysical foundations. In Plotinus and his followers it finds a thematic of unity, as opposed to plurality, central to Surrealist reflection on the individual: internal unification, the rediscovery of one's unconscious forces, goes together with a perception of the links that connect the individual to the cosmos in the great cycles of life and death, of light and shadow, of the rising and setting of the stars. In both cases, the unity of the individual is won over separation, experienced as a decomposition. Some basis for a morality is involved, too. "Pneumatics," possessors of the gnosis, are above the rest of humanity, whose terrestrial links they despise; there is thus an equivalence between two opposite forms of behavior, the ascetic and the libertine. The pneumatic is allowed to do whatever he wishes,

> since the pneuma is "saved in its nature" and can be neither sullied by actions nor frightened by the threat of archontic retribution. . . . Through intentional violation of the demiurgical norms the pneumatic thwarts the design of the Archons and paradoxically contributes to the work of salvation. This antinomian libertinism exhibits more forcefully than the ascetic version the *nihilistic* element contained in gnostic acosmicism.[42]

As Jules Monnerot noted, "The comparison between Surrealists and so-called licentious Gnostics (Carpocratians, Nicolites, etc.) is self-evident."[43] Finally, the role of woman in Gnosticism is either completely devalued, as in Manichean doctrine, where reproduction is the most dangerous ruse of Satanic strategy, or exalted. When woman's role is exalted, she becomes the receptacle of a fragment of divinity, as in the Gnosis of Sophia, in which "Life," the feminine principle, is included in man, so that the Archontes do not suspect its presence; it then leaves Adam and incarnates itself as Eve. Certain sects maintain a confusion between the feminine principle and the soul, "Life." This contains potentially the elements of the Surrealist thematic of "amour fou" ("mad love"). In Joachin de Flore, or even in the "negative theology" of Meister Eckhart, Surrealism finds traces of these themes and beliefs.

The sphere of Surrealist concerns and admirations was thus, as we have seen, an expanding one. In the end it is always a question of cultivating emotion, that "furrow of truth" (a wonderful phrase Breton found in Saint-

Pol Roux)—emotion as a means of understanding, including both aesthetic sensation (identifiable, for Breton, by "a feathery wind brushing across my temples") and erotic sensation, distinguishable from each other only in their different degrees of intensity.[44]

> To love, first of all. There will always be time, afterward, to ask oneself about what one loves until one no longer wants to be ignorant of anything connected with it. . . . Only the doorway of emotion can give access to the royal road; otherwise, the paths of knowledge never lead to it.[45]

But the Surrealists do not invent by imitating, by reproducing these compelling themes. They invent by a game I will call "bricolage," in Claude Lévi-Strauss's sense,[46] and which involves fabricating literary or visual works of art not only for pleasure but to understand. To understand, for example, by analogous intuition, the mental mechanism that presides over the fabrication of Oceanic masks. Thus Breton's propositions were reduced to a less demiurgic conception, often taking them out of their nuanced, questioning context. We can shed light on "the conception of the work of art as objectification on the material level of a dynamism of the same nature as that which presided over the creation of the world" if we remind ourselves that this is a question of "the everlastingness of certain human aspirations of major importance."[47]

At the heart of the Surrealist enterprise and the Surrealist universe, then, is this explicit notion of magical participation. When Surrealism preaches the value of magic—when it perceives, before any difference among them, "the common denominator uniting the sorcerer, the poet, and the madman," as Benjamin Péret says[48]—it does not suggest that modern man fabricate out of whole cloth a "past" or "primitive" world. In reading, we must be able to keep the thread of statements such as this:

> The advances of science, on which people were counting to dispel the illusions of times past, have had the paradoxical result of reviving on a vast scale a nostalgia for the childhood of humanity and for those ways of acting on a world whose secret the men of that time, blindfold, were exercising their wits to discover.[49]

Surrealism rather suggests that we become aware of the irrational element that always excites our individual decisions, that always weighs on collective

ideologies, for worse as well as for better. And that we give ourselves the practical means of *"maintaining in a dynamic state* the system of comparison in an unlimited field, available to humanity and offering us relationships capable of linking objects apparently very far apart, and showing us, in part, the mechanics of universal symbolism."[50] This is, with no contradictions, a completely scientific and completely poetic attitude.

3

History of the Movement and Its Progressive Theorization

It is a perilous enterprise to try to separate the history of the Surrealist movement from an elucidation of its major intellectual points. The function and nature of Surrealism changed between 1919, when André Breton and Philippe Soupault wrote *Champs magnétiques (Magnetic Fields)* [1] and 1969, when the group dissolved. However, much of this evolution took place in reaction to the remarkable shifts in knowledge and behavior characteristic of the society surrounding it during the half-century. Just to draw the vectors and fixed points of this evolution involves taking account of the dual movement of Surrealism and history. The advantage of this process is that we would no longer be presenting Surrealism as a shower of sparks that burst in 1924 and then refused to resign itself to dying. We could then stop

defining this movement simply in chronological terms of the individuals who enlivened it, through the stages of its successive developments and the landmarks of its positions during political troubles. We could define Surrealism *in its role*. In the last analysis, perhaps Surrealism is only a role—or perhaps the catalyst of a liberated world, of a world to liberate.

In 1952, Breton suggested that Surrealism might be a function when, answering a question of André Parinaud's, he replied:

> At the age of twenty or twenty-five, the desire to fight defines itself in relation to whatever around you is most offensive, most intolerable. *In that respect, the world today exhibits an entirely different sickness from the sickness of the 1920s. In France, for instance, what was threatening the mind then was stagnation; today, it is dissolution.*[2]

In 1919, social customs, political structures, and the system of international alliances all showed clear signs of inheritance from the customs, structures, and diplomacy of the nineteenth century. Relationships and human communication are invented as a function of these givens; what it means to be a person is defined in relation to them. No doubt the use of mass armies and the hecatombs of World War I must have given rise to some suspicion as to the practical value of the individual dignity that supposedly inspired such respect. But once the menace of war had vanished, people asked nothing better than to forget the readjustments they had been forced to make in a whole system, not even of values but of ideas. In this context, the function of Surrealism in 1919 was to break open, by every possible means, the stagnation of a self-satisfied society which, after a spell of delirium, was reformulating, quietly but certainly, its own good conscience. In 1952, Breton could characterize the situation of "world society" in these words:

> All kinds of giant cracks [appeared], in the structure of the globe as well as in human consciousness. . . . I am referring here to the irreducible opposition between the two blocs; to totalitarian methods; to the atomic bomb.[3]

In 1969, it was plain that the cracks had widened; not only did the politics of each country define itself in relation to larger economic and political

entities, but the mobility of the international systems of realignment was astounding—for example, the sudden opposition of the Chinese world to the rest of the nations that claimed kinship with Communism. Financial problems no longer had a direct relation with the concrete order of exchange and took an abstract form, swollen with their own mechanisms: the notion of fiduciary surety lost virtually all its meaning. In the communal consciousness, space lost a good deal of its practical reality. We all agree that in the nineteenth century the progress of means of communication had made space relative. But that relativity had scarcely been assimilated by the human consciousness before the idea arose of "cosmic space"—an idea that was either abstract or vague. From then on, the function of Surrealism could be the rallying cry of those for whom the vital magnetic poles were "poetry, liberty, love." In 1952, Breton could pride himself on having followed the "Front humain," led by Robert Sarrazac, which became the "Citoyens du monde" movement, "an action whose goals seemed [to him] the only goals broad enough to suit the circumstances."[4] Rising against the "dissolution" of the mind, giving a participatory function back to the individual conscience —this was the role to which Surrealism dedicated itself in its last decades.

Without multiplying systems of reference in a work of this size, I will now proceed by historical stages, so as to take into account an understanding of this role and how it has evolved, and an awareness of its theoretical position, together with a sense of the uneven investigations to which this position has been subjected. Thus the years 1919–32 correspond to an intense reflection on automatism and the establishment of a theory of the image; the 1930s, to the appearance of "objective chance" and a whole consideration of black humor; the late 1940s, to the discovery of the significance of myth. In the latter part of the book, we will be able to take up these threads in the context of more synthetic views of the movement as an ethics, as an aesthetics, as a ground for political positions, without fixing their interplay in some apparently immutable doctrinal synthesis. This way I hope to understand and adapt to both the consistency of ends and Surrealism's sometimes contradictory variety of means: both its absolute creativity and the fact that it so often seems like a response—an audacious, wary one, certainly—to the sicknesses of humanity and society.

From 1919 to 1932

Others have already noted the important role played by Apollinaire during the years 1919–32, when the great protagonists of the Surrealist venture were young, and Aragon, Soupault, and Breton, as soon as they met in 1917, began thrashing out their great question, "What is the modern 'idea' of life?" Apollinaire was the great awakener, "lyricism personified," he who "brings trailing behind him the cortege of Orpheus." (For Apollinaire's place in the origins of Surrealism, see *La Revue des Lettres Modernes*, "Guillaume Apollinaire," no. 3, 1964). The same is true of the more discreet but more critical role of Valéry, one of Breton's first readers, though the Surrealists admired Valéry through a partial misunderstanding: as he had published nothing since 1899, the Surrealists tended to confuse him with his character M. Teste.

The gong first sounded in 1919, with the discovery by André Breton[5] and Philippe Soupault[6] of the exceptional powers unleashed by automatic writing. This discovery came a few months after Breton, Soupault, and Louis Aragon had founded a new review called *Littérature*, at Valéry's suggestion, but by antiphrasis.[7] "Literature, underlined!" Valéry had suggested, alluding to the conclusion of Verlaine's *Art poétique:* "And all the rest is literature." Paul Eluard was to join them later, through Jean Paulhan's intervention.[8] But at the birth of the review, in March 1919, the three musketeers, all twenty-two or twenty-three years old, had already won a modest place in "literature." Soupault had published a booklet of poetry, *Aquarium* (1917), and was about to publish *Rose des vents* (1919); in that same year, 1919, Breton published *Mont de piété* and Aragon *Feu de joie*. Paul Eluard was to publish *Les animaux et leurs hommes* in 1920. And they invited a number of rather important literary figures to contribute to the issues of the first year, March 1919–February 1920 (André Gide, Paul Valéry, Léon-Paul Fargue, Max Jacob, Blaise Cendrars, André Salmon), even leaving room for the illustrious dead (Apollinaire, Mallarmé, Rimbaud). At the same time, a contempt for literature was expressed without benefit of theory by mining another lode: enigmatic poetic texts by Tristan Tzara[9] and Breton (whose work used collage); especially important were the publication of Isidore Ducasse's *Poésies* and Jacques Vaché's *Lettres de guerre*, two works that seriously question the supposed superiority of art over life. Finally, the review offered a questionnaire: "Why do you write?" All the approved

answers deny literature any inherent value ("I write to pass the time," Knut Hamsun).

Les champs magnétiques appeared from September 1919 to February 1920, in issues 7–12. In early 1920 different excerpts were given to other magazines, and the whole work appeared in May 1920. These prose pieces were written during six weeks, May and the first two weeks of June 1919, in a state of intense exaltation. According to Breton's first written testimony of 1922, they were born of the discovery of the productive power of the phrases that come to mind as one is falling asleep, together with the attention given by Breton to the method of free association prescribed by psychiatric treatises. They were written by Breton and Soupault, who took turns holding the pen, during collective work sessions in successive chapters which "had no reason to end but the end of the day in which they were begun" (*L'entrée des médiums*, 1922); the speed at which they were written down, however, was agreed upon beforehand. The subject was also sometimes set in advance. Artifice of subject, speed, and duration therefore presides over the writing of these works which—with no contradiction—claim simultaneously to give inspiration back its lost powers. Aragon, who was away from Paris at the time of the experiment, was stupefied on his return—first reticent, then astounded. After Breton's death he was to call it a book "through which everything begins," thus retrospectively fixing the origin of the whole adventure. And Tzara bore witness from Munich that the review responded favorably to an "attempt to create a growing demoralization."

A complete break with literary circles was very near. While Breton was breaking away from his family (refusing to follow his medical studies, receiving no more subsidies from them, and getting money to eat from jobs procured for him by Valéry), everything exploded when Tristan Tzara arrived in Paris in January 1920.

The Zurich group of the "Cabaret Voltaire" and subsequently the "Galerie Dada" had started a review first called, in 1916, *Cabaret Voltaire*, then *Dada* (Breton had seen Dada at Apollinaire's in 1917). By sending Tzara to Paris, at the invitation of *Littérature*, it was thus sending its prime mover, whose *Manifeste Dada 1918* had stunned the Paris group of friends. The Zurich group was already falling apart after a few years of activity in the midst of a Europe at bloody war. In 1916 Hugo Ball (who had refused to join the German army), Richard Huelsenbeck (who had been dismissed from it) and the Alsatian Hans Arp (who had escaped both the French and the German mobilizations) [10] had met up with the Romanians Tristan Tzara

and Marcel Janco and enlivened the evening parties of the "Cabaret" by reciting, to the rhythm of black chants, various "simultaneous poems" and "phonetic poems" invented by Ball. Ball's nihilism on a background of mysticism proposed to assert the silence of being across the spoken sound. Tzara's antiaesthetic intention was, while introducing journalistic expressions, noises, and sounds into his poems, to proceed "like Picasso, Matisse, and Derain" with the "different materials" of their canvases (Letter to Jacques Doucet, October 30, 1922). And there is an even more evident nihilism in the "simultaneous poem," in which the voices of the different actors negate meaning at its very origin. From the start of the review *Littérature*, its moving spirits were exchanging letters and texts with Tzara, which they did not do with the Dada group in Berlin. (The Berlin Dadaists met, from 1918 on, around Huelsenbeck, Raoul Hausmann, George Grosz, the brothers Herzfelde). Breton was equally drawn toward the painter and poet Francis Picabia,[11] the moving spirit of the review *391* (Barcelona, January 1917– October 1924), after being, together with Marcel Duchamp in New York between 1915 and 1917, against not only "good taste" but the validity of the very notion of aesthetic taste. Picabia was a man of parts, a real dandy, who brought with him other extremely attractive individuals, such as Georges Ribemont-Dessaignes.[12]

In Paris, the new group abandoned itself to various demonstrations,[13] in which a taste for scandal and absolute nihilism (involving a refusal of any literary tradition, the negation of all knowledge, the proposition that "thought happens in the mouth") were combined with a "joy of the mind," an intense feeling of "breathing in."[14] There is obviously something liberating in breaking the rules of "good taste," conventions, and social courtesies. The violence involved in the explosion of this joy was very soon to spoil the relationships of the group, even among themselves. Meanwhile, the collective demonstrations often passed to the theater, a privileged place where gestures in all directions and incoherent language were intended to prevent any possibility that meaning might emerge. The common ground between this and the adventure of automatic writing lies in the element of the arbitrary: "When will anyone give the arbitrary its proper place in the formation of works of art, or of ideas?" asked Breton.[15] But the arbitrary does not exist on the same level in Tzara's texts as in Breton's, even during this period of collective action. For Tzara, establishing a relationship between terms prevents any image from arising: "he is a convinced mandarin star on a deserted visiting card, and gets up early."[16] For Breton, on the

contrary, such a relationship tends to create an image or even to "make sense" in his automatic prose, and much more strongly in his poems, such as *Forêt-Noire*.[17]

Breton's reservations with regard to Dada are perceptible from the beginning, and even in his apology for them. He saw that in the negative spirit of Dada there is the potential for its own supersession: "We are well aware that in the future an irrepressible personal fantasy will run loose, more 'dada' than the present movement" (*La NRF*, August 1920). This intimate distancing can be seen also in the letters from Breton to Simone Kahn during that same summer.[18] Aragon, on the other hand, liquidated the Dada heritage of outbidding it in *Les aventures de Télémaque* (written 1921). This parodies Fénelon's tale, stuffs it and perverts it by introducing erotic themes and a collage of Dada manifestoes, while putting the whole thing under an epigraph from Kant: "It is better to consolidate [in expression] the meaning appropriate to it . . . than to lose everything by becoming unintelligible." A very strong inclination within Aragon still seems to me to remain close to the Dada instinct which denies meaning any opportunity to emerge, while remaining fascinated by the space of its emergence: "Through the magic sign of ink, I limit my thought in all its consequences."[19] To conceive of writing in the most concrete sense as *limit*, the limitation of thought, and as a "magic sign," is to refuse *movement* in writing. A magic sign is in fact a sign designating a multitude of possible significations, linked to it through the power of language. Do we not find in Aragon a judgment—completely abstract—on the impossibility of communication, and a fascination with the space invested by language, which disturbs any perception of its behavior as linear? This judgment and fascination are comparable to those of Dada on the meaningless gesture as a means of investing theatrical space.

Jacques Rivière's analysis in "Reconnaissance à Dada" (*La NRF*, August 1920) is irrefutable: "For the Dadaists, language is no longer a means, but a being. A sort of mysticism doubles the skeptical attitude toward syntax." Nevertheless, the communal activity continued, bent by Breton toward an ethical direction and an aesthetic elucidation. (This elucidation can be seen in the preface to the catalogue of the exposition which, thanks to Breton, Max Ernst was able to achieve in Paris—"Max Ernst," in *Les pas perdus*. The reflections on the ethics of the man of letters can be found in his remarks on the "Barrès trial," May 1921.) From May 1920 to the summer of 1921, then, *Littérature* (nos. 13–20) became the mouthpiece of the Dadaists. The break did not take place until February 1922, at the organization of a "Congress

for the determination of directives and the defense of the modern spirit," also called the "Congress of Paris." Tzara disassociated himself from this enterprise, and a violently resentful reaction against him on the part of the organizing committee turned his sympathizers against its members, particularly against Breton. This rupture between Breton and Tzara brought Breton closer to Picabia, who had already distanced himself from Tzara and who was collaborating on the new series of *Littérature*, despite Soupault's hostility toward him.

Surrealism began with this "new" review—with its new format, with playful covers by Man Ray or Picabia—or Surrealism began again, as Marguerite Bonnet invites us to say, since she sees Dada as simply a transition. Here we find the preoccupation with narratives of dreams (should they be written down in shorthand?); the interest in oneirism; the stories of amazing coincidences ("L'esprit nouveau" in *Les pas perdus*); experiments with hypnotic trance.

The future Surrealists thus paid newly close attention to the flow of the subconscious. The research was done chiefly by Robert Desnos and Breton, for whom the method of mental associations, tested by automatic writing, could be generalized, if one suppressed by some other means the control of reason and of consciousness. Hypnotic trance, practiced in collective seances after the spiritualist initiation undergone by René Crevel, allowed one to *say* what automatic writing had been marking down on paper. At the same time, this involved a kind of laicization: transferring to the level of immanence what spiritualism, which underwent a sudden resurgence in 1922–23, proposed in its methods and results. Surrealist seances of hypnotic trance set aside any transcendent hypothesis, any supposed communication with "the dead," but dreamed, as Picabia writes, of catching in their net something like "the beginning of the substance [of words]." These sessions only went on for a few months; the lifting of inhibitions against violence made them too risky to follow up. In Breton's view, they "strengthened the conviction that the disappearance of rational controls, suppressing their destructive mediation, permits the emergence of a poetic force."[20]

Aragon and Soupault were not associated with these seances; the former was in Berlin and the latter away from Paris. More to the point, Aragon was involved in his own experiments with various inventive techniques, the arbitrary element of which had an entirely different origin. On the one hand he adhered unreservedly to Breton's own discoveries: "that lyricism of the uncontrollable, which still had no name, and was in 1923 to be called, by

our common consent, 'Surrealism.' "[21] On the other hand, from 1919 on he also played, more regularly than others, the game of pastiche, rewriting, "correcting" Fénelon's *Les aventures de Télémaque* in the manner of Lautréamont "correcting" various writers in his *Poésies*. During 1922–23 he was reflecting on the role of collage as metaphor (see his text of August 1923 on Max Ernst and collage). And he also considered the *incipit* as a springboard, analogous to the wake-up phrases Breton used to start the process of automatic writing. In Aragon's case, however, the springboard led to the writing of stories that were to form the remarkable collection *Le libertinage*. Accepted as an as an arbitrary condition of creativity, the *incipit* tends to show that the liberty of literary inventiveness depends on the formal constraint of artifice.

Thus, during 1923 and the spring of 1924, the original group was restructuring and consolidating itself. From 1922 on, it had come to include Benjamin Péret and his friend Robert Desnos; Max Morise; the group behind the reviews *Aventure* and *Dés* (René Crevel, Roger Vitrac, Jacques and François Baron, Georges Limbour;[22] though not Marcel Arland or André Dhôtel, who remained at a distance). In the same year, the habitués of the painter André Masson's studio at 46 rue Blomet (Michel Leiris, Antonin Artaud, Roland Tual, as well as Georges Limbour and Jean Dubuffet) also participated in Breton's gatherings. *L'Oeuf Dur*, a review that appeared from March 1921 through the summer of 1924, disappeared; those involved in it, Mathias Lübeck, Francis Gérard (Gérard Rosenthal), and Pierre Naville[23] associated themselves with the "Surrealist" movement. For the group took up the challenge of the literary world, which had labeled these young people "Surrealists" as if to say "Apaches"; from then on, they used the name to describe their own activities.

But all this took place at the cost of a year of hesitation, during which perspectives seemed to be growing more limited. Philippe Soupault withdrew; now a member of the steering committee of *La Revue Européenne*, he had returned to his original inspiration, closer to Apollinaire (through whom he had met Breton). In 1923 he published his first novel, *Le bon apôtre*, which his friends saw as a return to "literature" in an entirely unironic sense. In fact, Soupault's tragic sense of things and even his modernity no longer had much to do with Surrealism as it was developing. He retained a generous admiration for Breton; Breton, for his part, was severe about Soupault's overinvolvement in literature, severe enough to publish four blank pages in *Littérature* (no. 10, May 1923) by way of an article on Soupault, merely

mentioning, as an epigraph, his participation in the writing of the *Champs magnétiques*. All the same, he was to pay homage to Soupault's lyricism by publishing a poem filled with remarkable long waves, "Est-ce le vent?" in *La Révolution Surréaliste* (no. 7, June 1926).

Each of them seemed to be turning back to his own individual work. André Breton organized and published the collection *Les pas perdus*. Aragon had accepted a job as a journalist at *Paris-Journal*, then some more literary work from the couturier Jacques Doucet. Having almost finished writing the stories that would appear in 1924 as *Le libertinage*, Aragon threw himself into an ambitious secret project. At Giverny, in the spring of 1923, he began *La défense de l'infini*, a novel he was never able to finish and destroyed in August 1927—Giverny, where he intoxicated himself with memories and with the absence of a "forbidden woman" who was probably Denise Naville. As for Desnos, after having composed *Pénalités de l'enfer ou les Nouvelles Hébrides* (1922), he continued with the writing of oneiric prose, *Deuil pour deuil* (1923). In the same year Benjamin Péret, who had shown his originality in 1921 with *Le passager du transatlantique*, published *At 125 boulevard Saint-Germain*, illustrated by Max Ernst. Antonin Artaud began a correspondence with Jacques Rivière that was to become famous. Paul Eluard, after a joint effort with Max Ernst (*Les malheurs des immortels*, 1922), wrote most of the poems which would be published the following year under the title *Mourir de ne pas mourir*. A certain confusion can be sensed, not only in the sparsity of texts by Breton (emphasized by the April 1923 interview in the *Journal du Peuple*, which allowed Roger Vitrac to title it "André Breton Will Write No More") but also in the prolixity and secretiveness of Aragon's writings. In any case the break with Dada is consummated by the violent evening of *Coeur à barbe*, in which the show that Tzara and his friends tried to perform was interrupted by Breton and his friends.

However, starting with the summer of 1923, things turned around. Breton had the notion of collecting poetical texts in a volume called *Clair de terre*, dedicated to the close friends of the group and its admired elders; and he met Saint-Pol Roux. It is true that Eluard left on a sudden voyage, motivated by anxiety, an exasperated relationship with his family, and a taste for rupture, and that the trip, which he decided to take on the spur of the moment, lasted six months (March–September 1924). But for Aragon, Breton, and many of their friends, a renaissance was under way.

During 1924, the group felt the necessity of affirming a body of com-

munal projects, as much in response to an internal need as because of keen attacks from outside the circle.

There were attacks on the paternity of the term "Surrealism," used by the editors of *Paris-Soir* (May 22, 1924) to characterize the activity now of "Reverdy, Max Jacob, Paul Dermée," previously of Apollinaire; and used by Ivan Goll to refer to Apollinaire (*Le Journal Littéraire*, August 16, 1924). Each of these journalistic notes made the group react by clarifying its position, pointing to the specific details of automatic writing and a certain conception of creativity, such as the one the Surrealists sensed in the work of Raymond Roussel, though they knew no more than anyone else of the mechanisms which were to be unveiled in his posthumous work. Moreover, they minimized Apollinaire's influence by tracing the form of Surrealism, if not the word, back to distant times. Ivan Goll, bent on claiming an aesthetic conception of Surrealism—and a very vague aesthetic ("this transposition of reality on a superior [artistic] level constitutes Surrealism")—even founded a review called *Surréalisme* (October 1924, a single issue). Finally, the welcome given to Breton's *Manifeste du surréalisme* (October 1924) tipped the scales decisively in favor of a model of thought involving more profound evidence (in the eyes of Maurice Martin du Gard, for example, in *Les nouvelles littéraires*). From then on, the term "Surrealism" belonged to Breton and his friends.

Attacks on Breton personally, and on his willingness to present himself as a party leader, were led by the enormously attractive painter Francis Picabia; the Surrealists maneuvered against Picabia cleverly, supporting as a possible rival Picasso, who had done the scenery for the ballet *Mercure* in June 1924.

Within the group itself, tension ran high in discussions about the boundaries of acceptable literary ways to earn one's bread. Where does compromise begin? There is no doubt that pressure from the group led Aragon slowly to abandon Hébertot and *Paris-Journal* during 1923. The two great texts of Surrealist proclamation that saw the light of day in the summer of 1924 can even be seen as competing with each other: Aragon's *Une vague de rêves* (originally published in *Commerce* in October and then reprinted in booklet form) and Breton's *Manifesto* (published by Sagittaire with Simon Kra, October 15, 1924). But although these may have competed with each other on the functional level, they must be considered intellectually complementary, the evocative attractiveness of Aragon's pages appearing as a mar-

velous aura for Breton's more massive and more complex text. It is true that in January 1925, with the *Introduction au discours sur le peu de réalité*, a text begun at the same time as the *Manifesto* and *Poisson soluble*, the automatic prose published with it, Breton showed the sparkling, dreamlike other side of his own thinking.[24]

At the heart of both the *Manifesto* and *Une vague de rêves* we can find testimony to the already aging enterprise of automatic writing. But both texts submerge it in the points they are trying to make—a more philosophical reflection in Aragon's case, more ethical in Breton's. Aragon's philosophical position is primarily that of the subject. The discovery of the contingency of the self is the foundation of all philosophical thought, when it is freed from the distorting influence of affect. This philosophical position is also that of the real, defined in Kantian terms as a relationship between the mind and the object of its perceptions; only these perceptions are multiplied, so that they establish other *primary* relationships—the relationship that the mind can grasp between itself and "chance, illusion, the fantastic, the dream." "These different species are reunited and reconciled in one genre, which is Surreality." The Surreal is henceforth defined as a limiting notion, "a relationship between the mind and what it will never reach." Breton's position is primarily an ethical one: practical necessity annihilates in humanity the powers of the imaginary (a trial of materialism and realism, with arguments borrowed from skepticism). We must shake off the yoke of logic: in life, this yoke of logic makes us refuse to acknowledge the disturbing power of dreams (this is a non-Freudian perspective) and, in literature, it leads us to stamp out the marvelous. Automatic writing offers us a technique for this goal. Surrealism proposes a new theory of the image, which leads to action. An implicit intellectual model guides Breton in describing the human mind and its functioning: a mechanical model, linked to concepts of energy and dynamism, which avoids any epistemological break between nature and function.

As for Breton's *Introduction*, written about the same time and first published in *Commerce* (Winter 1924), this is a primarily lyrical text: expectation of the marvelous, hymn to woman. But it contains keen reflections on the power—at once negative and fantastically affirmative—of poetic language: "Doesn't the mediocrity of our universe depend essentially on our powers of articulation?" Reflections, too, on the Surrealist object (a product of dreamed activity); about the dynamism of the process of becoming, carrier of the individual quest ("I search for the gold of time"). And on political action: the appeal to the Orient in the closing pages is certainly a mystic appeal to the

dispossessed self, but it is also a call to arms against popular opinion, which supported French action in Morocco, and in favor of the virtues of nonoccidental civilizations.

A change of direction had taken place. The "movement" of a few young men had taken a name and asserted its disturbing existence as something that society, literary or not, had to deal with. This was shown not only by the publication of the founding texts but also by the opening, under the influence of Antonin Artaud, of a "Bureau of Surrealist Research" at 15 rue de Grenelle, which Aragon called a "shelter for nondescript ideas and continued revolutions," as well as the launching of a new review, *La Révolution Surréaliste*, on December 1, 1924, edited by Pierre Naville and Benjamin Péret). The interplay between rebellion and the need to invent some sort of *other* life provided the exchange of terms necessary for this definition and affirmation.

But poetical affirmation was soon to include political action. A number of circumstances led to this.

With the radicalization of the Surrealist movement, the more united group no longer hesitated to offer provocations that allowed it to defend itself better against the constant threat of literary assimilation. For example, the flattering review of *Les aventures de Télémaque* by Jacques Rivière (in *La NRF*, April 1923) earned him a brutal reply from Aragon in *Paris-Journal:* "My imprudence in publishing a book gives you a hold over me." At a certain very "literary" dinner, the Polti banquet (February 1924), Desnos insulted a woman of letters. And there was an enormous scandal at the time of the distribution of the tract *Un cadavre*, which hailed with insults the death of Anatole France, for whose funeral national preparations were under way. A political and literary unanimity had formed around his name: anticlericals found something for themselves in his writing, and so did the various branches of the intellectual "right," which vied with each other in celebrating the great lucidity and Frenchness of his style. "Have you slapped a dead man's face today?" asked Aragon. Breton and Aragon were fired by Jacques Doucet, the couturier who was giving them the wherewithal to live (though the quarrel lasted only a few months). In June 1925, there was a scandal at the Vieux-Colombier. And in July of the same year the scandal at the Saint-Pol Roux banquet, originally harmless, aroused an outraged hue and cry because it wounded the patriotism of the French, who had just occupied the Ruhr and undertaken the Rif War in Morocco, against which

the Surrealists took a position the same day. An open letter to the poet and French ambassador Paul Claudel, who had called Surrealist activity "pederastic," was widely distributed by the Surrealists: this letter referred to France as a "nation of pigs and dogs." And a jingoist remark by Mme Rachilde led Breton to defend Max Ernst, a German citizen, present and accounted for. In the general free-for-all, cries of "Long live Germany!" and even "Down with France" could be heard. This was when rightist political circles decided to surround Surrealist activities with a conspiracy of silence. We can see objective proof of this conspiracy in the joint indignation of Drieu La Rochelle and Emmanuel Berl ("Une grève," *Les Derniers Jours*, no. 2, February 1, 1927), protesting the silence of critics after the appearance of Aragon's *Paysan de Paris*.

But from such provocative violence the Surrealists moved to political engagement. In 1925, then, the loss of the popularity they had still been enjoying took a clearly political turn.

The Rif War in Morocco was a response to the revolt supported by Abd-el-Krim, who had already beaten the Spanish; it was led, under protest, by the Left Cartel, victorious in the elections of May 1924. This war had been enthusiastically received by conformist intellectuals in the declaration "Les intellectuels aux côtés de la Patrie." Alone on the left, the review *Clarté* (staffed by Jean Bernier, Victor Crastre, Marcel Fourrier, Paul Guitard, Victor Serge, close to the Communist Party) launched an inquiry about these astonishing declarations, which justified a new war with a clear conscience. *Clarté* and the Surrealists were then joined in their protestations against this colonial war by a group of friends who were the guiding lights of the review *Philosophies* (founded in 1924, six issues): Henri Lefebvre, Georges Politzer, Norbert Guterman, Georges Friedmann, Pierre Morhange, and Paul Nizan, whose agenda was not so far from the Surrealists': "the defense of the spirit, of mysticism, and of liberty."

The already-old argument of 1924 between the Surrealists and *Clarté*, which had opposed Aragon and Jean Bernier (one of *Clarté*'s two editors) in a quarrel about the meaning of the Russian Revolution, had not really burned any bridges. Victor Crastre kept the readers of *Clarté* informed on the meaning of the "Surrealist explosion" (May 1925). Pierre Naville defended, in no. 3 of *La Révolution Surréaliste* (April 15, 1925), a point of view on art very close to that of *Clarté*, in which there is no possibility for a new art before the Revolution takes over.

By autumn 1925, it seemed possible to believe in an unreserved alliance

for political, economic, and social analysis among the members of *Clarté*, *Philosophies*, and *La Révolution Surréaliste*, joined by the *Correspondance* group, in Brussels, which included Camille Goemans and Paul Nougé. Together they all signed the declaration *La révolution d'abord et toujours!* "We are the revolt of the spirit; we consider the bloody Revolution as the unavoidable vengeance of the spirit humiliated by your works. We are not utopians: we conceive the Revolution only in its social form." Aragon, as usual, went further, publishing in November in *Clarté* a clarification on the status of intellectuals in which he firmly anchored their base in the proletariat: "What opposes them to anarchists . . . is the will to contribute to establishing the dictatorship [of the proletariat]" *("Le prolétariat de l'esprit")*. As for Breton, he had read Trotsky's Lenin, which he reviewed enthusiastically for *La Révolution Surréaliste* in the same issue (no. 5) that published *La révolution d'abord et toujours!* He now distanced himself from a previously unfavorable attitude toward the Russian Revolution:

> I think . . . that Communism, by existing as an organized system, is the one that has permitted the greatest social upheaval to take place within the time period belonging to it. . . . On the moral level where we have decided to place ourselves, it seems that a Lenin is absolutely unassailable.

Would a review supported by all four groups, *La Guerre Civile*, see the light of day?

But the year 1926 saw a withdrawal and a hesitation. The will—the good will—of Henri Barbusse was formidable. According to him, what had to be done was to invent a proletarian art. Pierre Naville, as a member of the Communist Party, took a revolutionary position. Breton believed that Surrealism was being fundamentally attacked. It was in a state of "legitimate defense."[25] Once that had been said, in order to prove their good will, first Eluard, then within a few months Aragon and finally Breton, Péret, and Pierre Unik each joined the Communist Party, explaining their position in the pamphlet *Au grand jour* (April 1927). As for Miro and Ernst, guilty of having collaborated on the scenery of the Ballets Russes, they were admonished; Philippe Soupault, Roger Vitrac, and Antonin Artaud, accused of being lukewarm politically (not to say active indifference on Artaud's part), were excluded in 1926.

This was a difficult position to maintain. In the various "cells," no one

rushed to welcome poets suspected of idealism. Elsewhere, the expulsion of Leon Trotsky from the USSR aroused the distrust of certain Surrealists (Breton, Péret) toward the purity of this revolution, while most of the group devoted itself to exceptionally brilliant literary and artistic activity. The collective expositions in 1925 at the Galerie Pierre and in 1928 at the Sacre du Printemps would have been enough to prove the existence of Surrealist painting. The group had already endorsed foreign expositions: in Zurich, at the Kunsthaus, in 1929; in Hartford, Connecticut, in 1931; in New York, at the gallery of Julien Levy, from 1932. At the same time, individual expositions proliferated. In 1926 and 1927, the expositions of the "Galerie surréaliste," rue Jacques-Callot, revealed the immense talent of Max Ernst, and the sudden blooming of the talent of Yves Tanguy. Arp, Chirico, and Dali had shows.[26] Crevel, Vitrac, Breton, and Aragon become the inspired introducers, and also the theoreticians, of Chirico and Dali, respectively, in *Le surréalisme et la peinture* (reprinted in 1928)[27] and *La peinture au défi* (1930). In 1926 Aragon collected the poems he had written between 1921 and 1924 under the title *Le mouvement perpétuel* and published in book form, the same year, *Le paysan de Paris*. And if 1927 saw the failure of his *Défense de l'infini*, it was also the year in which he wrote the virulent pamphlet *Le traité du style*, after the execution of Sacco and Vanzetti in the United States. During this time Breton was writing *Nadja* (published in 1928). In 1929, Aragon also published another collection of poems, *La grande gâté*. Robert Desnos published the lyric, sulphurous prose pieces of *La liberté ou l'amour!*, produced with Man Ray the film *L'étoile de mer* (1928), and in 1930 collected his poems of the years 1922–29 under the title *Corps et biens*. Eluard was particularly prolific, publishing *Capitale de la douleur* (1926), *Les dessous d'une vie ou La pyramide humaine* (1926), *Défense de savoir* (1928), *L'amour la poésie* (1929). In 1930, he published *Ralentir travaux* together with André Breton and René Char,[28] and also collaborated with Breton on *L'Immaculée Conception*. We should add to this Artaud's poems (*Le pèse-nerfs*, 1925, 1927); René Crevel's narratives and novels *(La mort difficile: Babylon; Etes-vous fous?)* and his own Surrealist manifesto, *L'esprit contre la raison* (1927). There was also Roger Vitrac's "drama," *Les mystères de l'amour* (1924), as well as his oneiric prose pieces, *Connaissance de la mort* (1926) and *Cruautés de la nuit* (1927); the poems *Humoristiques* (1927) and a "bourgeois drama," *Victor ou les enfants au pouvoir* (1929), not to mention his book in praise of Chirico at a time when the group was beginning to look at the painter with some suspicion. Max Ernst published collage-novels, *La femme 100 têtes* (1929) and *Rêve d'une petite fille qui*

voulut entrer au carmel (1930). Benjamin Péret published two collections of poems, *Dormir, dormir dans les pierres* (1926) and *Le grand jeu* (1928) as well as two volumes of short stories, *Il était une boulangère* (1925) and *Et les seins mouraient* (1929). But at this time most of Péret's work was still being published in reviews.

A meeting on the rue du Château proposed by Breton in March 1929 tended to regroup people along more political lines. Its theme was "A Critical Examination of the Fate of Leon Trotsky." Many people were invited who had not participated directly in the group's activities, or who did not accept the expulsion of Soupault, Vitrac, and Artaud in 1926. They suspected Breton of trying to monopolize everyone's attention and to realign the whole avant-garde under his own flag. The meeting turned sour at the condemnation of Roger Vailland, guilty of having justified Prefect of Police Chiappe: the whole *Grand jeu* contingent (René Daumal, Roger Gilbert-Lecomte, Rolland de Renéville), whom Breton must have been hoping to rally to Surrealism, joined forces with Vailland in front of Breton himself. And a number of notable personalities moved away from Breton: Georges Ribemont-Dessaignes, Georges Bataille, the painter André Masson, Robert Desnos, Jacques Prévert, Michel Leiris, Georges Limbour, and others.

Also, the *Second manifeste du surréalisme* (December 15, 1929), while proclaiming an "occultation" and defining the dual quest that should orient Surrealism henceforth (the search for the "supreme point" and the application of the principles of dialectical materialism), aggravated the quarrel with Pierre Naville, Artaud, Desnos, Vitrac, Soupault, and several others because it attacked them by name.[29] In return, most of them went on the attack in the tract *Un cadavre* (January 1930), presenting Breton, who was thirty-three that year, as Christ crowned with thorns.

However, the concentric force of the group remaining around Aragon and Breton (Crevel, Eluard, Péret, Ernst, Tanguy) was still so strong that other poets, painters, film makers joined or stayed: Salvador Dali, Buñuel, René Char, Alberto Giacometti, Georges Sadoul, Andre Thirion. Dali and Buñuel had already collaborated on producing *Un chien andalou* (1928) and *L'âge d'or* (1930). Dali brought to the group his scandalous reveries, his inspired painting, his paranoiac-critical "method."

Once again, the break between Aragon and Breton cut short the momentum of Surrealism, already slowed by the failure of the "rue du Château" meeting. We need only recall the silences that had begun to grow between the two friends, since Aragon's discovery that creativity, for him, went

through narrative form; the physical distance between them owing to Aragon's extremely cosmopolitan life, his endless voyages, his emotional life, which had led him to a suicide attempt (1928); but until 1932, whenever they were together, they had the complicity that comes of reading the same things and sharing the same tastes. What divided them between 1930 and 1932 was the precise meaning to give to their engagement with the revolutionary principles defined by Marxism. Elsa Triolet certainly divided them, too, "woman of high resolve" that she had made herself into after reading *Le paysan de Paris* and deciding to meet Aragon in November 1928. Elsa liked that book and *Anicet* but liked neither *Le libertinage* nor participation in the group. When Aragon and Georges Sadoul got themselves invited to the USSR in November–December 1930, to the second International Conference of Revolutionary Writers, at Kharkov, it was as Surrealists and Communists; the Surrealists played that card against the review *Monde* and the proletarian art of Barbusse. Aragon thought he had won all around. He was condemned by *Monde;* he proposed that the "true" proletarian literature must arise from the development of working-class correspondents. But in extremis, faced with the threat of being excluded from the International Union of Revolutionary Writers, he and Sadoul were made to sign a letter of self-criticism, dissociating themselves from the *Second Manifesto* (as too idealistic) and repudiating the principles of Freudianism and Trotskyism. Meanwhile, in Paris, Breton and Thirion were starting up a branch of the Association of Revolutionary Writers and Artists (AEAR). The two ambassadors to Kharkov had fallen into the trap of wanting to play a role in the definition of revolutionary literature. They were the pawns of a rather astute Party apparatus: when they returned, they were welcomed no more warmly by the French Communists than by the Surrealists.

The whole year 1931 was filled with this malaise. The only communal action anybody proposed for the Surrealists was to denounce the great Colonial Exposition and the significant power of religion in France. Nevertheless, during that year Breton wrote *Les vases communicants,* an attempt to make materialist theses prevail in the realm of dreams. He was thus, in his own way, replying to the accusations of the Kharkhov conference, claiming it was still possible to overcome the antinomy between poetry and Freudian thinking, on the one hand, and revolutionary politics, on the other. But Aragon, who gave a great deal of emotional weight to his relationship with the Communist Party, refused to accept Breton's giving an account (in *Misère de la poésie,* early 1932) of the reports he himself had made about intra-Party

matters; this involved the condemnation as pornographic of Dali's text "Rêverie" (published in *Surréalisme au Service de la Révolution*, no. 4).[30]

Along with this clearly political break came the simultaneous differentiation of two aesthetic systems: not the division between realism and Surrealism, but the distinction between the aesthetics of *Libertinage* and of *Nadja*. Before explaining this remark, I would like to return to the subject of the two great achievements of this decade: automatic writing, and more generally automatism; and the theory of image and of collage.

Automatism

The activity of automatism was invented and intensely practiced during the period we have just covered, 1919–33, from the writing of the *Champs magnétiques* to the stock-taking of "Le message automatique" (reprinted in *Point du jour*). This text was a balanced account, in which Breton noted the "continued bad luck" of his exercise; but it asks passionate questions beneath its reserve. The Surrealists had such high hopes for automatism that the word "Surrealist" was, for a while, synonymous with "automatic"—evidence that any definition of Surrealist activity revolves around the activity of automatism. Later on, in the *Entretiens* of 1952, Breton would recall its importance: "Automatic writing, and everything that comes with it—you can't imagine how precious it still is to me."

Automatism is a way of producing not only written texts but also words (in hypnotic trance) and graphics. Writing, speaking, drawing in such a way as to dissolve the control of reason and taste, and even putting a damper on self-consciousness in favor of a hand that writes, or draws graphic signs, or a word that offers itself—this involves the subject's questioning his own existence and the meaning of all language, all human communication.

The theory is Bretonian, if the practice was collective. Various painters, for their part, discovered pictorial techniques linked to automatism: *frottage*, invented by Max Ernst; automatic drawing, practiced by André Masson. As for hypnotic trance, experiments with which were not prolonged much beyond 1922–23, there were some talented people who were good at it, especially Robert Desnos but also René Crevel, Benjamin Péret and his lover Renée, Vitrac and his lover Suzanne. But there were also people who were resolutely incapable of it: Eluard and Gala, Max Ernst, Max Morise, Pica-

bia, Simone and André Breton. Almost all the Surrealists of the 1920s practiced automatic writing, on the other hand, with an attitude toward it much like Breton's. Only René Crevel consistently had suspicions about it as an interior language. Combining his own quest with the quest for a "first state," he affirmed that this state is silence: "it is sufficient unto itself and asks the help of neither philosophy nor literature. It experiences itself and has no other expression than an internal, affective, nonsyllabic chant" (*Mon corps et moi*, 1925).

These techniques, which question the subject's ability to create and communicate, used trails already blazed by medicine and spiritualism; but the techniques and the resulting "products" now acquired a special quality. What was once perceived as the result of insanity (which should be shut away in a lunatic asylum) or of the "other world" that speaks through distraught voice (spiritualism) became the valorized object of a marvelous invention. This qualitative reversal and misappropriation (of spiritualist beliefs in a transcendence of "spirits" and "the dead") were essential operations. They certainly reestablished some kind of link with a poetic tradition that prioritized inspiration and the poet abandoning himself to the powers of the marvelous, the mere echo of which he became. This is the Romantic tradition of the "voice of the shadow," to use Victor Hugo's term; the formulations of it closest to Surrealism can be found in Horace Walpole (for the writing of his novel *The Castle of Otranto*) or, closer to our time, in William Blake and in the whole German poetical literature from Novalis to Hölderlin. Breton preferred, however, to hark back to Lautréamont and Rimbaud, taking as his "given" the first phrase of Rimbaud's poem *Promontoire* (in "Le message automatique"). But at the same time these techniques were dated, since they were using in 1919–22 experiments already made in medical circles, or the testimony of mediums; and they were also dated by the state of psychological knowledge in the 1920s.

I will start by recalling, then, the experimental conditions of automatic writing (the example I prefer to work with here); the nature and significance of the discoveries, according to Breton; the mental topology underlying these maneuvers. We can then investigate the philosophical and epistemological implications that these Surrealist assertions may have for us today.

The conditions of the experiment are defined by Breton in the first *Manifesto*: "I resolved to obtain from myself . . . a monologue spoken as rapidly as possible without any intervention on the part of the critical faculties, a monologue consequently unencumbered by the slightest inhibi-

tion.. . . ."[31] The writing subject must therefore be isolated from any external disturbance, from any control by either reason or aesthetic taste, even from any modifications that might be the effect of the writer's own emotional experiences at that moment. The appropriate behavior is "indifference" and "absentmindedness"—but this behavior is nevertheless *active*. In the 1952 *Entretiens*, Breton reviews these terms, insisting on the mental exertion they presuppose:

> For this writing to be really automatic, the mind has to succeed in placing itself in a condition of detachment from the solicitations of the outside world as well as from his own individual practical or sentimental preoccupations. This is a condition that is held to be much more a part of the workings of Eastern thought than of Western, and presupposes on the part of the Western mind a more sustained tension and effort.[32]

This condition of isolation and detachment from oneself was originally connected, however, with a two-person experiment (Breton and Soupault); and the "remarkable analogy" of the results obtained by them in *Les champs magnétiques* argues in favor of a sort of impersonality of the instance of writing.

These conditions of the *movement* of writing were set, but its springboard was not clearly defined until 1922 by Breton (and Aragon underlines this gap of over three years between the practice and the formulation of its origin, whereas all the other experimental conditions had been frequently discussed between them). Breton certainly bore constant witness in private to the influence exerted over him by the phrases he heard on awakening, from a letter to Theodore Fraenkel in 1913, where he speaks of Mallarmé's auditory obsession, "The penultimate is dead," to a letter to Simone in July 1920 ("I am at the mercy of a phrase for a long time after I awaken"). But he established the link between these "waking-phrases" and automatic writing only in late 1922 in the article "Entrée des mediums" (*Littérature*, no. 6). Aragon, as we saw above, took special note of the gap:

> It was already after *Anicet* and certainly after the writing of *Libertinage* (though before its publication), when we were trying to objectify, for ourselves and the newcomers who had joined us, the Surrealist experience, that in the course of a conversation André tried in my presence

to give as a point of departure, as the first fact of the Surrealist frame of mind, the "waking-phrase." (You should know that this source had never been invoked in the early days of the experiments with automatic writing, and even for three or three and a half years afterwards—and that it's only after he was already accustomed to the mechanism of abolishing censorship by the speed of writing that A. B. began to see that *dictation*, for him, started with a *heard* phrase.)[33]

Aragon's reapproach is a keen one because the same origin seems to him to mark his own whole *narrative* invention. It is also a way for him to justify in a Surrealist sense the writing of the "dreadful little tales" of *Libertinage*, and even *La défense de l'infini*, so heavily attacked by the group. Now, this double ancestry seems to me the locus of the creative double track of Surrealism. For Breton, automatism tends, after the first "given" phrase, to stay as close as possible to this *blind* source. For Aragon, the first automatic phrase proposes a rhythm, makes an image, or makes sense: this image or this sense is then assumed as such, and developed in a combination in which consciousness takes its full place.

For Breton, automatic writing involves artificially maintaining this original state in which the phrases "knocking at the window" are formed. In 1924, Breton said that these "remarkably autonomous" phrases were accompanied by a "faint visual representation"; in 1933 he corrected this, saying that they sometimes addressed only the "inner ear," and were then characterized by an "absence of sound," without "any kind of visual or other representation." The interplay of the auditory and the visual seems to be peculiar to the experimenter, as Breton himself emphasizes, calling on each person to make repeated experiments so as to establish a statistically wider basis for an opinion. In Breton's own case, the process of hearing a phrase sometimes transforms itself into a visual hallucination. As a poet, Breton establishes a hierarchy in favor of verbal inspiration:

> I believe . . . that precisely because they infinitely resist the eye, verbal inspirations are infinitely richer in visual meaning than what we call visual images. This is the origin of my continual protest against the so-called "visionary" power of the poet.[34]

At other moments, listening to interior dictation is disturbed by "an almost uninterrupted succession of visual images, upsetting the murmur," images

sometimes fixed in place by the experimenter to the "great detriment" of the murmur he is trying to grasp.

Everyone was thus much struck by the complexity of the "source" discovered here, and preoccupied by the purity of its emission. If we restrict ourselves to the verbal impulse, the whole problem lies in the passage from one sentence to another:

> It is somewhat of a problem to form an opinion about the next sentence; it doubtless partakes both of our conscious activity and of the other, if one agrees that the fact of having written the first entails a minimum of perception.[35]

We can see how Breton is avoiding the term "signification" here. But this "perception"—of a tangible, not an intellectual order—implies a certain awareness of spoken signifiers. And the homogeneity of the resulting discourse is therefore always open to question.

Breton discussed the nature of the discovery and the finalities of the exercise several times in a way that was technically precise but very daring if we remember that he was defining the relations between thought and language. The goal would be to let "spoken thought" express itself "as closely as possible"[36] and to show a "unique concern for the authenticity of the product" ("Le message automatique"). This would involve obtaining, by writing or by human speech under hypnotic trance, a trace of the functioning of thought—a trace which would be accurate so long as the conditions of writing or speech strictly followed the ones defined above. One could determine "the actual functioning of thought"; the pure "psychic automatism" in which Surrealism consists "proposes to express—verbally, by means of the written word, or in any other manner—the actual functioning of thought."[37] This could be best captured by racing against the speed of thought: "It had seemed to me, and still does . . . that the speed of thought is no greater than the speed of speech, and that thought does not necessarily defy language, nor even the fast-moving pen."[38] These formulations are reinforced by a certain propensity to treat thought as *continuous:* "with every passing second there is a sentence unknown to our consciousness which is only crying out to be heard."[39]

Moreover, Breton's thinking oscillates between an affirmation that each person's individual heritage is brought to light through these techniques (whether one is talented or not) and the assertion that the intellectual mate-

rial obtained during these collective seances is communal to a number of people. As the conditions of writing *Les champs magnétiques* prove, Breton and Soupault wanted to speak together. And if the difference between their respective written interventions was carefully noted in various manuscripts recopied in 1924 and 1930, not destined for publication, it was in the last analysis to set up the proof in the first *Manifesto* that the only difference between them was one of "tempers."[40] The distinction here between communal and individual is not characteristic of Surrealism, if one considers the convergence of talents and sensitivities to which the group life tended to lead.

What Breton is ultimately looking for here is a democratization of the artistic function: to free "the individual from inhibitory factors which keep him back and disturb him to the point of sometimes completely preventing the exercise of his latent gifts" (Schrenck-Notzing speaking of hypnosis, quoted by Breton in "Le message automatique"). The novelty of this emergent speech is therefore "new" only because of our elitist concept of inspiration. "Everything is written on the white page, and writers make a lot of useless fuss about something that resembles a *photographic* revelation and development" ("Le message automatique"). Breton is chiefly concerned here with making fame-hungry writers get down off their pedestal. But the idealist implication is not far away.

Aragon's description of the entire automatic experience (writing, dreams) is far from equally daring in the mental topology it implies. What he emphasizes is the hallucinatory power of a language thus invoked: "Everything happened as if the mind which had come to this turning-point of the unconscious had lost the ability to understand where it was going. Images survived within it that began taking on flesh, becoming the stuff of reality" (*Une vague de rêves*).

Breton and Aragon were in complete agreement about the role of the texts produced through automatic writing. Aragon declares:

> The moral arising out of this exploration is the bluff of genius; what will strike one is indignation at this sleight of hand, this trickery which proposes the *literary* results of a method, and hides the fact that this method is within everyone's reach. *[Une vague de rêves]*

According to Breton's "Message automatique," the abundance of texts obtained through automatic writing claimed to clean out the literary stables by

a procedure of "dumping." We must abolish the distinction between "literary" and nonliterary. We could also abolish the distinction between "artistic" and nonartistic, if we follow Salvador Dali's interpretation of "modern style" as a dream world obtained through "the cruelest, most violent automatism" ("L'âne pourri," *Le Surréalisme ASDLR*, no. 1, 1930); this idea was taken upon by Breton in "Le message automatique."

On the individual level, automatic writing would allow the manifestation of a talent hitherto veiled by various inhibitions. But this talent remains unreliable, as Aragon teasingly insists:

> Surrealism is inspiration recognized, accepted, and practiced. . . . Normally limited by fatigue. Of varying breath, depending on the individual's strength. And the results of which are not necessarily interesting. . . . If, following a Surrealist method, you write dreary nonsense, what you have is dreamy nonsense. With no excuse.[41]

Breton, on the other hand, confident in the equal richness of material in everybody, insists on seeing the unequal results as the stupid voluntarism of the writer putting in "his own" additions ("Le message automatique"). Democratizing access to the artistic function is, at any rate, a key function attributed to automatism.

In the second place and as an extra benefit, Breton concluded in 1933, these texts can also provide information for the psychoanalyst, giving him a "human document"; while this was certainly not the intention of the early experiments, it is not negligible, insofar as this secondary charge of meaning locates the scientific level toward which Breton wanted to move. The psychoanalysts' interest justified, in Breton's eyes, the *neutral* (nonliterary) quality of the windfalls of automatism.

Most important of all: these texts, with all their gratuitous emergence and their total absence of representation, nevertheless manage to communicate a phantasm, visual or not, which writer and reader come to have in common. This involves a process of abolishing any distinction between imaginary object and real object, anything separating the "subjective" from the "objective." This abolition argues in favor of inducing a "unique, original faculty" from which ultimately all representation would proceed. "Le message automatique" ends by making this affirmation; it is also the philosophical center of Aragon's 1924 text *Une vague de rêves*, formulated in Hegelian terms that

tend to define the notion of the Surreal as a "relationship between the mind and what it will never reach." Aragon continues:

> When the mind has envisaged the relationship of the real in which it vaguely includes everything that is, it naturally opposes to it the relationship of the unreal. Surreality, a relationship in which the mind includes notions, is the common horizon of religions, magics, poetry, dream, madness, intoxications—and squalid life, that trembling honeysuckle which you think is enough to populate our heaven.

The role of automatic writing would thus be to *unify* the personality of the writer around this "unique, original faculty," this general ability to establish relationships. In Breton's eyes, this unification distinguishes automatic activity from mediumistic activity, which dissociates the personality instead of unifying it. But Breton finds the distinction difficult to make, insisting as he does on the passivity of the experimentation—a passivity equally characteristic of mediums and Surrealists. Breton insists that automatic activity takes place on a unique level of immanence, while spiritualistic mediumism is founded on a belief in the transcendence of "spirits" or the "dead." This may be an essential difference theoretically, but it is not one that is easy to perceive experientially. Aragon, on the other hand, recognizes no such difficulty, because his definitions are more active and functional: "Surrealism is inspiration recognized, accepted, and practiced. *No longer as an inexplicable visitation, but as a functioning faculty.*"[42]

The formulations of this whole period, Aragon's and especially Breton's, have a kind of imprudence about them: they refer to a dated psychological knowledge—evidence—which is also secondhand. This is to be expected as far as Freud is concerned, since his work did not begin to be translated into French until 1921, and then little by little. Only Max Ernst, Hans Arp, and Tristan Tzara could read Freud (or Jung for that matter) in the original.

For Breton, the nature of the discourse arising in automatic speech seems to be the very voice of "our unconsciousness" ("Entrée des médiums"). He did not write "our unconscious," and we should insist on this difference, as well as the *functional* problematic of Aragon. But ultimately in Breton's terms "flow," "spoken thought," dictation," in Aragon's term "mental matter," in the precautions to capture the "pure" stream ("pure psychic automatism"), could be found the idea that automatism involved "the very language

of the unconscious," and that this language "was formed in the zone of psychic activity whence arise instinctive impulses, primordial images, dreams— which implies that the unconscious manifests itself spontaneously as language: that it is a linguistic structure, a potential language that can be realized as soon as the closures imprisoning it are suppressed."[43]

The Freudian method of free association claimed to furnish raw material for the observer to study. It did not prejudge a priori exactly what proceedings would be unveiled by the technique. Nevertheless, Breton was eager to be part of the Freudian movement, insofar as the sources of *Les champs magnétiques* were experiences inspired by his listening to mental patients at Saint-Dizier (1916) and reading Dr. Régis's *Précis de psychiatrie*, where he found a summary of Freud's theories. Evoking this book in a letter to his friend Théodore Fraenkel, (August 31, 1916), Breton wrote:

> The subject must himself note, with the absolute neutrality of an impartial witness, or, if you like, of a mere *recording instrument*, all the thoughts crossing his mind, whatever they may be. Afterward it is the observer's responsibility to distinguish, in this series of cognitive manifestations, the ones that may lead to the road to the original pathological complex.[44]

And he would use the term "recording instrument" again in the first *Manifesto*. More naïvely, in a previously unpublished notebook dating from 1920–21, now published in the Pléiade edition of Breton's complete works (1:619), Breton thinks he can situate the experiment of the *Champs magnétiques* within the stream of scientific experimentation, which would have tended to produce uncensored texts. This is the scientific ambition of a very young man.

Breton never really risks formulating a precise mental topology; it is his commentators who push his thought in the direction of Freud. (This is the case of the notes to the Pléiade edition, which are entirely motivated by a concern to find a truth in Breton.) As for Jean Starobinski, he pushed Breton toward the "deviant branch—spiritualist, parapsychological, mediumistic— of the mainstream that goes from Mesmer to Freud, passing through the school of Nancy and the Salpêtrière."[45]

This is an exaggerated extrapolation, to be sure. We might note that Myers's work was known by Breton through Pierre Janet's *L'automatisme psychologique* (Paris, 1889), which summarized Myers's position; according to

Philippe Soupault, Breton had read Janet, though he did not mention him in his early correspondence. But the acquaintance was not a close one. Breton probably did not read Myers until 1925, until his attention had been directed toward him by William James. And elsewhere, even when he sums him up more favorably ("Le message automatique," 1933, reprinted in *Point du jour*), he emphasizes that the Surrealist intention is contrary to that of spiritualism: instead of trying to "dissociate the psychological personality of the medium, Surrealism proposes to unify this personality, nothing less. . . ." But clearly one might reproach Breton with having given the impression that he was referring to a precise mental topology, whereas the method of free associations was only, in fact, a method. And Breton's formulation is far from referring to Myers's whole theory; moreover, Breton always strongly and consistently distinguished spiritualist beliefs from Surrealist practice, from the "Entrée des médiums" to the "Message automatique."

In any case, it is more surprising to note that the remarkable originality of Breton, Aragon, and their friends was to reverse the hierarchy of the subconscious and consciousness, to the advantage of the former. Even in Freud, the product of free associations was not valorized in and for itself: it is the locus of convergence of various impulses, the place where psychoanalytic practice operates. Even for Myers, the productions of the "subliminal self" were not endowed with superior qualities. French medical tradition since Charcot had used automatic signs simply to diagnose madness. Françoise Will-Levaillant reminds us the Pierre Janet spoke of a "psychological automatism" (1889) and sometimes, as Breton would do, of a "psychic automatism": these were apparently involuntary modes of expression and behavior always arising, for Janet, in the lower regions of psychic behavior.[46] Dr. Gatien de Clérambault, among others, spoke of "mental automatism," and described phenomena of verbal hallucination as well as interpretative associations, obsessions, and phobias. And from 1905 on, the two expressions—"mental automatism" and "psychic automatism"—were associated in the writing of Dr. Rogues de Fursac.

However, the Surrealists were not completely isolated in their reversal of values: Dr. Jean Vinchon published (also in 1924) a medical work, *L'art et la folie*, which analyzed the drawings of schizophrenics, diagnosed them according to symbolism and ornamental tendency, and proclaimed that they contain "the sum of the possibilities of automatism, isolated from the superior control of the intelligence."[47]

To our eyes, there may of course be a certain theoretical laxity to this

overturning in favor of the subconscious of a grossly hierarchical high-and-low topology of the mind; but we notice this thanks to the sixty or seventy years of psychoanalytic reflection intervening between that time and our own.

To conclude, Breton's position is thus one of challenging psychiatric knowledge, since he reverses its perspectives; but this position is often epistemologically located on the same level: somewhat scientistic.

However, one could say that the philosophical and epistemological signifi-cance of Breton's and Aragon's assertions about the relationship between thought and language, far from any kind of idealism, is tinged with an absolute nominalism, in the modern sense of the term: that is to say, perceived as operational. Breton has sometimes been reproached[48] with setting up uncertain psychological substructures for a theory of language, and of distinguishing, in an idealist way, between thought (written and spoken) and the language expressing it by giving a logical anteriority to the former (the expression "spoken thought" and the image of the "photographic revelation" allowing for all kinds of interpretations). But the fact Breton saw a rhythmic equivalence between thought and written or oral speech would rather argue, on the contrary, in favor of a thought entirely reducible to its formulation. Aragon, who had something of a turn for philosophy, declared more clearly in *Une vague de rêves* that there is no thought outside words, and that this is a question of absolute nominalism:

> Any sensation, any thought—once we make a critique of it, we reduce it to a word. Absolute nominalism found in Surrealism a convincing demonstration; as for the mental material I was talking about, it seemed to us to be the vocabulary itself: there is no thought outside words.

Aragon's statement allows us to reread Breton's: the "spoken thought" is not a thought-substance making itself into a thing, degrading itself in lan-guage, but the speaking-of-the-thought; more precisely still, the form-of-the-thought. In modern times, absolute nominalism does not necessarily imply an idealism that would grant *being* to thought alone. On the contrary, the whole scientific development of the early twentieth century shows the emergence of "symbolic languages" finally offering the formal language, indifferent to content, toward which it seems logicians have always been tending. These artificial signs, placed on the threshhold of each system, are

essentially operational, and formalization leads to a purely syntactical nominalism.[49] In nominalism, the idealism of the sign is compensated for by the realism of the object, as Jean Largeault shows,[50] while in idealism, language and object are both relativized. The fear of the nominalist is to be fooled by words; the fear of the idealist (Descartes with his evil genius) is to be fooled by things. The invention of automatic discourse allows for an escape from the impurity of tribal language, but that discourse designates *some thing*. What passionately interested the epistemologically alert Aragon was the arbitrary side of the operation, and the rediscoveries of the arbitrary with the objects during hallucination. Breton was chiefly interested in the psychological side of the venture: the quest for the verbal flow—free from controlled language—bearing witness to the existence of uncontrolled fluxes that direct, in hiding, the stream of the subconscious mind.

Thus, by reducing the problem of automatism to an inquiry about language and the locus of its formation, one reflects certain vague or imprudent formulations of the Surrealists—and only those. This locus from which the verbal or graphic flow originates is, according to the evidence, fictional. The problem is more complex, however, because the Surrealists are *also* raising the question of the productive force of *invention*. If it is necessary to lose voluntarily, by a sort of *epoche*, control of a certain number of linquistic codes (with the exception of syntax), the goal is to win a new, and even heuristic, writing. And this invention is made possible by Surrealist nominalism in its operational aspect.

We can indeed see in Breton and even more in Aragon a great insistence on the idea of the *arbitrary*, and on its productivity in matters of invention. An indissoluble link seemed to be forming during the Surrealist period, through the expedient of automatic writing, between poetic invention and the arbitrary or artificial. The "murmur" recorded by automatic writing "is sufficient unto itself" ("Entrée des mediums"). But the arbitrary had presided over the exercise from beginning to end, in the fundamental writing of the *Champs magnétiques* as well as in the speed of the pen moving across the paper. In certain cases, the arbitrary presided over the adoption of a "subject," of the contents of a reverie. The arbitrary is what gives new impetus to writing that would otherwise die out in silence: "Following a word the origin of which seems suspicious to you, place any letter whatsoever, the letter 'l' for example," suggests the first *Manifesto*.[51] Later, as we see from their work notes, Breton and Eluard were inspired to write *L'immaculée conception* by using Aragon's *incipits* as springboards. Aragon emphasized the

difference between caprice, "your arbitrary" (which is always to *some* degree controlled by the intellect or by feelings), and the rigorous arbitrary, producer of *meaning*.[52] "Meaning is formed outside you. The assembled words end by signifying something." Later, he was to emphasize the arbitrary which governs the connection between the waking-phrase and the automatic text, and he generalizes this concept to make it applicable to the novel: there is "exactly the same necessity and the same arbitrariness between the waking-phrase and the kind of phrase, the most generally absurd, which is the origin of wit in the novel."[53] Only, in the novel, the ulterior development follows a scheme based on certain rules of representation and logic.

Aragon thus came to discover a very general epistemology—distinctly after his Surrealist period, it is true—in which we could locate identical laws of invention in poetry, the novel, and the modern sciences:

It is four centuries since Jérôme Cardan started mathematics along a path which must have looked like unreality itself, the use of the roots of negative numbers, which we call "imaginary" for the very reason that they are unimaginable. . . . By hypothetical force, poetry is the mathematics of all writing. . . . What seems to me closest, in the poetic domain, to the *throw of the dice* of imaginary numbers in mathematics is [the attempt] to explore the mind called, by journalists, Surrealism.[54]

The functioning of the arbitrary and the placing of the hypothesis play, in poetic writing, the role of the establishment of premises in mathematical reasoning.

While the lesson of automatic writing may have been an epistemological one for Aragon, it was an ethical one for Breton: ultimately true poetry, the poetry coming from automatism, would be another form of action: "We now know that poetry must lead somewhere," he affirmed in *La NRF* in 1920.[55] Art cannot be an end in itself. And again: "Poetry would hold no interest for me if I did not expect it to suggest, to myself and a few of my friends, a particular solution to the problems of our life."[56] The words of automatic writing would define a particularly authentic *line of desire*.

The whole enterprise of the *Champs magnétiques* had a stimulating effect on Breton. He who, "shortly before starting this experience, saw nothing before him but emptiness and despair, had changed in writing, bursting into laughter before images and phrases."[57] This involves a promise of life which

is also outlined in the choice of position for the dedication to the memory of Jacques Vaché: "To continue to live and to dedicate to Vaché—who 'produced nothing . . . insofar as that was possible' and who killed himself—a dedication which takes on, after all, the form of a book; isn't that to say no to his challenge, after feeling the appeal of it, and to refuse his chosen solution of suicide?"[58]

What remains for us today is to read these texts, much more numerous than is generally known, the glacial deposits of the activity around them. We should speak only of the "effect of automatism," with Michael Riffaterre, avoiding an undefined, unproductive quarrel on authenticity or on the psychological conditions of their production. We should establish that almost everywhere the syntax of the automatic text is no different from that of a controlled text but that the semantic approach permits us to outline a game of occultation combined with an inverse movement, which shows "intertexts," as Riffaterre convincingly demonstrates.[59] We should let ourselves be carried along, finally, by the pleasure of feeling touched by a code always promised and never given; and we may thus enjoy some lucky "find" capable of creating an image by projecting on it, contagiously, our own fantasies.

Theories of Image and Collage

Reflection on the image arose from the very beginning within Surrealism, at the same time as the practice and theory of automatic writing and drawing. In "Les yeux enchantés" (*La Révolution Surréaliste*, no. 1, December 1924), Max Morise hoped for the emergence of a kind of Surrealist painting in which "forms and colors do without an object, organize themselves according to a law that escapes premeditation, making and unmaking itself in the moment of its own manifestation"—in short, an automatic painting. But he opposes to this automatic painting a painting reproducing the dream or strange visual "apparition," for, in this latter case, "the traces of the brush . . . translate intellectual images only mediately and do not bear their representation within themselves." Chirico, for example, "can not pass as typical of Surrealism: the images are Surrealist, but their expression is not." In the debate opened by this argument, reproduction through words (narration) or drawing of the enigmatic image produced by the dream is somewhat deva-

lorized in relation to a "Surrealist" production in which the style as well as the content would completely escape the control of reason. But the distinction is not a rigorous one. An automatic painting may give rise to recognizable forms; a painting of a dream may be open to automatic impulses.

With respect to writing, the word "image" traditionally signifies a group of figures of speech. The relationship between the mental image and the text filled with "figures" is not a direct relationship. But automatic writing produces an overabundance of these stylistic figures, and the poetic richness of the pages of the *Champs magnétiques* or of *Poisson soluble* is largely based on their profuse multiplicity. Thus, in *Poisson soluble:* "A dazzling pact has been drawn up between the rain and me and it is in memory of this pact that it sometimes rains even when the sun is shining. Greenery is also rain, o lawns, lawns."[60] On the other hand, the narration of a dream or a hallucination is not particularly likely to produce figures of speech, which are then borrowed from clinical discourse. Aragon writes: "Rhodes, 1415. . . . It's impossible to find the battle in question, despite the basket-weavers I interrogate one after the other on the edge of this endless swamp, which I am crossing dressed as a vagabond" ("Rêve," *La Révolution Surréaliste*, no. 9–10, October 1, 1927). And from Robert Desnos: "Tonight *** came as usual, but instead of sitting in the armchair, she sat down on my bed" ("Journal d'une apparition," in the same issue).

We should note that although Surrealism is interested in the image-making consciousness as productive of hallucinatory dreams and reveries (like the apparition described by Desnos), it emphasizes the resemblances interwoven between perceptive consciousness, memory consciousness, and image-making consciousness, following a path that will be called later in France, in the 1930s, phenomenology. As a result, what is defined as the producer of images then becomes the whole individual consciousness. Aragon can write:

> The vice called *Surrealism* is the unregulated and passionate use of the narcotic *image*, or rather of the uncontrolled provocation of the image for itself and for what it involves in the realm of the representation of unforeseeable disturbances and of metamorphoses: for each image at every blow forces you to revise the whole Universe. And for everyone there is an image to be found that will destroy the Universe.[61]

Breton's *Manifesto* echoes this: Surrealism "acts on the mind very much as drugs do. . . . It is true of Surrealist images, as it is of opium images, that

man does not evoke them; rather they 'come to him spontaneously, despotically.' "[62] The last few words are Baudelaire's.

Whether the "drugged" consciousness produces visual images or whether, through its abundant figures of speech, language (particularly automatic language) produces an irrational, overpowering mental representation, both movements are alternately—and sometimes simultaneously—explored by Surrealism. Surrealism finds in these productions, whether phantasmagoric or rhetorical, models of worlds "to come." To Surrealism, they are formidable ways to deny the presence of the real: they appear heuristic. The world they create seems to prossess two qualities. First, logical contradiction has no meaning in them; the absence of a being is no more painful than its presence, since although absent, it could become present (*Journal d'Une Apparition*). Moreover, in such a world words of desire would have the mission of designating a reality, just as the words of the 1923 poem *Tournesol* portray a walk actually taken by Jacqueline Lamba and Breton in May 1934):

> At first limiting itself to submitting [to images, the mind] soon realizes that they flatter its reason, and increase its knowledge accordingly. The mind becomes aware of the limitless expanses wherein its desires are made manifest, where the pros and cons are constantly consumed, where its obscurity does not betray it.[63]

The functioning of the (poetic) image is thenceforth determined by its function, for its author as well as for us: the function of a narcotic. Breton, in the first *Manifesto*, used Pierre Reverdy's words to define nature and the mechanism of the image, while taking his own distance from him.[64] And in this play of definitions some essential ideas take precise shape.

Reverdy had written in *Nord-Sud* (March 1918):

> The image is a pure creation of the mind.
>
> It cannot be born from a comparison but from a juxtaposition of two more or less distant realities.
>
> The more the realtionship between the two juxtaposed realities is distant and true, the stronger the image will be—the greater its emotional power and poetic reality. . . .
>
> The emotion thus provoked is poetically pure, because it is born free from all imitation, all evocation, all comparison.[65]

Jules Romains and Georges Duhamel had already shown the resources of energy and tension contained within the image. Duhamel had declared in 1913: "The more an image is addressed to objects naturally distant in time and space, the more surprising and suggestive it is."[66] And Romains, in 1909, inviting readers to try Apollinaire, admired in his work "the appearance, the explosion of unforeseen analogies, which suddenly juxtapose such distant parcels of the universe."[67] Now, as E.-A. Hubert has shown, Reverdy posits his theory of the image by opposing himself to that of unanimism. In the first place, he rejects the ideological background of unanimism; then, too, unanimistic poetry does not renounce spatial and rhythmic poetical indices (a rhythm emphasized by Symbolism), so that the image is less privileged than in Reverdy's writing; finally, the "objects," the "parcels of the universe" brought into each other's presence by the image according to unanimism are sometimes called "notations" (a term dear to Duhamel, involving direct seizure of the real), which is very far from Reverdy's own thinking. Reverdy refuses to allow that the image's role might be to make explicit connections that could have any existence independent of the poet. He widens the gap between the world perceived by the senses and the world created by poetry.[68]

Thus Breton and Reverdy both attacked the simile as it had been valued by unanimism, because of its presuppositions or its confusion on the philosophical level: the image could not possibly have the same nature as "parcels" of the universe. Above all, before Pierre Reverdy, theoreticians of poetic discourse claimed that it implied two necessarily hierarchical rhetorical "levels," the comparing term and the thing compared. Now, in the twentieth century, poets and their readers have stopped considering as a value what we call the isotopy of discourse, or semantic homogeneity. As distinct from baroque or precious poetry, in which the mirror-games do not hide the hierarchies, we can no longer follow in Rimbaud or in Reverdy or Eluard the homogeneous line of a primary discourse to which the comparing terms would add their decorative scrolls. Reverdy writes:

> L'étoile echappée
> L'astre est dans la lampe
> La main
> tient la nuit
> par un fil.

The escaped star
The star is in the lamp
The hand
holds the night
by a thread.[69]

"The signification obtained is in the bringing together of the star and the lamp, and not in a comparison that would place one of the terms in the privileged position of the thing compared."[70] The same could be said of Eluard's "The chevelure of the road has put on its stiff coat" ("Ne plus partager," in *Capitale de la douleur*).

But Reverdy's theoretical formulation disappointed Breton by its allusion to the "realities" brought together, which implied, for Breton, a persistent referential value, by indicating the "accuracy" of the relationships established by the image and ultimately by the role of the "mind" in its creation.

Breton seems to have misread, and wanted to misunderstand, the meaning given to the word *esprit* by Reverdy, who was to answer him on this point very precisely. To be sure, "mind," for Reverdy can sometimes mean "thinking" (active, and possibly rational), but it can also mean "dreaming."[71] Reverdy's use of the term therefore does not imply "intellect" to the degree Breton thought it did.

Now it is true that Reverdy's interest in "realities" (by which we should understand "signs of realities," to take into account his distance from unanimism), as they are brought together by the image, related for him to what we might call today a rhetoric of metonymy. Braque believed that Cubist collage introduced a "certainty" on the canvas—that is, in the heart of the work of art, the indicative presence of the real, which introduces a tensional relationshp with it. Similarly, the aim of Reverdy's poetry was no doubt to "produce on the mind of the reader the same effect as the real,"[72] and in any case to establish with that "real" an ambivalent tension in which the pleasure of our reading is marked. In any case, imaginative activity in the metonymical figure of speech seems to start from the signs of things, while in metaphorical figures of speech it seems to start from the signifiers. When Breton declares: "The value of the image depends on the beauty of the spark obtained; it is, consequently, a function of the difference of potential between the two conductors,"[73] he is also affirming the simultaneity of the operation that brings together the two "terms" which he defines as "conductors." And he seems to me to be defining the mechanism of inventing the

metaphor—which might very well be of the order of the immediate (and doubtless aleatory) bringing together of signifiers. Among these signifiers, moreover, a process of selection would immediately take place, in accordance with the majority customs of the given culture at a given time as well as the mental habits of the individual.

Thus Breton finds the notion of the "accuracy" of the relationship established by the terms of the image an inadequate one since, for him, it is a question of creating, through the image, an effect of sense—and thus of creating the "rightness," so to speak.

This is why Breton's criterion is the arbitrary: the strongest image is "the one that is arbitrary to the highest degree, the one that takes the longest time to translate into practical language."[74]

Consequently, the distinguishing feature, for our reading consciousness of the Surrealist image (in its majority tendency), would be found in the overflowing of the meaning (signifier) or in the (mental) "nonimage" through an *excess* of images. An example taken from his own work is quoted by Breton in the *Manifesto:* "On the bridge the dew with the head of a tabby cat lulls itself to sleep."[75] The mental images vanish in their turn, scarcely having arisen in our mind, even if, afterward, the sexual connotation of the terms may appear evident. As for Breton, he declares this image to be "of a hallucinatory kind," in a formula which clearly situates the problem as a visual one.[76]

We can see that these disputes about comparisons and images have nothing to do with a rhetoric of figural speech. The aversion of both Reverdy and Breton to comparisons did not mean that they completely renounced the words "like," "such as," "just as," in favor of stylistic figures in which comparisons are suggested by grammatical usage (for example, the determinative "of," as in Eluard's "the hourglass of a falling gown"), or, especially, in favor of a complete grammatical indeterminacy. Breton seemed to be leaning toward such indeterminacy in 1929, when he wrote: "Surrealism [has] suppressed the word 'like' " ("Exposition X . . , Y . . . ," in *Point du jour*). Later, however, Breton expressed this absence of interest in a phrase that has been too much quoted and too often cut: "The most exalting word we have at our disposal is the word LIKE, whether it be pronounced or silent" ("Signe ascendant," in *Néon*, no. 1, 1948). Breton's only problem lay in the coming to consciousness (and remaining there) of terms attracted to each other by the force of lightning.

In return, Breton constructed a typology of the arbitrary image, envis-

aged from the angle of our reading and in which we discover criteria of content, rhythm, and form. This typology was drawn up in the *Manifesto* and taken up again in 1938 in the *Dictionnaire abrégé du surréalisme*.[77]

These criteria are linked to the signification of the terms that have been brought together, when Breton talks of the "immense dose of apparent contradiction" existing between the terms of Lautréamont's phrase "the ruby of champagne"; when he gives an example of the attribution of abstract qualities or their reverse and quotes Aragon: "A little to the left, in my firmament foretold, I see — but it's doubtless but a mist of blood and murder — the gleaming glass of liberty's disturbances"; when he shows the image denying "some elementary physical property," quoting Roger Vitrac: "In the forest aflame / The Lions were fresh"; when the image contains humor, as in Max Morise. In the three last definitions and the examples of them, Surrealism situates itself directly within the heritage of the literature of the absurd as it developed in the nineteenth century (Jean-Pierre Brisset) or in the tradition of pataphysics, although the first example is almost a classic metaphor if we recall the burst that connects the ruby color and the sound of the champagne cork.

Breton also uses criteria linked at once to content and to the rhythm with which the image is presented to us. The arbitrary may lie in the breaking of our expectation: "presenting itself as something sensational, [the image] seems to end weakly (because it suddenly closes the angle of its compass)." The example he gives is from Soupault: "A church stood dazzling as a bell."

The example of Lautréamont's phrase corresponds to the question of the image's content, but this time to its absence of significant content. Lautréamont writes: "Beautiful as the law of arrested development of the breast, whose growth in adults is not in proportion to the quality of molecules that their organism assimilates." Breton comments on this by pointing out that one of the terms is "strangely concealed." In the same category belongs, I think, the "hallucinatory" remark of Breton himself: "the dew with the head of a tabby cat." A last criterion is linked to the form of the words brought together: the example taken from Desnos effectively gives the signifiers the freedom to interact in an algebra of letters: "Eros, c'est la vie: in Rrose Sélavy's sleep a troll from a well eats her roll in night's lull."[78]

Only these two last categories seem to me to belong exclusively to Surrealism: a total absence of rational signifying content, an exalted game of letters and sounds.

Eluard's reflections on the image, and on language generally, were very

different: he shared Jean Paulhan's distrust of words. Paulhan emphasized the placement of words and their relational function; he had been studying Chinese poetry, Malagasy *hain-tenys* poems of amorous dispute, and French proverbs. According to Paulhan, words are deceptive signs. The primary matter of thought, he wrote to Breton, is constituted not so much by words as by phrases: "A whole meaning makes and unmakes itself every instant, in a thousand exchanges." Moreover, Paulhan noted, the codified formula becomes a structure which creates other meanings:

> Every proverb could thus become a mold, a pattern able to give me, with a few slight retouches, hundreds of reproductions. . . . Afterward, what struck me first tended to be the abstract framework, the armature common to an entire family of proverbs: this framework was then garnished with words.[79]

Finally, proverbs and commonplaces are analogous to "events": from them arises a truth that commands obedience: "Certain words should be considered things." This is a theme taken up later in *Les fleurs de Tarbes:* "The commonplace is a linguistic event."

Jean Paulhan provided, then, a belief in language itself as bearing salvation, whereas Breton wanted to make allowance for the human unconscious to measure the relational powers of language.[80] This opposition between them is related to the question of the meaning of words. We have seen how, for Breton, the most perfect image allows the effusion, the loss, of all meaning—all rational meaning. For Paulhan, poetry must lead us to "think as accurately as our language" *(A demain la poésie).*

For Eluard, what we must seek is a new language, a language of pleasure —relieved of the obligation to signify—a language open to all the potentialities of meaning, and the breath of which constitutes, as Jean-Pierre Richard says, "a tangible analog." This language, different from the one "that satisfies chatterers," will become "an enchanting language, a true one, a mutual exchange among us" (preface to the collection *Les animaux et leurs hommes,* 1920).

Eluard's game with codified forms of language (*152 proverbes mis au goût du jour,* a collaboration with Benjamin Péret, 1925) followed Paulhan's suggestion in assuming that this is not a gratuitous game: it disturbs the functioning of mental habits and exposes the true realities of the world ("Greatness consists not in tricks but in errors," or "You have read everything,

drunk nothing"). Poets play, Eluard writes, "but pay attention: for the first time since the beginning of the world, they are playing like grown men."[81]

Language is therefore both the matter and the agent of human transformation. This is why the *act of speech* is valued in itself: "to speak thus for a long time so as to learn the habit" (*Littérature*, no. 16, 1920), Eluard notes à propos of Baudelaire. This is a formula that Eluard was to repeat almost word for word: "[Baudelaire] seems to recognize only the form of words and phrases and to speak without thinking, like the bored king of a foreign country who speaks so as to learn that habit" (*Conduite intérieure*). Later he quoted Novalis: "the formula for deliverance is speaking for the sake of speaking" (*Premières vues anciennes*).

But the theory of the image as it was explored in the London conference of 1936, though it valorized the same images that intrigued Breton, explained the theory of the image very differently: rather, it claimed that an explanation could still be provided:[82]

> *"Your tongue the goldfish in the bowl of your voice."* The beauty of this image of Apollinaire's comes from its apparent accuracy. It flatters falsely our sense of *déjà vu*. The same is true for Saint-Pol Roux's *"Brook, silverware from the drawers of the valley."* We accept their evidence for the same reasons as we do the old metaphors *breasts of marble* or *lips of coral*. A few simple connections make us overlook the odd terms of the comparison. We hear *firm as marble* and *red as coral*, without objecting that marble and coral are cold. Dazzled, we take a relative resemblance for absolute reality. To the mobility of the tongue and the fish, Apollinaire adds the color. The brook is the silverware, because we have often said or heard the banal expression "silvery brook." And under cover of these identities of form and color and these relationships, new images slip in, composed in a most arbitrary, because purely formal way: *the bowl of your voice* and *the drawers of the valley*.

The linguistic, purely syntactical work, which certainly permits the arbitrary to intervene, but starting from accepted metaphors or clichés (where we find Paulhan once again), was valorized by Eluard; he saw in it the whole poetic function. For Eluard, the image is therefore recognizable by the impression of *déjà vu*, by evidence. After the anxious experience of being dazzled, we rediscover the general interdependence of objects in the world,

"everything being comparable to everything." The extraordinariness comes just from the form.

For Breton, the image makes any preoccupation with meaning evaporate. It creates meaning; the *terms* brought together ("dew" and "cat") define the extraordinary. For Eluard, the extraordinariness comes from the syntax which brings the terms together; under the most astounding image may still be found the clichés that polarize our reading.

In the realm of the visual arts, a parallel Surrealist practice and theory of collage developed. Collage functions in a way reminiscent of the image: collage is its plastic equivalent. It was Max Ernst who "invented" collage in the Surrealist sense; as early as 1923, Aragon made some very precise critiques of it. Max Ernst gives his own account of this in *Au-delà de la peinture* (1936):

> One day in 1919 . . . I was struck by the way my irritated gaze was obsessed by the pages of an illustrated catalogue showing objects for anthropological, microscopic, psychological, mineralogical, and paleontological demonstrations. I found this to combine such disparate elements of figuration that the very absurdity of having them collected together intensified the visionary faculties within me and spawned a hallucinatory succession of contradictory images. . . .[83]

From then on, Ernst himself practiced this irrational juxtaposition of ready-made elements, "diverting each object from its meaning to awaken it to a new reality," as Aragon said. However, in order to show the novelty of Ernst's invention, Aragon distinguished it from Cubist collage, from what was called after 1912 the pasted *papiers collés* of Braque and Picasso. The practical object pasted on the canvas was the starting point of the organization of the tableau, of its *syntax*. Braque had said that the object gave the canvas a "certainty"; Aragon interpreted this impression as an attempt to rise above the perspective of art for art's sake. In any case, the intention of Cubist collage is quite "realistic," to use Aragon's word;[84] we would say "referential."[85] In *La peinture au défi* (1930) Aragon contrasts it with Ernst's work, detailing their respective techniques to reduce them to two mechanisms: the borrowed elements "were taken either to represent what they had already represented, or, in a kind of absolutely new metaphor, to represent something absolutely different." The intention of Surrealist collage is indeed

semantic; its functioning is metaphoric. Surrealist collage could be compared to the game Marcel Duchamp and Francis Picabia played between the produced work and its title (Picabia called an electric lamp *American*). "We can see that painters here are really beginning to use objects like words," Aragon commented.[86] The "readymade" (a manufactured object simply chosen by the artist) and its title form a pair of terms linked by a metaphor.

Surrealism generalized this collage procedure in exercises that no longer had so much to do with their theories and practices of the image as with the generalization of metaphorical procedures. But each case should be examined in its particular context. For example, Michel Leiris is practicing Cubist collage when he inserts in *Aurora* a narration of actual dreams, written down before he had any plan to write the text, and then declares that he thinks these collages somehow guarantee his story, the perspective of which was in some broad sense autobiographical. When Breton copies a news item into his diary, replacing only the person's name with Guillaume Apollinaire's ("Une maison peu solide," 1919, in *Mont de piété*), he is constructing what Marcel Duchamp would have called a perturbed "readymade," and the relationship of the recopied text to the intrusion of Apollinaire's name creates an effect of metaphorical collage. Aragon's collages in *Le paysan de Paris* are not all metaphorical. Moreover, he connects "the morality of collage" to the apology for plagiarism one finds in Lautréamont. But the function of the procedure is always clear: to subvert traditional poetry, whether under cover or out in the open.

Theories of image and of collage evidently involve a theory of the imaginary that belongs to Surrealism. The ambiguity of the Surrealist quest has been formulated by Ferdinand Alquié: "Does imagination create a real that is proper to it? Does it express a real unknown to us?"[87] For Breton and Aragon, if not for Eluard, metaphor is a creator of meaning. It is not limited to revealing preexisting forms still unknown to us, as the Baudelairian theory of correspondences affirmed.[88] If metaphor creates a reality which depends on itself and inscribes itself in the course of history, it is an effect of meaning, through the medium of language.

The 1930s and the War

The weight of political preoccupations remained heavy during this whole period. It took two successive forms: first, after the break with Aragon, the pursuit of an attempt to take action in common with the Communist Party; then, after 1934, the struggle against the rise of Fascism.

The founding in 1930 of the new review *Le Surréalisme au Service de la Révolution*, despite what Pierre Daix called "the humility of its title," did not dispel the prejudices aroused in the Communist Party after the reading of *Légitime défense*, certain pages of the *Second Manifesto*, or even, in the first issue of the review, the text on the death of Majakowsky: according to Breton, the life of the proletariat and the life of the mind are two completely different dramas. Nevertheless, the title's reference to Surrealism's service to the Revolution was obviously "a notable concession" on the part of surrealism *(Entretiens)*. "Unconditional solidarity" with the proletarian cause still seemed to Breton perfectly compatible with, and parallel to, the total independence of the Surrealist experience, though distinct from it.

The ebb tide of the willingness to form an alliance was visible as early as 1932. The formation of the Association of Revolutionary Artists and Writers (AEAR), an offshoot of the International Union of Revolutionary Writers, was contemplated starting in late 1930 by Breton and André Thirion, in contact with the Communist Party. This association was taken in hand by the Party during 1931; *L'Humanité* announced its foundation on January 5, 1932, without mentioning a single Surrealist, even Aragon. The Surrealists were irritated by the pacifism of Henri Barbusse, who together with Romain Rolland launched an appeal to the "Amsterdam-Pleyel" Congress; they responded to this appeal with their tract *La mobilisation contre la guerre n'est pas la paix* (Mobilization Against War Is Not Peace). They were irritated by the moralizing of their allies. Breton was banished from the office of the AEAR in late 1933 because he had supported Ferdinand Alquié, who had written to Breton: "I find your book *[Les vases communicants]* very easy on Russia, very subtle about the interpretation of the differences that separate our wishes from her accomplishments . . . I was bursting with indignation at the performance of the *Chemin de la vie*," a Soviet film offering an apologia for work and stigmatizing what were called women of little virtue (*Surréalisme ASDLR*, no. 5, p. 43). Moreover, in autumn 1933 the association's

magazine, *Commune*, was created; its steering committee included Barbusse, Gide, Gorki, Romain Rolland, and Vaillant-Courturier and its editorial board included Aragon, Paul Nizan, and Pierre Unik, who had left the Surrealist ranks. From autumn 1935 on, Aragon's role in it was to become a major one.

Meanwhile, in 1935, faced with the rise of Fascism, Laval had engaged France in a pact of assistance with the USSR in case of war. The deep-seated pacifism and antimilitarism of the Surrealists, together with their spiritual debt to Germany because of Novalis and Hegel, led them to protest against any policy of surrounding or isolating Germany—a Germany of which Hitler's Germany did not seem to them a total negation. So said Breton in his speech to the "International Congress of Writers for the Defense of Culture," organized by the Communist Party in June 1935.[89] Eluard read this speech under most unfavorable conditions, after a violent quarrel between Breton and Ilya Ehrenbourg a few days previously. The break with the Communist Party was complete: Stalin's USSR already seemed to the Surrealists the total negation of Lenin and Trotsky's. The deportation of Trotsky from French territory in April 1934 had provoked the Surrealists' tract *La planète sans visa*. They now published *Du temps que les surréalistes avaient raison*, "On the Time When the Surrealists Were Right," in which they denounced the moralizing and the apology for propagandist art now flourishing in the USSR, as well as the "idolatrous cult" of Stalin.[90] This text was signed by Breton, Dali, Eluard, Max Ernst, Magritte, Nougé, Méret, Oppenheim, Parisot, Péret, Man Ray, Andre Souris, and Yves Tanguy, among others. The Surrealists participated in meetings denouncing the workings of the "Moscow trials" (1936–37).

In 1935, the most urgent struggle became the fight against Fascism. To be sure, as early as the Fascist uprisings of 1934, Breton had issued a call to arms, trying to make Léon Blum understand the intellectuals' solidarity with him (*Entretiens*, p. 174). On the other hand, Salvador Dali was issuing his first pro-Hitler proclamations. As the Franco-Soviet pact did not live up to the Surrealists' expectations, they moved closer to Georges Bataille, who was trying to start a revolutionary movement of "imperative violence" capable of constituting a popular government by "an adamant dictatorship of the armed people." This appeal, published in *Contre-Attaque* (October 1935), was signed by Breton, Bataille, and their friends, as well as Boris Souvarine's, members of the "Communist Democratic Circle." Plans were made for the *Cahiers de Contre-Attaque*, of which only one issue, edited entirely by

Bataille, saw the light of day (May 1936). The Surrealists could not avoid seeing ambiguity in this primarily antidemocratic project, hostile to the Popular Front program, and they repudiated its publication.

These anxieties crystallized only with the war in Spain, in which Benjamin Péret was participating; but their interplay was complicated: "We all know what the Stalinist intervention did to all these illusions, all these hopes" (*Entretiens*, p. 178).

In 1944, looking back on this period, Breton thought that the principal cause of the defeat was that the democracies had forgotten the very meaning of the word liberty, with the aura that the French Revolution had given it:

> Liberty, not only as an ideal but as a steady regenerator of energy, as it has existed in certain men and can be given as a model for all mankind, excludes any idea of comfortable equilibrium: it must be imagined as continual irritability.[91]

Thus Breton's mission in Mexico, in 1938, was strongly motivated by the hope of meeting Trotsky. The manifesto *Pour un art révolutionnaire indépendant* (reprinted in *La clé des champs*), which they worked on together, is a response to the Surrealists' ideological hopes of finding a revolutionary theory the philosophy of which would allow for Surrealist modes of thought. According to Trotsky, the Revolution is the "invisible axis" of the literary work of art. If the Revolution is also to be permanent, literature and art must appeal to an analogous internal dynamism—a multiple dynamism. In the spirit of all this, an International Federation of Revolutionary Independent Art (FIARI) was created in 1938 with its own periodical, *Clé*, the two issues of which, published a few months before the declaration of war, warned respectively of the dangers of chauvinism and Fascism. However, as to Fascism, the tract *Ni de votre guerre ni de votre paix!* ("Neither Your War Nor Your Peace!") was not at all clear: clouded by the desire to denounce the weakness of the democracies, it denied that the coming war could be "the war of justice, the war of liberty." In any case, if Breton's mission to Trotsky was fully successful, bypassing the reservations of the French Trotskyites (whereas the Party apparatus had diverted the 1930 Russian mission of Aragon, who had attempted a similar step, bypassing the reservations of the French Communist Party), that success had less to do with Breton's

superior diplomatic qualities than with a certain convergence of Surrealist and Trotskyite ideas.

Such intense political activity slowed the rhythm of collective publication to some degree, and tended to take the place of the "group life" with its rituals, café meetings, and common productions. The review *Le Surréalisme ASDLR* had only six issues and came out four times: no. 1 in July 1930; no. 2 in October 1930; nos. 3 and 4 in December 1931; then, also simultaneously, nos. 5 and 6 in May 1933. These installments were certainly rich ones, but the slowing down of the rhythm betrays the decreased need on the part of Breton's friends to express themselves as a constituted group. This is also connected to the fact that they were now beginning to be recognized, even if the critics were deliberately silent about certain publications or exposi-tions. The Surrealists collaborated more and more actively on the luxurious *Minotaure*, a review founded by E. Tériade (nos. 1 and 2, June 1933). There they had all they needed—absolute artistic liberty of expression—since their tracts and lampoons gave them a means of political expression. Breton, Péret, Pierre Mabille, Dali, the young Gisele Prassinos, and Eluard all published texts of primary importance in this review.

Their individual publications were still major ones. Although certain booklets reprinted portions of previous works (such as *Nuits partagées*, which repeats in 1935 a passage from *La vie immédiate*), Eluard's literary work was remarkably abundant: *Dors*, 1931; *La vie immédiate*, 1932; *Comme deux gouttes d'eau*, 1933; *La rose publique*, 1934; *Facile*, 1935; *Le front couvert, La barre d'appui, Les yeux fertiles*, 1936; as well as texts on poetry and theory. Tristan Tzara published in 1930 *L'arbre des voyageurs*, certain sections of which have a Surrealist lyricism, and his *L'homme approximatif* (1931) renewed formal ties with Breton's group, as did *Où boivent les loups* (1932), *L'antitête*, and the beautiful prose text *Grains et issues* (1935). The later collections were still Surrealist in workmanship (*Midis gagnés*, 1939, etc.), even if Tzara had once again broken with Breton to move closer to the Communist Party. As for René Crevel, he published his most violent, most political texts (*Le clavecin de Diderot*, 1932; *Les pieds dans le plat*, 1933) before committing suicide in 1935. René Char, during the 1930–34 period when he remained close to the group, published several of his major poems: *Artine, Hommage à D.-A.-F. de Sade, L'action de la justice est éteinte, Le marteau sans maître*. Breton rear-ranged his poems in the collection *Le revolver à cheveux blancs* (1932), reprint-ing as a preface the crucial meditation "Il y aura une fois" which had

appeared in the first issue of *Le Surréalisme ASDLR;* he collected pieces for *L'amour fou,* in which the theory of objective chance takes shape, and prepared *L'anthologie de l'humour noir,* edited in 1940 (its distribution was prevented by the censor). One of the most amazing Surrealist "recruits" of the 1930s was the widely cultured doctor Pierre Mabille, a friend of Breton's rather than a member of the group.[92] Mabille's remarkable work, a rather teleological synthesis of biological and psychological knowledge, was published over several years: *La construction de l'homme,* 1936; *Egrégores ou la vie des civilisations,* 1938; *La conscience lumineuse,* 1938; as well as a violently antireligious psychological essay, *Thérèse de Lisieux,* 1937. His finest book, however, was *Le miroir du merveilleux* (1940), an anthology of marvelous texts, conceived as a "means of human emancipation" and dedicated to his wife Jeanne Mégnen, the beloved and loving mistress of the quest.

The really remarkable surge of Surrealist activity at this time, however, took place in the visual arts. During this period, the internationalization of the movement that had occurred, with no change of direction, because foreign artists has been moving to Paris was accompanied by a spread of Surrealist or surrealizing activity in other countries.

The crisis of 1929–30 was translated on the pictorial level by an "increased distrust of conventional techniques."[93] The major source of renewal seemed to be the fabrication of "Surrealist objects." Giacometti invented "objects with a symbolic function."[94] Méret Oppenheim, Dali, Valentine Hugo, Dominguez, and Paalen fabricated objects, and Breton proposed the "poem-object."[95] This was a process that nourished Breton's thinking on "objective chance" (a subject I will discuss below). In fact, the whole fascinating side of these conjunctures or fabrications of objects is connected with the idea that they are what Breton called "precipitations of our desire." These very tendencies attracted the Romanian painter Victor Brauner, who in about 1932 changed his originally Cubist style to move closer to the Surrealists.[96] Max Ernst, who had been one of the first to introduce an unexpected third material dimension to painting (*Two Children Are Threatened by a Nightingale,* 1924), was not the last to fabricate "objects," but he remained faithful to his collages, presented in the form of "novels" (*Une semaine de bonté,* 1934). Finally, the rise of fascism swept Hans Bellmer and his "doll," with its horrific seductiveness, toward Paris in 1937.

But in a parallel movement, Surrealism was reinforced by the current of what Breton called "absolute automatism." These painters included, from 1934, Oscar Dominguez (Spanish, born in the Canary Islands);[97] from 1935,

Wolfgang Paalen (Austrian);[98] and Roberto Matta Echaurren, called Matta (Chilean), who did his first paintings in 1938.[99] In January 1938, the seventy artists exhibited in the great International Exposition of Surrealism in Paris bore witness to the incomparable brilliance of these diverse pictorial tendencies.

The reason for this is that Surrealism crossed national boundaries more easily in painting than in Surrealist texts. In Belgium the Surrealist movement already had a literary and pictorial past, to be sure. Camille Goemans and Paul Nougé, the group's theoretician, founded "Correspondance," which immediately got in touch with Breton's Parisian group (1925). The painter Magritte and the poet E.L.T. Mesens formed another group, which joined the first with *Distances* (1928). During the 1930s, they were joined by the musician André Souris, the poet Louis Scutenaire and his wife Irène Hamoir, Paul Colinet, and Marcel Mariën. Another group, "Rupture," was formed in Flanders around Achille Chavée. In Yugoslavia, too, a rich spreading and interchange were fostered by the fact that from about 1915 a whole generation of intellectuals had been nourished on French language and culture (in 1915, thanks to the activity of André Honnorat, 4,000 Serbian scholarship students had come to France, among them Dusan Matić). The richness of the interchange also had much to do with the personality of Marco Ristić. The relationship with Czechoslovakia was more complex: an entire school, "Devetsil," founded in 1920 and inspired by fantasy, developed under the influence of the poet and theoretician Karel Teige and the painters Jindrich Styrsky and his wife Toyen (Marie Germinova); they founded the Czech Surrealist group in 1933.[100] In March and April 1935, Breton gave lectures in Prague at the invitation of this group, and in May of the same year a lecture in the Canary Islands, where an international exposition of Surrealism took place. "Surrealist" groups, or activities comparable to the ones going on in France, could be found in Denmark after 1934; Holland, to a lesser extent; Switzerland, first with Giacometti and Méret Oppenheim, then with Kurt Seligmann; England after 1936, when the movement was introduced in an Anglo-French exposition planned by the collector and painter Roland Penrose. (Later, Penrose was to be seconded by the Belgian E.L.T. Mesens and, after 1940, the French Jacques B. Brunius.) Very early, Japanese poets had translated a few Surrealist texts (Takiguchi translated *Le surréalisme et la peinture* in 1930), and several painters claimed to be inspired by them. Two Canadians, Alfred Pellan and Paul-

Emile Borduas, lived in Paris during the 1930s. Gyula Illyès, Tibor Déry, and a number of others also made the trip to Paris.

This explosion of surrealism outside France can be seen in the four bilingual publications that appeared in 1935–36 under the common title *Bulletin international du Surréalisme* (no. 1, Prague, April 1935; no. 2, Santa Cruz de Tenerife, October 1935; no. 3, Brussels, August 1935; no. 4, London, 1936). The year 1935, as Etienne-Alain Hubert notes (*Bulletin* of the CNRS, no. 8, April 1978), also saw the appearance of Péret's article "Le surréalisme international," which gave a good deal of space to collective and individual texts coming from foreign countries (nos. 5–6, vol. 10, *Cahiers d'Art*). Three of these *Bulletins* came out of an international exposition of Surrealist painting that took place in the country under consideration. The differences among them are the best testimonial to the diversification of the spread of Surrealism. Each has its own tone, related to its moment and its place. Despite the fact that 1935 was the year of the final break of Breton's group with Marxism (to which the Brussels issue is devoted), they are all laced with ideological references to Marx, Lenin, and Trotsky—even though, as E.-A. Hubert notes, a glance through *Commune* or the speeches given at the Congress of June 1935 shows that the Communists were showing a tendency to desert the lexical field of battle in favor of rallying the troops.

During the War

All one can do is to survey this period of dispersion and enormous difficulty.

Most of the Surrealists were forced into exile from France, under pain of imprisonment. Nevertheless, the painters Jacques Hérold, Victor Brauner, and Oscar Dominguez remained throughout the war; the doctor Adolphe Acker, silent but lucid, practiced in Paris without interruption. We know, moreover, that Eluard distanced himself from the group after 1936, and broke with Breton in 1938, publishing in the Communist press. Eluard remained in France and cooperated with Aragon and Piere Seghers in underground poetic publications such as *Poésie et vérité 1942*. René Char did not publish a single line throughout the whole period, but participated actively in the armed struggle of the Resistance. As for Robert Desnos, Michel Leiris, Raymond Queneau, Ribemont-Dessaignes, Soupault, Tzara, and

Unik, they stayed in France after the demobilization and during the Occupation, publishing occasionally, for example in *Domaine français*, an anthology of very diverse writers (Geneva, Trois Collines, 1943) and *L'Honneur des poètes* (2 vol., Europe, 1944).

Among far more modest figures, a very young generation of poets, jazz lovers, and art lovers tried in 1938–39, in a Dadaist spirit, to attract the Surrealists' attention with an "Open Letter" to Breton, a mixture of charm and aggressive provocation. There would be no reason to mention them if they had not included Jean-Francois Chabrun, Noël Arnaud, Boris Rybak, Gérard de Sède, and, for a while, Christian Dotremont, and if they had not kept up—throughout various activities connected with the world of letters and the Resistance—a certain Surrealist spirit that matured with the years.[101] A few, like Jacques Bureau, were heroic as members of the Resistance. This is the group known under the name of one of their clandestine publications, *La main à plume*. This maturity can be seen in a comparison of two letters to Breton composed by the group: a few rough lines in 1938 and the touching "bottle in the sea" of August 1943.[102] In the same spirit as this second letter, the group also published in August 1943 a collective booklet, *Le surréalisme encore et toujours!* But 1944 saw the breakup of this circle of friends, which J.-F. Chabrun apparently wanted to constitute as a rigid group and direct as a high-handed theoretician (very Bretonian, said his former friends) and as a Communist (whereas most of the others remained Trotskyite).

Most of the Surrealists mentioned here chose exile. Paalan had already left for Mexico, where he was joined, not without difficulty, by Péret and his wife Remedios, and then, after other tribulations, by Max Ernst's last prewar companion, the painter Leonora Carrington. Pierre Mabille spent the winter of 1940 inventing the "Game of Marseilles" in the villa "Air-Bel" with Bellmer, Brauner, Breton, Char, Daumal, Domiguez, Ernst, Hérold, the Cuban painter Wilfredo Lam, Masson, and Péret; then he finally left Marseilles for the Antilles, while Breton, Duchamp, and Masson left for the United States. Yves Tanguy, Matta, and Nicolas Calas were already there.

The Surrealists in exile in New York and Latin America, despite various difficulties, kept up correspondence and regrouped around collective publications. In June 1942 Breton, Duchamp, Ernst, and David Hare founded *VVV* (Triple V) in New York; the review was published four times, through 1944, and the texts were often in French. Here Breton published some beautiful poems and *Prolégomènes à un troisième manifeste du surréalisme ou non* (1942), and Leonora Carrington published short stories. In Mexico, Paalen

founded the review *Dyn*, which tried to be dissident but remained Surrealist in spirit (1942–44). In Chile, Braulio Arenas and his friends continued to publish *Mandragora* and created the review *Leitmotif*, which offered a translation of the *Prolegomena* in 1942, as well as texts by Benjamin Péret and Aimé Césaire. In Fort-de-France, Martinique, Césaire was the guiding light of the review *Tropiques*; a stopover on the way to the United States allowed Breton to meet him. This was an extremely important moment for both of them. Surrealist expositions were held in Mexico (1940) and New York (1942). It is impossible to assess these interchanges here; but young North American painters drew from this contact with the "old" ones multiple sources of inspiration, however reoriented and displaced (after 1940, to the studio of the painter and engraver Stanley William Hayter). Moreover, Surrealist texts were beginning to be translated, whereas until now the movement had been known, in this part of the world, only through its painters. In Latin America, literary progress and interchanges were both easier and more scattered. In Buenos Aires, Roger Caillois published *Les lettres françaises*; this publication, oriented more toward France than toward local aims or talent, was reminiscent of *Fontaine*, then edited by Max-Pol Fouchet in Algiers.

Breton's most remarkable individual public activities were *Pleine marge* (1943) and *Arcane 17* (late 1944), published after his Yale lecture "Situation of Surrealism Between the Wars," given at the invitation of Henri Peyre. These texts pursue the Surrealist reflection on itself, especially on the two great "discoveries" of the 1930s: objective chance and black humor. A closer look at these two ideas is now in order.

Objective Chance

The term "objective chance" began to turn up in Surrealist texts, especially Breton's, after 1930, while on the pictorial level the paranoiac-critical activity proposed by Salvador Dali offered a similar, "limitrophe" reference in Breton's 1935 expression. The *practice* of objective chance, which had been going on since the 1920s, was thus followed by its theoretization.

Since what Breton calls "this light of the anomaly" is turned on what he considers an established fact, it cannot be essentially defined on the level of pictorial or literary art, because it involves the real world and the time lived

by the person conducting the experiment.[103] Chance is classically defined as the "accidental cause of exceptional or accessory effects, taking on the appearance of finality" (Aristotle), or as an "event brought on by the combination or the encounter of phenomena which belong to independent series in the order of causality" (Antoine Cournot). A definition of Henri Poincaré's is close to Cournot's, presenting chance as "an event rigorously determined, but such that an extremely small difference in its causes would have produced a considerable difference in the facts." In *Minotaure*, Breton recalls all these definitions and, "boldly trying to interpret and reconcile Engels and Freud on this point," adds his own: *"Chance is the form of manifestation of the exterior necessity that traces its path in the human unconscious."* In other words, before the (exceptional) coincidence of natural necessity and of "human necessity"—of human desire and sometimes human fear—chance can be called "objective" because then everything happens as if the (desiring) subjectivity of the person concerned projected itself on an *object*.

It may not be irrelevant that Aragon was at a distance when Breton was formulating this more theoretical position. Theorization is the essential difference between the "petrifying coincidences" to which *Nadia* bore witness and the idea of "objective chance" outlined by Breton between 1931 and 1937. Beside Breton's admiration, we find from 1910 on, the reveries non-Euclidian geometry inspired in Marcel Duchamp, such as the seizure of "preserved chance" proposed in 1913 in the work *Trois stoppages-étalon* (three straight horizontal wires, one meter long, falling from a height of one meter on a horizontal plane). This involves an enjoyment of the arbitrary and of chance reminiscent of Aragon:

> In these magnificent and sordid times, almost always preferring these preoccupations to the occupations of my heart, I lived at random, pursuing chance, which alone among the divine powers had preserved its prestige. No one had provided any instructions about this process, and some people attributed an absurdly great magic to it, entrusting even the tiniest decisions to it. I thus abandoned myself to chance.[104]

These inquiries vary greatly. In Aragon they are sometimes found in "life," as in the above story, but at other times in the invention of the text: this is the aleatory game of the incipit and of collage in the novellas of *Libertinage*.

For Breton, however, the whole interplay consists in the intersection of life and writing, each heightening the invention of the other.

For Breton and the Surrealists who followed him, to perceive the object (or the found *being*) in its relationship with the observer-actor's own desire is to perceive a gap between the foreseen and the given; but this gap is then experienced as an excess, thanks to which the marvelous occurs, "all feeling of duration abolished by the intoxicating atmosphere of chance."[105] The object or found being objectifies my desire, but in "a solution which is always superior, a solution certainly rigorously fitting and yet somehow in excess of the need." This object "put the elementary character of my predictions to shame."[106] This involves a diversion of the system of causality as it functions in rational discourse when such discourse is modeled on mathematical science. Closer to the conception of causality as it is defined in the physical and biological sciences—where it sometimes has something to do with *effect*—the system of causality in the context of "objective chance" gives an essential role to the unconscious and to the way the imaginary takes hold of it. This must be the origin, on another level, of the ambivalence of the evoked desire: what sometimes occurs is the tragic, the object of my *fear*. But Breton nevertheless remains fascinated with this system of thought, and he persists in "recommending, more and more electively, the *lyric* behavior" likely to give rise to the signs of it, as if one had to run the risk of the tragic in order to assume one's desire. For Freud, listening to desire across the barriers of neurosis is not invoked as a privileged means to a cure, which should be the natural consequence of a restructuring of the self. But Breton, and with him the Surrealists of the 1930s, believed in the virtues of such listening and the contagiousness of such adventures.

"Objective chance" is accessible to us only through written or oral transcriptions, narrations, or legends: Apollinaire recognized himself in the cut-out profile of a target figure in the background of a Chirico canvas. After his head wound, people tried to see in it the realization of this sign. In 1931, Victor Brauner painted a *Self-Portrait with Enucleated Eye;* in 1938, intervening in a brawl at the painter Oscar Dominguez's, he was hit in the eye with a bottle, which knocked it out.[107] In 1934, Breton was walking in the flea market with Alberto Giacometti and bought,moved by "elective" choice, a spoon "whose handle, when it rested on its convex part, rose from a little shoe that was part of it." He then remembered that, several months previ-

ously, he had tried to persuade Giacometti to fabricate a "Cinderella cinder-tray," or ashtray, the idea for which came to him from a fragment of a waking-phrase.[108] Each time, the event realized in an *excessive* way—tragic or marvelous—what a pictorial or linguistic sign had previously indicated.

The combination sign/event called "objective chance" thus decomposes into a sign without signification, chronologically prior, followed by an event called "random" which sustains a privileged relationship with the prior sign. The event "gives meaning" to the sign; it responds to certain characteristics evoked by the words or pictorial signs in what they signify as well as in their signifiers. This system in its entirely may be called, as I have proposed elsewhere, a "event margin."[109]

The (second) event is historically inscribed by Surrealist narrative with great concern for precision—"strict authenticity." Let us reread Mabille's text. Let us recall the minuteness of the contextualization of the "fact-glissades" reported in the prologue to *Nadja*, datable by contemporary readers and by us, too, if we pay attention to the other Surrealist publications, particularly the reviews. Let us recall the chronological precision with which the first meetings between Breton and Nadja are evoked. Breton always emphasizes how much the event is controllable by collective history; at the same time, the event is accompanied by an emotive charge for anyone who saw it, but this charge is mentioned by the narrative as an established fact, with an authenticating precision that refuses lyricism:

> Only a precise and absolutely careful reference to the emotional state of the subject to whom such things happen can furnish any basis for their evaluation. . . . The time in which such a poignant interrogation is inscribed seems far too valuable to permit additions or subtractions.[110]

Each system of "objective chance," each "event margin," is thence forward presented as functional and defined qualitatively. From the beginning Breton's reflection is a practical one: "It's a question of facts which, if they are on the level of proof, always present the appearance of a signal, though one could not say exactly what signal."[111] The sign, the first moment of the whole system, does not refer to an ontology of things, although certain of Breton's formulations are ambiguous: "it may be that life needs to be deciphered like a cryptogram" *(Nadja)*. It is a signal—that is, an injunction to act, or to count on time to decipher the signification of the sign. For

example, Eluard confused Breton, whom he did not then know, with one of his friends, who had supposedly died in the war. Shortly afterward, this sign of a friendly polarity "took on meaning" in a meeting made possible by Jean Paulhan. As if, contrary to Descartes, an infinite power (limited certainly in time) were opposing itself to a more or less annihilated will. Later, in *L'amour fou*, Breton constituted a whole Surrealist ethic from the image of a screen or grid on which human desires are projected:

> The luck, the fortune of the scholar or the artist when they *find* can only be thought of as a particular case of human luck; it cannot be distinguished from that in its essence. A person will know how to proceed when, like the painter, he consents to reproduce, without any change, what an appropriate grid tells him in advance of his own acts. This grid exists.[112]

And this ethic spreads to the whole group: for example, Max Ernst quotes this whole page in *Au-delà de la peinture* (1936). One would thus have to pay attention to the indications projected on the hallucinated screen of the real and follow the directions one can read on it.

Moreover, each "event margin" is qualitatively defined, in the sense that the links woven between the sign and the mark of the later event have nothing to do with lineal causality. The causal relationships become "twisted skeins" (*Les vases communicants*, part 2); a zone of emotional turbulence has arisen in which phenomena seem to obey mechanisms of "condensation, displacement, substitution, alteration" (*ibid.*). Thus the spoon-slipper of *L'amour fou* realizes, by a metonymic mechanism of displacement, the play on words "Cinderella cindertray" (ashtray). When Breton met Suzanne, the beginning of the word "hope" in Russian seems, in a metaphorical effect, to have presented his eyes with hope transformed into woman by the very name of "Nadja." Of course, people were right in protesting to Breton that these are secondary linguistic reconstructions in an indefinite field of possible terms. In the end, the mechanisms evoked are experienced as specific, since they relate to language on one hand and the historical course of things on the other, and since the first seems to have made the second happen. We could formulate this differently: chance is, for Breton, the reason for the series (in a mathematical sense) of its effects. The series of effects is thus, in *Nadja*, the series of disturbing meetings between Breton and the young woman, and the reason for this series is the name "Nadja": the beginning

and only the beginning of the word for hope. If we remember that history today defines the event as "the rationalization of its results" (Blandine Barret-Kriegel), we will be less surprised by the Surrealist reflection on the event. It is not as irrational as people have tried to make it sound.

The problem, stated differently, is that of the relationship between thought, the word or gestures of communication, and writing, in the broad sense of graph, trace, -gram. An idealist conception of this relationship gives a logical and chronological priority to the injunction of speech and gestures. In contrast, contemporary thinking gives writing—in this broad sense—a logical anteriority in relation to the word itself, in the degree to which communication cannot be conceived without a trace, without some form of inscription on which memory can depend. Without memory, communication has no meaning.

For Breton, too, it is as if communication (words or gestures, particularly in chance meetings) were brought on by writing, considered not in the sudden appearance of an inspiration but in its very duration. The sign—first limit of the "event margin"—is to be considered in its written trace. And when Breton affirms in his *Second Manifesto* that "the idea of love tends to create a being," we must rather understand this as the writing of his nostalgia. In the summer of 1927, while he was writing the first two parts of *Nadja,* he left out everything that was happening to him at the time he met her. These omissions are not at all negligible: he was then preparing no. 8 of *La Révolution Surréaliste* (December 1926), which contained two of his own poems and *Légitime défense.* This putting aside of a whole realm of preoccupations, especially political ones, focused his nostalgia about the romantic meeting, a nostalgia that stayed with him after Nadja's disappearance. A sort of "event zone" is constituted by the temporal schema that leads from the writing of the central narrative to his meeting with "X" (Suzanne, autumn 1927), which would ultimately be lyrically evoked and published as the third part of the book.

Other examples could be found in the writing of *L'amour fou,* keeping in mind that all of "La beauté sera convulsive" was in print by May 12, 1934 (for *Minotaure,* no. 5: "Beauty will be convulsive, or it will not be") and that Breton's meeting with Jacqueline occurred on May 29. The same is true of Aragon's *Paysan de Paris,* since between writing the two main movements "Le passage de l'Opéra" and "Le sentiment de la nature aux Buttes-Chaumont," written and published respectively in spring 1924 and spring 1925,

Aragon met the "Lady of the Buttes-Chaumont Park," who filled his expectations of "a woman so truly ready for everything that she makes turning the universe upside down worth the trouble."[113] In Surrealism, as opposed to Dada, writing or sign—which may be pictorial—has a logical priority over words or gestures—as if, in addition, it were liberating, like them, a certain relational energy.

Similarly, according to Breton, Max Ernst, and Dali, the aim of pictorial art must be to stimulate the activity of interpreting forms suggested by Leonardo da Vinci to his pupils in his *Treatise on Painting*. What Dali called "paranoiac-critical" activity is defined as an active will to "systematize the confusion and to contribute to the total discredit of the world of reality"— an active and critical will that opposes itself to "automatism and other passive states" by completing them (*Le Surréalisme ASDLR*, no. 1, July 1930). The paranoiac mechanism is essentially a provider of images with multiple figurations, as in the case of Leonardo's old wall; an example of this is the African box shown in the same magazine (no. 3), which, held vertically, suggests a Cubist face.

> Paranoia uses the external world to valorize the obsessive idea, with the disturbing peculiarity of making the reality of this idea valid for other people. The reality of the external world serves as illustration and proof, and is at the disposal of the reality of our mind.

Max Ernst did not quite repeat this analysis in *Au-delà de la peinture* (1936), in which frottage, the technique of rubbing, is related to automatism. All the same, the way he explores the material is also connected, secondarily at least, to paranoiac activity:

> Looking at the drawings thus obtained, the dark parts and the lightly shaded parts, I was surprised by the sudden intensification of my visionary faculties and by the hallucinatory succession of contradictory images, superimposing themselves one after the next with the persistence and rapidity characteristic of lovers' memories. . . . I insist on the fact that through a series of spontaneously offered suggestions and transmutations—like what passes for hypnagogic visions—the drawings thus obtained increasingly lose the characteristics of the material interrogated (such as wood) to take on the appearance of images of

undreamt-of precision, probably capable of divulging the first cause of the obsession, or of producing a simulacrum of this cause.

Max Ernst is clearly keeping silent about the content of the obsessions that induce forms, as well as about the temporal implication of this venture in which chance objectifies itself. All we have left is the object, the only final term that closes a zone of creative turbulence. On the other hand, Dali shows us the sign of origin, for example the African box: the space of the magazine page gives us the means of mentally covering the space and time of the hallucination, in an inductive movement.

Moreover, the mechanism as Dali describes it claims a sort of objectivity, at least for some people, whereas for Max Ernst, as for Breton, the description of the temporal space in which objective chance propagates itself seems to concern only one person. Nevertheless, Breton was to come around to this conception of paranoia as contagious, as the source of an intersubjective emotional communication:

> There seems to be no a priori reason for this primary illusion not to roam the world. It will suffice for it to correspond to the most insistent and penetrating vision, in that it must potentially put into play the greatest possible number of *optical remainders.* . . . Therein resides a deep source of communication between beings that has only to be disengaged from everything that is likely to unsettle or overlay it.[114]

We will not linger over the psychological attitudes or diverse techniques likely to produce such occurrences. Surrealism, in both its statements and its established facts, is a mixture of provocative incitement and suggestions for prudence.

Let it suffice to say here that obviously such occurrences, whether in life or in pictorial space, happen only to people whose attention tends toward deciphering the links that are woven between forms and words, between words and other words. A "lyric behavior" is necessary, to use Breton's expression. Favorable conditions are offered by a certain openness, an eagerness, a sort of childlike spirit, but also the passionate romantic state, or its sharp nostalgia, and the exaltation of fusional friendship: think of the multiple meeting narrated in "L'esprit nouveau" *(Les pas perdus)*. Openness and eagerness are required, not a "will to industry, booty, possession," Breton clarifies in *L'amour fou:*

I am only counting on what comes of my own openness, my eagerness to wander *in search* of everything, which, I am confident, keeps me in mysterious communication with other open beings, as if we were suddenly called to assemble.[115]

A childlike spirit is the bearer of the greatest possible faith in the imaginary *(Manifesto)*. With it comes the possibility of speaking to the potential of the past ("tearing away from the past its prey of mystery"), and of the improbable future: "Il y aura une fois" ("Once there will be").[116]

In their absence, techniques can be cultivated. One technique is the systematic cultivation of semiconscious states, for example by the extended pursuit of automatic writing, which can arouse hallucinations such as those Breton describes in *Nadja* about the words "Bois-Charbons" (Wood-Coals). There is also the use of the "baits" of magic, of "lots" (Virgilian or other): the door left open for the woman one hopes will pass by; a paperknife slid into a book chosen at random; cards interrogated "far beyond the rules of the game, although according to an invariable personal code, precise enough," among which is sometimes placed "some central object, highly personalized, such as a letter or a snapshot."[117] Wandering is another privileged technique, whether pursued in places full of "finds," such as the flea market, or in certain area particularly disturbing for a certain individual: for Aragon, Parisian "passageways" and parks; for Breton, the Ile de la Cité, and even the tropics, those "ultrasensitive" zones discovered by Breton in 1935 and then again in 1941. But it may also be invoked collectively, as Aragon, Max Morise, Roger Vitrac, and Breton decided to do in May 1924, starting from a town picked at random on a map—it was Blois—and progressing haphazardly, on foot.

Parallel to this, however, Breton still formulated the precautions one should take to avoid continual and multiple hallucination: "Interpretive delirium begins only when man, ill-prepared, is taken by a sudden fear in the *forest of* symbols."[118] In *Entretiens*, he gives a posteriori proof of his anxiousness to interrupt seances of hypnotic trance for this reason.

Moreover, as we must finally insist, Surrealism tries to integrate major research into these kinds of chance with a materialist conception of the world: the signs called up are never assumed to be transcendent, and when Breton thought about the presuppositions of spiritualist trends he was inspired to call them a "nauseating terminology." In *Les vases communicants* he proposes, in various ways, a synthesis which is intended to be Marxist.

Nevertheless, it does take note of a a few marvelous moments of "objective chance."

Black Humor

It was also during the 1930s that Breton and Surrealism "invented" black humor. Although black humor existed before Surrealism (without the name) and Surrealism was permeated by it before the 1930s, its name clearly dates from these prewar years. Breton's texts of 1935 ("Situation surréaliste de l'objet"), 1937 ("Limites Non-frontières . . ."), 1938 (*Dictionnaire abrégé du surréalisme*, with Paul Eluard), and 1940 (preface to the *Anthologie de l'humour noir*, publication delayed by the censor) develop the transition from the Hegelian concept of "objective humor" to that of the specifically Surrealist "black humor." Roughly speaking, the Surrealist definition of black humor integrates the implications suggested by Freud, the French translation of whose *Jokes and Their Relation to the Unconscious* appeared in 1930.[119]

Breton had no difficulty in seeing both the opposition and the complementarity between the behavior conducive to objective chance and humor in the Hegelian and then the Surrealist senses of the term; and we should note that the two concepts—objective chance and black humor—were clarified at about the same time. On the one hand, a tremendous sense of hope emerges, even if what happens may turn out to be tragic instead of the marvelous things my desire expects. It is the knowledge that a magical agreement may *sometimes* be revealed between the words formulated by a subject and the train of events, of verifiable history, when the event realizes in a certain metaphoric or metonymic way a previously given sign. On the other hand, humor goes in the opposite direction if its goal is to undercut the representation we give ourselves of events and their oppressive connection with the self by offering a completely subversive image of it. With objective chance, it is things that seem to move; with humor, it is words. Humor undercuts the representation of the world; chance seems to attack reality itself. This is why humor, as Breton was quick to show in "Situation surréaliste de l'objet," is powerless before the force of its hypothesis:

This still almost unexplored region of objective chance . . . is . . . a place where there filters in a light so close to being able to be con-

sidered the light of revelation that objective humor for the moment is
dashing itself to pieces against its steep walls.[120]

Their functions are divergent, at any rate, although complementary: "Inso-
far as humor is a paradoxical triumph of the pleasure principle over real
conditions at the moment in which those conditions are considered most
unfavorable, it is naturally bound to have a defensive value" ("Limites non-
frontières"); objective chance, on the contrary, proceeds from an *offensive*
motion. The first involves pleasure—in the moment, in words; its triumph
is thus only a paradoxical one. The second involves pleasure—in time, in
things. But poetry is capable of resolving this "contradiction," and in this
consists "the whole secret of its movement" ("Situation"). In the poetic
practice of Surrealism, these two attitudes of the mind fuse. They are the
"two poles between which Surrealism believes it can make its longest sparks
flash" ("Limites").

What can the mechanism of humor be, when it denies any relevance to
the reality principle and is intoxicated with its own power and pleasure?
Breton quotes Rimbaud, Apollinaire, Lautréamont, and Alfred Jarry, whose
poem "Fable" tells of the romance between a can of corned beef and a
lobster. The corned beef, struck by their fraternal resemblance, falls in love
and addresses "the little live self-propelling can."[121] Here, declares Breton,
using the terminology of Hegel's *Aesthetics*, is the product of the "dialectical
resolution" of two movements: subjective humor, responding to the "need
of the personality to attain the highest possible degree of independence," on
the one hand, and the "force that made the accidents of the outer world a
matter of interest"—humor attached to an "object," in the "contemplation
of nature in its accidental forms."[122] Here we see the classic opposition
between invention and imitation. And we should recall that at other points
in the notes of the *Aesthetics*, Hegel emphasizes the negative character of
subjective humor, and what I will call its narcissism. According to Hegel,
in humor the artist introduces himself into the object he wants to represent:

By this means every appearance of self-subsistency in such a content,
the embodiment of which is secured in its coalescence through means
of a given fact, is entirely destroyed, and the product is now simply a
play with certain objects, a derangement or a turning upside down of
a given material, the enterprise of a rover throughout such, the inter-
woven woof of the artist's own expression; views and moods, through

which he gives free scope to himself quite as much as to his immediate subject-matter.[123]

The correction provided by the *objective* determinant is important. As we see, Breton separates the function of humor from its objectification, and distinguishes it sharply from the play on words as simple irony. Humor, for Hegel and for Breton, has to do with things—certainly in the mere representation of the real which it subverts. It is also, therefore, the source of a rebellion, the political dimensions of which were suggested by Surrealism. For example, Aragon pointed out in 1931 that Lewis Carroll's work was written at the same time as the English massacres in Ireland; and, he added, *Les chants de Maldoror* and *Une saison en enfer* were written in the same decade, suggesting that we make the connection with the crushing of the Commune (*Le Surréalisme ASDLR*, no. 3).

In the preface to the *Anthologie*, Breton's reference point is Freud's discussion of humor. The reading of Freud's *Jokes and Their Relation to the Unconscious* had been the source of a careful analysis in *Le Surréalisme ASDLR*, no. 2 (1930). Breton uses Freud's definition of the role of humor: a mode of thought tending to spare the expense made necessary by pain. This game depends on the superego, presumed to guarantee a formulation that is actually perverted in regard to the values defended in the name of this process. Breton goes on to quote Freud: "The sublime is obviously related to the triumph of narcissism, with the invulnerability of the ego victoriously asserting itself. The ego refuses to be undermined, to let external reality impose suffering on it." A minor pleasure, it would seem, Freud comes close to saying, but one to which we attribute "—without quite knowing why— a quality of *great value*, which we feel is peculiarly apt to deliver and exalt us." The pleasure of humor, defined in terms of *exchange* in the *Anthologie*, as it is by Freud, is thus given a value "not only above all others but also capable of controlling the others until many of them stop being esteemed altogether."

Meanwhile, people had begun calling this Surrealist humor "black." Max Ernst used the term in *Au-delà de la peinture* in 1936. Breton used it himself for the first time on October 9, 1937, in a conference at the Comédie des Champs-Elysées. He was thus no doubt avoiding a facile resemblance to objective chance, the two attitudes being complementary but not symmetrical, if indeed the movement bearing the mind toward the object is different in each case: in humor, a defense against the objective reality of the external

world, and a perversion of its representation; in objective chance, an attack by words of desire in order to "become real." Moreover, as Breton shows, the concern of humor is death. Taking Freud's example of the condemned man being led to execution on Monday who shouts, "This week is getting off to a good start!" Breton offers evidence that verbal humor is capable of using the human mind's denial even against death. In Mexico, the abundance of funeral toys made him look on that country as the "chosen land of black humor." Thus the qualifier "black" could come from the inclination of humor to play with the image of death, since its ability to deny reality then reaches its highest potential. But despite this play with death, acceptance of the "tragic" is not admissible. Max Ernst confines himself to saying that black humor is "humor-that-is-not-rosy." Only Annie Le Brun uses the term in its tragic sense, when she asserts that black humor "may be situated in regard to objective humor as the very awareness of this inadequacy to apprehend the world, as the precise grasp of the contradictory principle which every consciousness of life always comes up against."[124] Finally, when we think about the choice of an adjective to qualify "humor," let us not forget the contagious influence of the "black novel," as murder and suspense stories were called. A few years before the *Anthologie*, in "Limites non-frontières," Breton had drawn a parallel between the "black novel," "a pathognomonic symptom of the great social trouble that gripped Europe at the end of the eighteenth century," and humor, called upon in 1937 "to take on a defensive value in the age, overloaded with threats, in which we live." Like what is called the "black novel," black humor must respond to these brutal attacks on human liberty. Far from being the color of tragedy, black is ultimately, for Breton, the color of exaltation: it is the color of the flag of Anarchy.

The linguistic procedures through which black humor manifests itself are divided by Freud into two main categories, which account for the apparent multiplicity of processes (as his faithful analyst Jean Frois-Wittmann emphasized in *Le Surréalisme ASDLR*). These categories are the various techniques of condensation and the techniques of displacement. In the notices introducing the authors of his anthology, Breton seems to have been inspired by these categories. Thus in speaking of Isidore Ducasse he mentions, for condensation, most of the techniques of "reassembling thoughts or famous sayings in reverse, or the wrong way round," as well as "calling up a swarm of immodest comparisons"; for displacement, "elaborating on the material" or "torpedoing the solemn."

Many of the wordplays used by the Surrealists from the beginning were a response to this back humor in its technique of condensation. In their *152 proverbes mis au goût du jour*, Paul Eluard and Benjamin Péret averred, "It is better to die of love than to love without regrets," and "One mistress deserves another." Robert Desnos writes: "Rrose Sélavy slips the heart of Jesus into the sport of Croesus," and:

> *Tu me suicides, si docilement*
> *Je te mourrai pourtant un jour.*

> You suicide me, if docilely
> One day I die to you anyway.
> *(Langage cuit)*

And Michel Leiris proposed these definitions in his *Glossarei j'y serre mes gloses:* "CHARNIER: charnière?" ("CHARNEL-HOUSE: universal joint?") and "DICTATEUR: tortures d'Etat, les tics du tueur" ("DICTATOR: the State's torture tricks, the tormentor's tics"). This way of thinking was also valorized by Aragon's fondness for Lewis Carroll: in the 1929 preface to his translation of "The Hunting of the Snark," Aragon showed the many implications "portmanteau words" had for his writing ("two meanings hanging on one word like a hanger") and emphasized how much Judge Shallow would have saved —his own life!—if, when asked to decide between "William" and "Richard," he had been able to answer "Rilchiam." [125]

Surrealist humor may also preserve certain forms of the real in order to devalorize its content. This is the way Leonora Carrington proceeds in *La débutante* when she shows us a hyena devouring a servant girl: experiencing satiety like anyone else, our animal stops at the feet, which have to be hidden in a little embroidered bag. Gisèle Prassinos uses elements of the real also, in *Une défense armée*, among a luxurance of logical contradictions and bizarre reasonings, perceptible in the very excess of the logical apparatus of her sentences: "He said that even if he did have yellow eyes, no one could tell him that his hat was velvet."

The literary world was not the only forum for black humor, although Breton, following Hegel, claimed that poetry led all the arts because it was the only universal art. In the past, Breton showed in the preface to the *Anthologie*, painting often perverted humor into caricature, through a "satiric moralizing intention." There are exceptions in Hogarth's and Goya's work,

however, and perhaps, less evidently, in Seurat's. As for contemporary painting, the Mexican José Guadalupe Posada is the only non-Surrealist painter Breton cites, but he praises in the highest terms the subversive collages that constitute the "novel-collages" of Max Ernst, such as *La femme 100 têtes*. And the cinema is also presented as a locus for black humor. Mack Sennett, Charlie Chaplin, and "the unforgettable Fatty and Picratt are at the head of the line that leads straight to those midnight-sun suppers *One Million Dollar Legs* and *Animal Crackers*, and to those trips into the grotto of the mind *Un chien andalou* and *L'âge d'or* by Buñuel and Dali, passing through Picabia's *Entr'acte*."[126] (We might add René Clair.) Moreover, in the order of the visual arts, we should not forget the Surrealist photographers.[127]

Together with this presentation of the ways in which humor is expressed, the collective thinking of Surrealism gave pride of place to ethics in relation to the life from which it proceeds, and reinforced its role. Marco Ristić had highlighted the absolute priority that should be given to collective revolutionary activity, if one wants "the freedom of the desystematized life to become universal" (*Le Surréalisme ASDLR*, no. 6, 1933). In that sense, according to him, humor, "the fleeting image of the arbitrary unbound," certainly constitutes a value, but not, nowadays, a generalizable moral attitude. In 1940 and later, this reservation disappeared. Faced by the menace of the spread of Fascism, Breton published his *Anthologie*, in which humor is perceived as a powerful force for revolt, as the origin of an avalanche the *political* repercussions of which could go on indefinitely.

From 1945 to the Disintegration of the Group (1969)

The Surrealists' return to France emphasized the break between their state of mind and the ideas of most Frenchmen. Breton and Pierre Mabille had brought back from the Antilles and the United States a new way of thinking about the power of esotericism and so-called "primitive" art. The *Prolégomènes* of 1942 had proposed strengthening the (political) "opposition" by fighting on two fronts: first, using the support of new "ancestors" such as Heraclitus, Abelard, and Meister Eckhardt, together with familiar ones (Sade, Swift, Lautréamont, Jarry, Engels, etc.), and then using the attractiveness of a new myth (Breton proposed the myth of "The Great Transparent Ones").[128] Mabille's *Le miroir du merveilleux* had reached a number of

people; selections from it had been translated in various reviews, and reading it had prompted Leonora Carrington to narrate, in *En bas*, her descent into the hell of madness (1943). In Haiti, Pierre Mabille had become friendly with the Haitian ethnologist Jacques Roumain, and had gained access to voodoo cults; he had been able to help Breton attend several group seances during his 1946 stopover. And before leaving the United States, Breton had visited the Indian reservations of Arizona and New Mexico. At Henri Peyre's suggestion, he had read Charles Fourier more thoroughly and had found there the principle of a universal analogy which was to become a constant reference point for him from then on.

As for "liberated" France (Paris had been liberated in August 1944), it enjoyed a brief period of political unity, thanks to the adroitness of de Gaulle, who conciliated the all-powerful forces of the Communist Party through the amnesty of Maurice Thorez. In January 1946 de Gaulle withdrew and in May 1947 the Communist ministers were pushed out of the government. Jean-Paul Sartre's influence became decisive, thanks to his review *Les Temps Modernes;* Leiris, Albert Camus, and the whole intelligentsia worked together on it. Breton's belated return in spring 1946 made his presence more out-of-date than ever. He was held responsible for the booklet *Le déshonneur des poètes*, published in Mexico in 1945 by Benjamin Péret in response to Eluard's and Jean Lescure's clandestine publication of the poetic texts of the Resistance, *L'honneur des poètes*. No dialogue was possible between those who were blindly accused of having fled—who were pointing out how much poetry had regressed by a general return to conventional forms such as litany—and those who, staying in place, had striven to give voice to a culture menaced by Nazism. Péret spoke bluntly: "Poetry should not intervene in the debate except through its own action, even by its cultural significance, though poets are free to participate as revolutionaries using revolutionary methods to defeat the Nazi enemy." And it is to Péret's credit that he had taken this position at the time of when he was bearing arms in the Spanish Civil War, fighting for the Republic—without writing. But his words aroused almost unanimous opposition. In 1947 Roger Vailland was able to publish *Le surréalisme contre la Révolution*, calling Surrealism "against the Revolution," without encountering much criticism.

For more than two years, the Surrealist forces had no way to finance a collective publication. However, in 1947 an international exposition at the Maeght Gallery gave a new spur to activity. The thick catalogue *Le surréalisme en 1947* developed the idea that a new myth should become the model

of a new society; this was to provoke a virulent attack by Sartre, repeated in *Qu'est-ce que la littérature?* and leading to Bataille's leaving *Les Temps Modernes*. From 1946 on—a season of discontent if ever there was one—a Surrealist group reconstituted itself around Breton with two tracts which reactivated the great struggles: against imperialism *(Liberté est un nom vietnamien)* and against enfeoffment to established political movements *(Rupture inaugurale)*. A year later, the tract *A la niche les glapisseurs de Dieu* protested against religion and against the threat of reinterpreting Surrealism as a resurgence of the sacred, in the religious and transcendent sense of the term. (Jules Monnerot's 1945 book, *La poésie moderne et le sacré*, 1945, a remarkable work still fresh today, could in fact have been read this way.)

Rupture inaugurale was an important text; its implications went beyond its immediate context *(Tracts surréalistes*, vol. 2, Losfeld, 1982). A group whose French contingent came largely from *La Main à Plume* was founded, that same year, in Paris by Noël Arnaud and in Brussels by Christian Dotremont; Dotremont gathered around himself almost all the old Belgian Surrealist (Chavée, Magritte, Mariën, Nougé, Scutenaire). This group tried to keep the possibility of free artistic exploration open but recognized the Communist Party as the "only revolutionary example." The only issue of the review *Le Surréalisme Révolutionnaire* was published in March–April 1948; its contributors included René Passeron, Edouard Jaguer, Jean Laude, Raymond Queneau, and Tristan Tzara. But before it had even appeared, Breton and his friends were protesting against this attempt at conciliation—an avenue they themselves had explored before the war, certainly, but according to them one irreversibly ended by Stalinism: such reconciliation would be offensive at a time when the French Communist Party was practicing a politics of class collaboration. Moreover, they paid solemn homage to the "German people, the people of Hegel, of Marx, Stirner, Arnim, Novalis. . . ." They were certainly the first to dare to do so. *Le Surréalisme Révolutionnaire*, attacked by everyone including the Communist Party, dissolved to become *Cobra*, with more aesthetic, more international horizons.

In 1947 *Néon* was founded—an audaciously conceived paper, rather like a large newspaper, striated with drawings, sprinkled with texts, and extremely fragile (the newsprint was typical of the period).[129] Contributors included the painter Victor Brauner, de Matta, Marcel Jean, Jindrich Heisler (who had just arrived from Prague, where he had been a publisher), a few young people (Claude Tarnaud, Sarane Alexandrian, Stanislas Rodansky); then Benjamin Péret, back from Mexico; and, just after Brauner and de

Matta were expelled, Jean Schuster and Jean-Louis Bédouin. There would be, in all, five issues. But the wonderful review Breton dreamed of founding, *Supérieure Inconnue*, never saw the light of day. The years 1949–52 were another stretch of time during which the Surrealists did not have a publication of their own. In 1950, Lucie Faure gave the Surrealists a chance to express themselves in a thick special issue of *La Nef*, "Almanach súrrealiste du demi-siècle"; and in 1951 *L'Age du Cinéma* offered a special issue on the cinema and Surrealism (August–November). But where could they carry on the ideological and polemical wars? Where respond to Camus's recent attack on Surrealism in *L'homme révolté?* The Surrealists found support in *La Rue*, an anarchist satire published in Marseilles (June 1952), and then in *Le Libertaire*, on which they collaborated in 1951–52.[130]

The group was also disturbed by the Carrouges-Pastoureau "affair." They had given a warm welcome to Michel Carrouges, whose book *André Breton et les données fondamentales du surréalisme* (1950) they had greatly admired. In fact his evaluation, together with Ferdinand Alquié's more rigorous *Philosophie du surréalisme* (1955) and Jules Monnerot's book, had been one of the first to offer a synthesis on the implications of the Surrealist venture. And now Michel Carrouges turned out to be a militant Catholic.[131]

Meanwhile, a specifically Surrealist publication, lightweight though it may have been, was born in November 1952, and put out eight successive issues (until June 1953): this was *Médium*, subtitled "Informations Surréalistes." From then on, one review followed another, increasingly attractive, even luxurious in appearance: the magazine *Médium*, "a Surrealist communication," November 1953–January 1955, four issues; *Le Surréalisme, Même* (late 1956–Spring 1959, five issues); *Bief* (November 1958–April 1960, twelve issues); *La Brèche* (October 1961–November 1965, eight issues); and, after Breton's death, *L'Archibras* (April 1967–March 1969, seven issues). Their titles were not immaterial. *Médium* was no doubt a reference to automatism, but also to the intermediary role this review was intended to play between the group and its public. *Néon* had made important concessions to modernity, even if one took it as an anagram, with the "meaning," found in automatism's seance, "be Nothing, be Everything, be Open" and then "Navigate, Excite, Occultate."[132] But no real contact had been made with the public. The title of *Le Surréalisme, Même* was a tribute to Marcel Duchamp, as that of *L'Archibras* was to Charles Fourier. *Bief*, a Surrealist "junction canal," simultaneously ran parallel to *Le Surréalisme, Même* and was trying to be more utilitarian than that handsome magazine, which thus presented

itself as the main "channel." And the review *La Brèche* was trying, as its title indicated, to make a more incisive "break."

From a political point of view, the Bretonian group—violently hostile to the French Communist interpretation of Marxism—found no movement at home or abroad with which to join forces. Participation in the Garry Davis "world citizen" movement of 1948–49 lasted only a few months. Their characteristic posture was therefore one of alert vigilance. After the legislative elections of 1955, Poujadism suddenly began to look like a "political movement," uniting those who had been excluded from prosperity. As the tract *Côte d'alerte* warned in 1956, its propositions were often fascistic. After the Twentieth Congress in Moscow (1956) and the subsequent Communist revisionism (echoed by Aragon in 1965 in *La mise à mort*, which also renewed links with Surrealist writing), the leaders of the French Communist Party (PCF) still remained Stalinist (Tract *Au tour des livrées sanglantes!* April 1956). In the same year, the harsh repression of the Budapest rebellion seemed to justify Surrealist prudence. But meanwhile, the French war in Vietnam had been followed by the Algerian War, and the Surrealists rediscovered the Sartrean "left" and a goodly number of intellectuals in the "Action Committee of French Intellectuals Against the Algerian War." De Gaulle's coup in 1958 mobilized Dionys Mascolo and Jean Schuster, who founded the review *Le 14 Juillet* and initiated in 1960 the "Declaration of the Right to Insubordination in the Algerian War," also known as the "Manifesto of the 121."

Regarding the development of aesthetic ideas and of artistic activity in general, this last period saw no major theoretical changes, except in a modification of the theory of the image in the direction of the "ascending sign"; Breton's text, which would appear in the first issue of *Néon*, was read by him at midnight on December 31, 1947 in Brauner's studio. We will return to this. Otherwise, after his great texts *Ode à Charles Fourier*, the prose accompanying Miró's *Constellations*, and the postwar poetic texts collected in the 1960 *Poésie et autre*, Breton republished, added, corrected. He offered new, expanded editions of *Arcane 17* and the *Anthologie de l'humour noir;* he published *L'art magique* in collaboration with Gerard Legrand; he reprinted his most important articles in *La clé des champs* (1953). He finally corrected *Nadja* in 1962, and completed *Le surréalisme et la peinture* in 1965. He locked himself away in an intimate poetic silence and in a proud exactingness which led to one of his most beautiful poetic "collections": *Le la*, automatic phrases and phrases arising during dreams (1960). In a short introduction, he recalled that he had once made such phrases the starting point for texts, or the

thread of long poems, but that now it was simply a matter of bearing witness to the existence of these "touchstones."

If Breton's work came to an end this way, making no excuses, it almost seems as if Julien Gracq's carried on for it somehow, however complex and ambiguous Gracq's relationship to Surrealism may have been. This relationship involved admiration and friendship for Breton rather than participation in the group, and a thematics of transgression different from, but comparable to, that of Surrealism. Gracq sometimes seems linked to Breton in the way Breton himself was linked to Lautréamont or to Rimbaud. At any rate, in his *André Breton, quelques aspects de l'écrivain* (1948), Gracq wrote as the lightning-bright critic of the importance of the whole Surrealist venture and his points of contact with it are frequent, whereas André Pieyre de Mandiargues, to take one example of someone whose work is often connected with Surrealism, touches it only very tangentially, through a chilly eroticism reminiscent of that of Pierre Molinier. After the war Jean Ferry showed his "gray humor," and Leonora Carrington her brilliant anxiety for life. The younger Joyce Mansour suggested a poetic work in the frenetic, lyric vein; Jean-Pierre Duprey (who died in 1959) and Stanislas Rodanski (who died in 1978) wrote appealing poems and prose. Nor must we forget the strange texts of Robert Lebel, the poetic texts of Gérard Legrand, the erotic and lyric verve of José Pierre (evocative of Péret in various ways), the subtle critical work of Philippe Audoin, the work of Jean Schuster—as well as the names of Robert Benayoun, Radovan Ivsic, and Alain Jouffroy (however episodic Jouffroy's participation in the Surrealist group may have been).

The "grand old men" were dying: Artaud, rediscovered after the war, died in 1948; Péret in 1959; Eluard and Vitrac had gone in 1952.

In the realm of painting and art criticism, these two decades were of primary importance. There is no doubt that painting and the visual arts engulfed Surrealism and forced it to change, as had already begun to happen in the movement of the 1930s. For economic reasons more than anything else, the art market placed its bets on Surrealism, while Jean-Pierre Duprey's finest pages were never sold at auction. "Society" has always made its choice between poetry and painting. But beyond these considerations, Surrealism attracted a large number of great talents in the visual arts.

Surrealism was now confronted with "lyric abstractionism," about which Breton and a number of other Surrealists were very reticent. In 1954, Charles Estienne and José Pierre drew very different conclusions from a questionnaire on the "situation of painting" (*Médium*, review, no. 4). José

Pierre was anxious about it, though he found a "concrete richness" in the canvases of Arnal, Corneille, and Degottex, and thought the figuration-abstraction opposition too simplistic. Charles Estienne had faith in it, though he refused to accept an abstractionism that would be afraid of words and things. The battleground for these two tendencies was automatism. For the Surrealist painter, automatism remained a means of understanding: to this degree it included interpretation as the fulfillment of its gesture or even in the course of experience, as we see, for example, in the 1950–55 work of Simon Hantaï. For lyric abstractionism, on the other hand, the meaning of automatism must remain suspended and the process becomes aesthetic again, seeking a source of beauty. (Hantaï's post-1955 work provides an example of this.) This did not prevent some painters such as Wolfgang Paalen (who had returned to France in 1952) from apparently synthesizing this double quest.

This period also saw the exploration of Celtic art and "raw art," zones of art previously pushed aside toward ethnography or pathology.

And we can see what remained constant in the aesthetic quest of Surrealism. On one hand, Surrealism rejected the positivism vindicated by "Socialist realism" and its postwar triumph after the "theses" of Jdanov and Stalin. "Why are they hiding contemporary Russian painting from us?" Breton asked ("Pourquoi nous cache-t-on la peinture russe contemporaine?" *Arts*, January 1952); in the same periodical, in May of the same year, he asserted that "social realism" was a means of moral extermination ("Du 'réalisme socialiste' comme moyen d'extermination morale," a position paper which was to become the ending for *La clé des champs*). On the other hand, Surrealism also rejected conceptual art and op art, as well as the undemanding automatism propounded by Georges Mathieu. And we should distinguish further to show Surrealism's points of convergence with certain aspects of the "Pop Art" visible in the work of Enrico Baj or Alberto Gironella. But in the last analysis, between abstractionism and realism, Surrealism maintained the existence of a kind of figuration involving automatic origin and magic essence, the possibility of which had been shown by the so-called "savage" arts and the painting of schizophrenics. Then, too, ethical demands may overdetermine aesthetic choices, as in 1954, when Max Ernst was ostracized for accepting the grand prize of the Venice Bienniale. In the eyes of the Bretonians, Max Ernst's painting, certainly Max Ernst's intention, remained Surrealist, but he himself no longer was.

The two sources of automatism and magic-eroticism seem to correspond to the two constant demands of Surrealism in this discourse. The automatic

source was sought in the ludic realm by the Surrealist game of "L'un dans l'autre," one-thing-in-another *(Perspective cavalière)*.[133] The magic-erotic source was sought with determination and some enjoyment of risk. After Benjamin Péret's *Anthologie de l'amour sublime* (1956), the "Eros" exposition of 1959 was intended to be a ceremonial. A "Banquet" was proposed on opening day by Méret Oppenheim: this was a recumbent woman covered with food. There is certainly an element of humor here but also a quest for the sacred. Meanwhile, Jean Benoit's "Execution of the Testament of the Marquis de Sade," for a more restricted audience, was a ceremony Georges Bataille would have liked. (A posteriori, we may see in these two ceremonies the same intention as in the 1960s New York fondness for "happenings," in which the act replaces the work of art.) More than ever would Rrose Sélavy have said "Eros—that's life." The links between this Eros and esotericism can be seen in the way the Surrealist group was attracted to alchemy and in general to all the occult sciences (René Alleau's work was favorably received by the Surrealist reviews). This Eros is a counterpoint to the positivism characteristic of many critical and aesthetic tendencies in the 1960s; we are in a better position to judge it today. Thus the 1965 exposition "L'écart absolu" ("The Absolute Deviation"), under the apparently benign wing of the "utopian" Charles Fourier, attacked the scientific ideologies then in the ascendant: the saving myths of space conquest, data processing, advertising. The meaning of advertising, for example, was lucidly analyzed in the catalogue by Jean Schuster:

> In second-stage capitalism, which has baffled Marxist predictions by overcoming its contradictions, advertising takes on the role formerly assigned to economic Malthusianism: the maintenance of surplus value. It is now the workers (producers) who destroy themselves, by frenzied consumption of finished products the need for which is completely artificial in any case. . . . Advertising has taken the place of Malthusianism to achieve the same goal more efficiently and in a superficially less outrageous way.[134]

A backward glance will remind us of the enterprises—particularly the aesthetic enterprises—parallel to the Surrealist quest, and sometimes intersecting with it. This explains the common cause during 1959–63 between the Bretonian Surrealists and the "Phases" group led by Edouard Jaguer. Jaguer was one of the young contributors to the leaflets *Quatre-vingt et un*

(1943) and *La Révolution la Nuit* (1946, edited by Yves Bonnefoy, two issues), and to the review *Les Deux Soeurs* (1946–47, three issues); he then became the receiver of the "revolutionary Surrealist" movement, after which he helped establish the French base of the *Cobra* enterprise (1948–51).[135] A primarily artistic venture, started by the Belgian Christian Dotremont, oriented toward Northern Europe (Copenhagen, Brussels, Amsterdam), somewhat against Paris and Surrealism, *Cobra* saw the rise to fame not only of Dotremont's poetic demands but of such gifted painters as Asger Jorn, Constant, Karel Appel, and Pierre Alechinsky. This painting arose out of a reflection on automatism, but also from the great Expressionist tradition still alive in Northern Europe. As José Pierre said, "*Cobra* opened the door to the wind of liberty, poetry, joy, and provocation which, thawing the atmosphere to some extent, was to foster the appearance of lyric abstraction and then, symmetrically, that of New Objectivity." Meanwhile, the critic and poet Jaguer founded in 1952 the review *Phases*, the spirit of which was particularly gobal and the concerns probably more aesthetic than political. The New York International Exposition of Surrealism of November 1960–January 1961 was organized by Edouard Jaguer as well as by Marcel Duchamp, André Breton, and José Pierre. Common position papers issued during this period emphasized the community of opinions.

André Breton died in September 1966, a few weeks after a ten-day meeting devoted to Surrealism, led by Ferdinand Alquié at Cerisy-la-Salle with the participation of young members of the group. Breton's death did not destroy the group but forced it to reflect more deeply on the definition of the movement. The review *L'Archibras* had been planned before Breton's disappearence from the scene; its first issue appeared six months afterward. In this issue, testimonials to the movement's leader tried to clarify what was lasting about Surrealism through the tributes to Breton. All seven issues of the review remained faithful to a resolute, lucid sense of political engagement. For example, no. 3 (March 1968) published a collective address "For Cuba," dated as of November 1967, in favor of the revolutionary process symbolized by the names Che Guevara and Fidel Castro; this followed a trip to Cuba in 1967, at Castro's invitation, by French intellectuals among whom were Michel Leiris, Georges Limbour, and several more recent members of the group. But no. 5 (September 1968), a special issue entirely devoted to Czechoslovakia, invaded in August by Russian tanks, published *in extenso* the "Open Letter to the Communist Party of Cuba" written by Robert

Antelme, Maurice Blanchot, Marguerite Duras, and Dionys Mascolo against Castro's justification of the Russian invasion. The editorial board of *L'Archibras* supported this declaration completely. No. 4, dated June 18, 1968, devoted to the "events of May," was seized as offending the President of the Republic, defending the "crime," and slandering the police.[136] The issue was not in fact an unreserved apology for all the events: the demanding tradition of lucidity was still there. But the political normalization after May 1968 did not favor the group, which was once again having trouble defining itself aesthetically in the maelstrom of contemporary art. Jean Schuster was the group's spokesperson: "Le quatrième chant" (*Le Monde*, October 4, 1969) announced *both* the disappearance of the group and the pursuit by various Surrealists of the collective enterpirse, but without any explicit references to "Surrealism," henceforth a historic term. This is how Gérard Legrand, José Pierre, and Schuster presented their new publication *Coupure* (seven issues, from October 1969 to January 1972): with this title the three editors intended to make a break, as well as to underline their position on the cutting edge. "Cuttings" can also be newspaper clippings, and the publication presented itself as a montage of quotations, current or not, intended to provoke ideological analysis on the part of the reader. After 1972, the Surrealists went their separate ways.

Was Surrealism destroyed by being exposed to the gaze of outsiders? Certainly not. But one of the things its historical evolution shows, as Schuster wrote in "Le quatrième chant," is that all this repeated attention was destructive. Outflanked by its followers as well as by the avant-grade, stifled by critics, Surrealism became increasingly difficult to define, even as a state of mind. It has spread throughout our culture. Does this mean, ipso facto, the disappearance of all rigorous behavior according to the tenets of Surrealism, and all rigorous critical judgment of its contributions? I do not think so. As long as the concepts used are clearly defined, and the order (ethical, aesthetic, political) in which they are being used, a criticism of Surrealism still remains possible. As long as the stakes of any work created today are made clear, its place (or lack of one) in the Surrealist orbit can be measured —in a criticism open to discussion.

The term has not been abandoned to the general public because of theoretical inadequacy and outdatedness. On the contrary, some of the most interesting critical research today is the study and evaluation of the different veins of inspiration structuring the movement from the beginning. Mediocre conceptual definitions of Surrealism are often due to a casual consideration

of it. Creative research today remains open about the visual exploration of automatism and collage, about experimentation in written work of the notion of taboo and its implications: the violent and the sacred interrogate our societies on the individual and collective levels. On the horizon of this quest, we have the assurance that poetic "models" are no less able to account for the violent and the sacred than scientific models. And the "humanities" have now become aware of this.

Problematic of the Myth

Between *mythos* and *logos*, Plato says in the second book of *The Republic*, we have a choice—between the myths of Hesiod or Homer and the philosophical word that makes the claim to be rational. Between a language used to create helpful or harmful illusions and a discourse ruled by the conquest of Truth, Surrealism chose the former. This is a first version of the movement toward the past that so often characterized Surrealism—a loop-shaped movement, though, which also claims to light the way for modernity by taking into account the most irrational aspects of the human mind. This is not a regressive movement, but a totalizing one. What in fact weighs against *logos* is the use rationalism makes of it, and its pretension to exorcise myth through reason. And the paradox of this undefined war is that, as Paul Ricoeur says, "it is never finished with adversity." Plato himself writes myths. The power of imagination and representation translated by myth is not inferior to a conceptual truth. It is *other*. Its truth is *alle-gorical*.[137] On one side we have representation; on the other, concept. We could take this further: according to Schelling, the persistency of myths and their proliferation through the mesh of expanding conceptual knowledge raises the question of *the* truth. Is scientific truth the whole truth? Or perhaps, could myth be saying the *same* thing, but in a way completely irreducible to any other form of expression? The difference would be in the way of apprehending a single reality, and would ultimately question the obligatory opposition of concept and representation. Does concept not include some element of representation? Could mythic representation not be another form of the same knowledge? This intuition is at the origin of the Surrealist proceeding.

We could address this problem differently. Between myth, on the one hand and, on the other, the analogy and symbol which qualify the horizon

of the Surrealist research into images, there is certainly neither cross-checking nor identity; but myth formulates itself in an analogic or symbolic language. Myth is a discourse—a series of meaningful articulations or phrases—the interest of which lies in the coherence we assume it has and the belief we accord it. It demands a particular kind of commitment. As Jean-Paul Valabrega says:

> The attitude of the mythic consciousness is that of an ambiguous, mixed, attenuated conviction. What is involved is a semi-, quasi- or subconscious—let us say the word—a *preconscious*, leaving a good deal of room for perplexity, for suspensive meditation, for silence, in short for mystery.[138]

Moreover, myth depends on a network of images and plays on the polysemia of language; it requires a poetic reading which, far from plucking the image and disengaging it from the isotopy of discourse, considers all the dimensions of significations equally relevant: "For a myth to be viable, it must satisfy several meanings at the same time" (*Arcane 17*, p. 104). There is no impasse or aporia in this statement. As Valabrega says, myth is not founded on univocal themes, because it situates itself in the field of the psychic experience of contradiction and division: anguish. Somewhere, then, every myth has its contradictory version.

In the 1920s, Surrealism was indeed aware not only of the centrality of myth and its radiant power, but also of its historical relativity. Beliefs which work to *polarize* the quest for truth are called "mythical" as a way of rejecting them. "Myths" are always the myths of *other people*. In the nineteenth century in France, however, poetry is there to take responsibility for the continual appearances of the irrational; Hugo, the great "seers," and most of all Apollinaire claimed for modernity a "marvelous" place: mythical. From then on, Apollinaire's beloved "fetishes from Oceania and Guinea" became the direct ancestors of Aragon's "great red gods, great yellow gods, great green gods stuck beside the speculative trails" and along the roads (*Le paysan de Paris*, p. 146). Gas pumps are the idols of today, and soon "we will make the sign of the cross before your fountains." For Desnos, the billboard of Bébé Cadum is involved in a titanic struggle with Bibendum Michelin for the role of the Messiah of modern times (*La liberté ou l'amour!*, reprinted 1982, pp. 34–36).

In the end, truth is a result of signification. No one says this more clearly than Aragon:

Who is unable to see that the face of error and the face of truth cannot have different features? Error is accompanied by certainty. Error is forced upon us by evidence. And whatever we say of truth we can say of error: we will not be more in the wrong. There would be no error without the feeling of evidence itself. Without it, no one would ever be content with error. ["Préface à une mythologie moderne," 1926, first part of Le paysan de Paris]

This conviction allowed Aragon (who had read Schelling during the summer of 1924, between the publication of the Passage de l'Opéra and the drafting of the Sentiment de la nature aux Buttes-Chaumont) to extrapolate the idea of the myth in a remarkable way, and to reverse the proposition that today's myths would be the residue of conscious human activity.

I used to think about sleep as others do, that religions are personality crises, while myths are truly dreams. . . . I had not understood that myth is, before anything else, a reality, necessary to the mind; and that it is the path of consciousness, its endless conveyor belt.[139]

In Schelling's system, the myth is a mode of sensibility and corresponds to one of the stages of the process through which the Absolute reveals itself to consciousness. Aragon replaces Schelling's Absolute with the Unconscious. Humanity today is thus impregnated with *mythic* activity:

I had been experiencing the strong effect certain places and sights had on me, without understanding the source of this enchantment. . . . It soon became apparent to me that the characteristic of my own thought —of the evolution of my thought—was a mechanism completely analogous to the genesis of myth, and that I probably could not think anything at all without my mind immediately making up a god, however ephemeral and unconscious it may have been. It became apparent to me that man is full of gods, like a sponge submerged in heaven.[140]

This "mythological" vein is rich in the Surrealism of the 1920s. It is rooted in a reflection on the modes of consciousness. But it is during the 1930s that

the qualitative reversal I have mentioned took on a *practical*, specifically sociological meaning. Since the myths of *our* society, even the most "modern," support it in its injustice, its hierarchies, and its mental conformity, we must fabricate a collective myth attractive and "true" enough so that we can read in it the outline of our own desire; so that a collectivity can orient its collective unconsciousness toward this model; so that a new society can spring from this. The Surrealist reflection on the idea of myth, as it appears in all its originality at this time, can be separated neither from reflection on the notion of a *projective model* nor from its political and social context.

Political: Breton formulated this idea for the first time in the preface to the *Position politique du surréalisme* (1935). In 1935, Breton and his friends, together with Georges Bataille and the *Documents* group, undertook the formation of a new review, *Contre-Attaque* (of which only one volume was published, but much in the way of material survives). This review was the organ for the "Union for Combat of Revolutionary Intellectuals" fighting against the rise of Fascism and all the totalitarian systems, which evidently have ideological mechanisms and mythic functions. In some ways, this involves using the enemy's own weapons against him. Breton suddenly now spoke of his "preoccupation over the past ten years . . . to reconcile Surrealism *as a method of creating a collective myth* with the much more general movement involving the liberation of man." [141] He thought he might find an ally in the process of creating a "united front of poetry and art" in Pierre-Jean Jouve, who believed that "in its experience today, poetry is in the presence of multiple condensations through which it manages to touch the symbol—no longer controlled by the intellect but rather rising from the depths, redoubtable and real." Other possible allies include Tristan Tzara and André Malraux, in their common apologia for the "process of symbolization." [142] Later, he would be more specific: "in what measure can we choose or adopt, and *impose*, a myth fostering the society that we judge to be desirable?" [143] During this period of the struggle against Fascism, George Bataille wanted to transform the Popular Front as it then existed, which he categorized as defensive (an "organic movement" assuming the liberation of the exploited) into a "fighting" Popular Front trying to "found revolutionary authority" and "provoke the passionate convergence of throngs of people from all countries." [144]

After a short period of being interpreted in an almost completely political sense, however, this collective myth—as proposed by Breton or Bataille's group, or in the *Mythologies* André Masson dreamed of in the late 1930s—

was displaced to the *poetic* level. And the poetic always swallows up politics in the Surrealist mentality. This is because poetry is already *action*—writing in action, and not conceptual research on a truth; and because painting (another "poetic" activity) keeps suggesting mythic themes—especially autodidactic painting.

Bataille's train of thought, and that of his friends Michel Leiris and Roger Caillois, went in a different direction: toward practical sociology. This involved creating "moral communities"—closed societies, confraternities—to study, within them, myths in their very formation. The *Collège de sociologie* (1938) made it easier to grasp these myths by setting up the conditions under which they arose. As Georges Bataille said, we must become like the "sorcerer's apprentice" and *create* myths:

> Myth remains at the disposal of whoever cannot be satisfied by art, science, or politics. . . . Only myth gives back to someone broken by experience the image of an abundance offered to the community in which men gather. Only myth enters into the flesh of those it connects, and demands the same of them. . . . Myth may be fable, but that fable is opposed to fiction if we look at the people who dance it, enact it: it is their living *truth*.[145]

We must thus create closed societies, so as to analyze the rise of myths and their function in the state of living belief. Bataille's statement reflects a sociology-in-action. Now, Breton and Bataille had separated in 1936. When the Bretonian group organized a postwar international exposition, Breton's foreword to the 1947 collection *Le surréalisme en 1947* reaffirmed the need to create new myths. However, Breton expected them to come from *poetic discourse:*

> *everything* happens nowadays *as if* such relatively recent poetic and visual works had a power over people's minds greater in every way than that of the work of art. . . . The excitement aroused by these works . . . and the resistance they offer to the grasp of the present state of human understanding . . . , together with the thrill of almost pre-ecstatic *joy* they are capable of giving us, . . . give credence to the idea that they are giving rise to a *myth;* and that it is up to us to define and place this myth ourselves.[146]

The political tract *Rupture inaugurale*, hostile to the Communist Party, had come out shortly before the publication of this volume; it was still more explicit:

> Since the time when the last myth was frozen in deliberate mystification, we seem to have lost the secret of knowing and acting without alienating established knowledge. It is time to promulgate a new myth capable of carrying humanity into the next step toward our final destination. [147]

To act "without alienating established knowledge": that is the horizon of the quest. To live according to a myth is effectively to perceive even the most ordinary action as ultimately permeable by consciousness. This is the kind of higher rationality Surrealism kept indefinitely seeking.

If we are to encourage the definition of liberating new myths, that is one more reason to struggle against the existing myths, particularly religious ones, which are certainly oppressive. As for the critique of religious myths, we should let Péret speak, as the title of his own essay "La parole est à Péret" suggests. Péret saw a deterioration of mythic poetry in the myths of our society's dominant religion, leading to its ultimate "ossification." And he quoted Marx: "Religion is the illusion of a world in need of illusions." Moreover, we must take into account the myths created by a commonplace adventure literature and idiotic "feelings" — "poetry adulterated for mass consumption" which creates "a safety valve regulating their spiritual pressure" and "directs their thirst for the irrational into harmless channels." And Péret added in 1957, in reference to an apparently inexplicable social upheaval in Sweden: "The dissolution of religious myth in favor of rational thought alone has left unclaimed the irrational outbursts latent in all people" [148] On the other hand, Bataille, invited to contribute to *Surréalisme en 1947*, suggested that the absence of myth is *the* modern myth: a position contrary to the steps being taken by the Bretonian group.

A projective model: in Surrealism, reflection on myth is thus related to all reflection on models of life, from Breton's "Il y aura une fois" (1930) to the famous page of the "Prolégomènes à un troisième manifeste du surréalisme ou non" (1942), in which the example of the myth of the "Great Transparent Ones" is offered to us. It also includes the 1930s thinking about objective chance, which is also projective, as we have seen; and Pierre Mabille's

decisive improvement during the 1940s of the projective personality test known as the "Village test" (published in a scientific review in 1948).

Although the Surrealist purpose is to propose a discourse, what matters is the way we adjust our actions to follow this discourse. This discourse must be such that it arouses us to action. In this sense, despite the fact that after 1942 Breton found a certain resemblance between projective myth and the social utopia of Charles Fourier (and so much in common!), there is a substantial difference. In the case of social utopia, a closed system displays the mechanisms of its inventions in an imaginary space and an uncertain time (present, future?). The interrelationships of social groups are fixed so that all struggles are stuck in place. In contrast, even a text like "Il y aura une fois" leaves room in the interstices of its description for unknown things (for example, a condemned play, which nobody can see)—and these, however symbolic they may be, give history *drive*. Arranging the backdrop of an adventure in an imaginary castle, Breton let us imagine the sequel or suggested, through the captivating force of the evoked imagery, that we invent in our lives equally strange, equally unlikely places and adventures. Using the components of a village as the common ground of the dreams we weave around our relational lives, Pierre Mabille proposed to his friends a sort of construction game, the interpretation of which gave rise to a typology of neurosis. How can we remain indifferent to this game, and these possible dreams? This is how I think we must read the page of the "Great Transparent Ones": not as a serious appeal to the scientific verification of the hypothesis, but as an appeal to the *spirit of hypothesis:*

Man is perhaps not the center, the cynosure of the universe. One can go so far as to believe that there exists above him, on the animal scale, beings whose behavior is as strange to him as his may be to the mayfly or the whale. Nothing necessarily stands in the way of these creatures' being able to completely escape man's sensory system of references through a camouflage of whatever sort one cares to imagine, though the possibility of such camouflage is posited only by the *theory of forms* and the study of mimetic animals. . . . It would not be impossible, in the course of a vast work over which the most daring sort of induction should ever cease to preside, to approximate the structure and the constitution of such hypothetical beings (which mysteriously reveal themselves to us when we are afraid and when we are conscious of the workings of chance) to the point where they become credible.[149]

The dual lesson of the text—poetic *and* scientific, each turning into the other—can be seen in the way Breton appeals first to the testimony of the poet Novalis ("In reality we live in an animal whose parasites we are. The constitution of this animal determines ours and vice versa") and then to that of the scientist Emile Duclaux ("Perhaps there circle round about us beings built on the same plan as we are, but different, men for example whose albumins are straight").[150]

What *provokes* us, what captivates us is the invitation to a change of perspective. The unsettling effect of this refusal of anthropomorphism forces us to displace our systems of reference. The myth sought by Surrealism is not a content of beliefs, imposed from the outside on the human consciousness; the whole misunderstanding of the myth of the "Great Transparent Ones" comes from this narrative, positivist reading of a paradigmatic proposition. Rather, it is the desire for an appreciable removal from our usual surroundings; the content of such a move is to be invented by each of us for ourselves.

The second lesson of these Surrealist propositions is a lesson of method, which we should relate to that of automatic writing. Just as the myths of primitive societies seem to us a collection of "signifiers whose significations it is up to us to find," as Emile Benvéniste said, similarly, but in a "sorcerer's apprentice" procedure (to use Georges Bataille's expression), why not pour a mass of signifiers on the paper, for which we would each have to find appropriate significations in response to our own individual desires? This would be a kind of epistemological lesson, to encourage us to keep intact the spirit of invention within us, following the idea that runs throughout modern epistemology, according to which arbitrary premises are productive in both mathematics and logic.

4

High Stakes and Their Actualization

Until now, we have focused our attention on a few elements of the definition of Surrealism, in its French invention; the tendency of the whole history of Surrealism shows that we must give due weight to the fact that it was a gathering place for artists and poets determined to use their sensibilities in common and to set precise, ritualized limits for the functioning of the group. We should also recall the various beliefs underlying this definition: in objective chance, in the value of automatic writing and of black humor, and in the necessity of inventing myths to serve as models for the society to come.

A Philosophy of Action, an Ethic of Risk

Our introductory survey of the models in relation to which Surrealism arose has also allowed us to see the background of magical and esoteric thinking against which the unquestionable newness of Surrealism took shape.

This would be a good time to review, in a synthetic, synchronic way, various aspects of Surrealist thought and practice which have not been highlighted in the various perspectives proposed so far: the philosophy of the subject and its ethic; the political positions of Surrealism, particularly as related to art; the aesthetics and poetics this involves.

Status of the Subject

For the Surrealist consciousness, the individual presents itself as pure subjectivity and also (without paradox) as pure dynamism defining itself through its acts.

It is pure subjectivity for Breton, who humorously praises Aloysius Bertrand for "resorting to dialogue every time he wants to ignite a quarrel."[1] He also asserts: "We each nurture within ourselves the disappointment of knowing ourselves to be unique." And again: "Imagination is omnipotent, except that it cannot identify us (despite our appearance) with anyone other than ourselves."[2] It is also pure subjectivity for Aragon when he declares: "I do not believe in the experience of others."[3] But at the same time, the subject defines itself in action, which is where it justifies itself. In the first *Manifesto* Breton writes: "It seems to me that every act is its own justification, at least for the person who has been capable of committing it, that it is endowed with a radiant power which the slightest gloss is certain to diminish."[4] And Aragon can talk about acts he has committed or is capable of committing as "these sparkling marvels which have separated themselves from me by scissiparity."[5] "Radiant power," "sparkling marvels"—such formulas, even tinged with a certain irony, as they are in Aragon's case, are to some extent Nietzschean.

This double attitude justifies a double rule. The first part of the rule is not to refuse the help of introspection, which allows subjectivity to plunge

within itself, for lack of anyone else who can do it. As Breton says in the *Second Manifesto:*

> Let us not lose sight of the fact that the idea of Surrealism aims quite simply at the total recovery of our psychic force by a means which is nothing other than the dizzying descent into ourselves, the systematic illumination of hidden places and the progressive darkening of other places, the perpetual excursion into the midst of forbidden territory. . . .[6]

And this depth psychology displaces the negativity associated, even by Freud, with the unconscious; it is founded on a belief in the productivity of self-analysis. The second part of the rule is to recognize oneself in every act one commits, without an a priori fixed moral distinction, until one can take on "the simplest Surrealist act": going out on the street holding a revolver and shooting *at random*. This involves a breaking of the murder taboo that has been identified with absolute liberty, denying the liberty of others. I see in it, rather, the sign of a violence boundary whose function would be, in a Dionysiac way, to assume space in its totality and, symmetrically, to realize a consumption of consciousness, which would make itself space and would in that moment, in despair, dissolve its own becoming.

The scope of the Surrealist subject lies *between* these two antithetical poles: between the immolation of a Romantic consciousness in the Nietzschean act or the Dadaist gesture and, on the other hand, the introspective regard or self-analysis, through all possible means.

If we concentrate on the second of these two poles, we can connect Surrealist consciousness and Romantic consciousness, insofar as they are introspective; and we could even reproach Surrealism with trying to be scientific and not believing enough in intuitive, effusional understanding. More legitimately, we may see in this creative subjectivity (which self-analysis could liberate) a fertile myth encouraging each of us to invent, but a form of the naive: we must admit that the forces battering the buttresses of the preconscious are the archaic, the infantile, the erotic; and that the power of these impulses is not necessarily creative. Granting that: from what struggle between these impulses and the blocking of consciousness is the "beautiful" born? What are the possible configurations of Freudian "sublimation"? At present, we are hampered by too many theoretical and epistemological unknowns. But isn't the only rule of life and of aesthetic creation

to go forward? And may not Surrealist naivety be so strong here precisely *because* it is naive—to the degree that it does not present itself as a body of knowledge but as a practice? On the other hand, if we concentrate on the first of the two poles, we will connect the Surrealist act with the Dadaist gesture or the Nietzschean apologia for action. It is in the dialectical tension between these two poles that I see the specificity of the Surrealist position on the subject.

However, this model does not include all Surrealist thinking about the subject. In Aragon and Breton can be found a *full* consciousness of the subject. On the edge of Surrealism, on its outer fringes, can be found a whole problematic of absence and reversal—of the *dissolution* of the subject. According to Breton or Aragon, subjectivity is a centripetal (though obscure) entity, one which its acts serve to define. According to Marcel Duchamp (one of the leaders of the group, about ten years older than Breton, Aragon, Soupault, and Eluard), subjectivity is a game of dis-proportion, and a reverie on the identity of things and of oneself.[7] For Antonin Artaud, anxiety about death seems to be the privileged experience through which the self turns and twists itself, so that one can glimpse its *limits*. The *thought* of the subject should simultaneously be the abrupt presence of its *body* within these limits. For Georges Bataille, these same limits, considered obsessionally, arouse nostalgia for a "communal being" whom we can sketch or guess at through privileged experiences such as ecstasy, laughter, tears, sexuality, sacrifice, festivals, or orgies, thus transcending the rifts and tears with which the relational web among beings is woven.

Moreover, we should certainly distinguish between the subject's experiences founding its central definition for Breton and for Aragon: two versions of the subject at the very heart of Surrealism. For Aragon, the privileged experience is a philosophical one, the experience of the contingency of the self. As he says in *Une vague de rêves:*

> I understand within myself the occasional cause, I suddenly grasp how
> I go beyond myself—the occasional, *c'est moi*—and having formulated
> this proposition, I laugh at the thought of all human activity.

In contrast to Sartre, Aragon finds this experience an exalting one. It is the basis for his escape from the trap of narcissism and makes possible the development of objective thought—of philosophical thought:

At this point, anyway, thought begins—and not the safe game of mirrors some people are so good at. Once feel that vertigo, even once, it seems impossible to accept instinctive ideas again. . . . You see beneath the apparently purest speculation an unconsidered axiom that had escaped criticism. *[Ibid.]*

For Breton, the central experience on which subjectivity is based belongs to the ethical order of things. This would be the discovery of its "pure" becoming (with no representation of an end). Going beyond the passion of love is the best illustration, as if the passionate impulse could still exist without attaching itself to any beloved object. At the heart of the lyric page "Homme, je regarde maintenant cette femme dormir" ("Man, I now watch this woman sleep"), he affirms his will to indifference: "I have systematically forgotten everything happy or unhappy that happened to me, but not the indifferent. Only the indifferent is admirable."[8]

If for Breton the Surrealist act-limit is the possession of space by violence, and the dissolution of becoming in the instant, Aragon and various other Surrealists situate it in the intellectual experience of the equivalency of contraries and its ethical homologue: treason. In the act of betrayal, the being consumes itself in the instant and seizes itself as a pure liberty: "No one is ever bound by a word given, and thus lost. The future today is more obscure to me than ever. I have no notion of trying to make it agree with my past, I let my thoughts run only on this minute which is burning away at me" (preface to *Libertinage*, 1923 text).

We must now look at the Surrealist techniques through which the "unconscious" is brought within the course of human activities. These techniques are the basis for the tension between "pure" subjectivity and "pure" act with which I have defined the Surrealist subject. All these techniques are oriented toward the wish to *disturb* the so-called certainties around which our self-consciousness stagnates—certainties inherited from a long Western rationalist philosophical tradition. We have already seen how Surrealism rejected this majority tradition, turning to the inspiration of non-European, nonrationalist, nonnormative philosophy and art.

The definition of the Surrealist movement given in the first *Manifesto* lists several techniques and their finality:

SURREALISM, *n.* Psychic automatism in its pure state, by which one proposes to express—verbally, by means of the written word, or

in any other manner—the actual functioning of thought. Dictated by thought, in the absence of any control exercised by reason, exempt from any aesthetic or moral concern.

ENCYCLOPEDIA. *Philosophy*. Surrealism is based on the belief in the superior reality of certain forms of previously neglected associations, in the omnipotence of dream, in the disinterested play of thought. It tends to ruin once and for all all other psychic mechanisms and to substitute itself for them in solving all the principal problems of life.[9]

Automatism, free association, dreams, and games are not only cultivated for their own sakes because of their "superior reality" but have a *practical* usefulness. The shift between the first and second paragraphs—the first is epistemological, the second ethical—has been a source of confusion for criticism of Surrealism. What happens is that the first statement is too often isolated from the second. By "the actual functioning of thought" Breton means the functioning of thought "in working order" and not in an ontology that would be arbitrarily isolated by our intellect from both its temporality and its mode of action. He is not claiming to grasp thought in its "truth." The act of knowing is thus an act like any other for Bretonian Surrealism.

As we have seen, "psychic automatism in its pure state," as it is activated by automatic writing or drawing, is not so much referring to an origin in a "real" place in the mind as responding to a nominalist intuition: the arbitrary is a source of invention in a system of signs. Apart from one despairing moment of Breton's, marked by his "Le message automatique" (1933), Surrealism rediscovered in this practice an active meaning, and extended its range to visual as well as poetic art as early as 1935, in the Prague conference. This is a position at the heart of the Surrealist aesthetic and poetic: "I cannot repeat often enough that *only automatism* can offer elements on which the secondary work of emotional amalgamation and the passage from the unconscious to the preconscious can operate validly.[10]

To dream truth (as in *Peter Ibbetson*); to make dreams *true*: such projects were worth inducing hypnotic trance, the "wave of dreams" of which Aragon spoke in his "vague de rêves" (autumn 1922). At the same time, reviews during the 1920s were publishing scrupulous narratives of nocturnal dreams with claims of ever-increasing accuracy. In the first *Manifesto* and then in *Les vases communicants* (1931–32), Breton summarized the premises of this research and its achievements. He brushed aside both spiritualist beliefs,

which see in dreams elements of a message from the beyond, and a positivist attitude, which consistently perceives oneiric activity as residual and therefore negligible. For Breton, it was a question of turning around the positivist hierarchy of values without falling into spiritualist assumptions. First:

> Within the limits where they operate (or are thought to operate) dreams give every evidence of being continuous and show signs of organization. Memory alone arrogates to itself the right to excerpt from dreams, to ignore the transitions, and to depict for us rather a series of dreams than the *dream itself.*

Second: The waking state becomes a "phenomenon of interference" if we note that it often obeys "the suggestions which come to it from the depths of that dark night." (See *La vida es sueño.*) Third: In dreams anything is possible, and the way this opens up the notion of possibility seems to depend on some "other," less narrowly rationalist, human reason.[11]

Such are the proposals of the first *Manifesto.* The Surrealism of the 1920s waxed enthusiastic about this confidence in the dream; for example, Surrealists compared the dream and the cinema and tried to create "psychic films" such as Man Ray's *Emak Bakia* (1927). Desnos, a talented hypnotic subject, expressed lyric admiration for the cinema:

> A taste and love for the cinema has some of the same characteristics as a desire to dream. . . . We go into the darkened theaters seeking artificial dreams and, perhaps, a stimulant capable of peopling our lonely nights.[12]

Surrealists united in search of Freud, dreaming: "One is asked to close one's eyes."

Breton's conclusion in the *Manifesto* is rather enigmatic: "I believe in the future resolution of these two states, dream and reality, which are seemingly so contradictory, into a kind of absolute reality, a *surreality,* if one may so speak."[13] But this seems to me explained in the beginning of *Les vases communicants.* The activity of the night before and the activity of the dream should not be merged like two abstract entities. It is a question of bringing the dream, in the recollection we have of it, back to its affective sources which we decode through self-analysis, the better to take bearings on our experiences, or rather the experiences we are to have. The dream is a point

of reactualization and of affective resource, in its latent rather than its manifest content. But the word with which Breton refers to oneiric activity is not "unconscious," but "imagined." Through dreams, Breton writes, we must attempt "the increasingly necessary conversion . . . of the imagined to the lived or, more precisely, what we are to live."[14] The outline of the subject implied here is thus not founded on a spatial image; it does not lead us to think that the mind should dive into its own depths. Breton speaks to us immediately of action, establishing a direct link between the imaginary and the experience to come.

As for Freud, the *Interpretation of Dreams* (translated into French in 1926) discusses action only in a second stage, the dream providing once and for all the symptoms of the dynamics of the unconscious. Another major difference between Breton and Freud is that Breton assimilates the functioning of the waking dream with the nocturnal dream (*Les vases communicants*, vol. 2). How the terms "waking dream" and "daydream" can mean two completely different mental processes: compensatory fantasies, which can extend to hallucination (Desnos, in *La Révolution Surréaliste*, nos. 9–10, gives a striking example of this under the title "Journal d'une apparition"); but also daydreams which seem as if they were as capable as nocturnal dreams, but *differently*, of revealing unconscious fantasies and giving us their grammar, showing how the subject writes his life and constitutes himself. At any rate, this was the hypothesis posed in 1938 by Robert Desoille, developed by the practical analysis of the "directed waking dream."[15] And in any case this distance from Freudian doctrine allowed Breton to affirm in an interview about *Les vases communicants (Entretiens)* that he had made "materialist theses prevail even in the realm of dreams," without abandoning the careful utilization of the dynamics of dreams in order to learn to *live*.

In Surrealism, then, all these ludic practices tended to *disturb* the order of the subject by questioning his relation to the *other*, and, through his pleasure or pain, to make him rediscover the path of his desire. These practices range from the dialogues with subjects under hypnotic trance (published by *Littérature* in 1922) to automatic activity, conceived as a dialogue; from the games of absolute sincerity (games of favorite things, notes about people's faults and virtues) to games of gratuitous action (such as the aimless trip taken by Aragon, Breton, Max Morise, and Roger Vitrac in May 1924, starting from a town chosen at random on a map). As Aragon remarked, it is a question of "restoring life's tragic color," of "giving back to ideas which have stopped working in our society the efficacity, that primary offensiveness from which

quarrels, jealousies, suspicions, the ruins of love and of friendship arise."[16] The intention of these practices is not only to make us more aware of the roots of conscious feeling but also to make mental activity collective. The game of "exquisite corpses," constructing a phrase or a drawing, as well as the game of "one in another," based on the production of analogies (*Médium*, "communication surréaliste," 1953) show the latter intention more clearly.[17] In general, these are games with invention or with life, not with death. Little games, the adolescents of Rheims would say—*we* play "the Great Game" with death. This is in fact the whole difference between René Daumal or Roger Gilbert-Lecomte and Breton or Aragon.

What we have seen discovered here is less the unconscious as a place where sources are found than the imaginary as the subject's central function, around which knowledge and action can reorganize themselves.

The imaginary in its phenomenological function is Surrealism's first court of appeal. "Classical" philosophy, while recognizing that the imaginary insinuates itself into perception, tries to reduce its importance: Kant writes that imagination is a "necessary ingredient" of perception, but Alain suggests that a "prompt inquiry" will allow us to eliminate it. While recognizing that imagination can dispose of the elements of memory as it wishes, classical philosophy recommends an objectifying and reductive investigation.

Nothing like that in Surrealism. In perception and in memory, error is claimed—not hunted down through the mechanism that founds it, as in the psychoanalytic cure; it is observed and preserved. Aragon writes lyrically about error in the "Préface à une mythologie nouvelle" *(Le paysan de Paris)*. He shows it usefulness in the pages following the preface.

The great wave of descriptive details to which Aragon subjects us in this narrative (the Opera Passage and the Buttes-Chaumont park are both minutely described) offers us at random what one might see with an "objective" glance and what, in the greenish light of the Passage or the excitement of the night, the confusion of such a sensitive person might make him notice. But this rich motley of experiences serves as a springboard to the imaginary: *after* the description of the "Petit Grillon" and the appeal to the residents to join the Committee in Defense of Neighborhood Concerns comes a hymn to love and a hymn to Imagination; *after* the painfully thorough description of the Cartâ café comes a hymn to reverie; *after* the plan of the Buttes-Chaumont park comes a hymn to night.

For Breton, in the first place, the gaze of perception is selective. One could draw a map of the places in Paris he named and evoked: there are not

too many of them, and the way he evokes them is anything but exhaustive. But neither are individual objects perceived in the totality of their physical characteristics, "as if we could claim that our attention is equally attracted by all the windows of those houses, or by all the folds in that dress."[18] Surrealists were not unaware of Gestalt theory: from 1925 on, accounts of it were published in France.[19] Breton turned his conversations with the West Indian philosopher René Menil toward this theme in the early 1930s. Cognition is recognition. Our intentionality is the basis for the symbolic reality of an object. And the two components of this intentionality are our memory and our imagination. But for Breton there is a third component: the possible use, the dreamed use of the object. There *are* some objects which have "halos," auras that immediately predict their dramatic use. Cézanne would be the painter of such objects. The deeply moved perception of this possible use—imaginary and yet soon-to-be real—constitutes the privilege of sensibility. We can analyze this in *The House of the Hanged Man*.[20] The emptiness of the front of the house is the space of the fall of a human body, a rope around its neck.

What this involves is clearly a phenomenology of perception, apparent especially in Breton: a perception that assumes responsibility for the role of the imaginary to the extent of sometimes giving it a predictive function.

Thus imagination is much more than the power of displacement (and from what norm?) that we could find in perception and memory. Projecting around us a margin of "possibility," it anticipates and predicts; it participates in every action: it sketches and makes us see the configuration both of what can be made real and also of what *could* be.

Of course, in a "reasonable" ethic, there is always a second stage in which imagination adjusts its models to what Janet calls the "function of the real"; it then keeps rebuilding new configurations all the time. If not, its fantasies would lose credibility and usefulness. It would destroy our desire for practical control of reality.

In Surrealism, this game does not work the same way. The prospect of a great imagined project does not have to humble itself before the denial reality may bring. As Breton says:

Imagination is not a gift, but primarily the object to be conquered.
. . . I say that imagination, whatever it may borrow—and, as far as I am concerned, we still have to be shown if it really borrows anything at all—does not have to humble itself before life. Between what are

called commonly accepted ideas and ideas . . . that we should perhaps make people accept, who knows? there is an important difference capable of making the imagination mistress of the situation of the mind.[21]

For Breton, an example of this would be the prospect of *unique* love:

[The scene is] blocked off . . . by a row of seated women in pale clothes, the most appealing they have ever worn. . . . A man enters . . . and recognizes them: one after the other, all at once? They are the women he has loved, who have loved him, some for years, others for one day.[22]

Between the hope of a unique love and the dreamed "reality" of this series is a gap that makes Breton exclaim: "How dark it is!" A displacement, an emotion, but not a contradiction.

Here Surrealism is in complete disagreement with the classical theory of the imagination found in Plato, Aristotle, the Stoic philosophers. For them, *phantasia* belongs to the realm of appearance, not of being. Clearly, however, as Jean Starobinski shows, this locks art into the prison of nonbeing and the lie.[23] On the other hand, Starobinski also reminds us that in the Renaissance Giordano Bruno presented imagination not as *an* internal sense, but as the totality of internal senses, "the living source of original forms, the principle of the infinite fecundity of thought." Giordano Bruno owed a great deal to the Gnostic influences from which Surrealism, in some ways, arose. This philosophical current was joined by a whole body of medical thinking which begins with Paracelsus. Surrealism found its guide through the labyrinth from Paracelsus to Fludd, to Jacob Boehme, to Mesmer, and even to the Romantic philosophers.

Nothing could be further from the Surrealist imagination, therefore, than the arbitrary. The arbitrary is the work of the intellect alone; it is a logical construction. The imagination has taken sides with action and feeling; it constitutes a spiritual reality. German Romanticism provided Surrealism with the notion of *Märchen*: the immediate, necessary, ideal, and *prophetic* product of imagination left to itself, as Novalis said.[24]

At this point we should distinguish among various conceptions of the forms imagination may take. For some, imagination is essentially a provider of

images in the sense of phantasms; it is in league with space and with things. For others, imagination is primarily a question of language; it is in league with the unconscious.

Let us first examine the way in which the Surrealists and those close to them conceive of language.

We have seen that for Breton, relational language was never in any case perceived as a means of intersubjective communication. Ordinary, nonpoetical language, for Surrealism and its fringe movements, leads to error and deceit. We have seen what Breton thought of dialogue; all controlled language with rational pretensions falls foul of the critique of logic in the first *Manifesto:*

> We are still living under the reign of logic. . . . But in this day and age logical methods are applicable only to solving problems of secondary interest. The absolute rationalism that is still in vogue allows us to consider only facts relating directly to our experience. . . . Under the pretense of civilization and progress, we have managed to banish from the mind everything that may rightly or wrongly be termed superstition, or fancy; forbidden is any kind of search for truth which is not in conformance with accepted practices.[25]

But in Breton, this critique of banal relational language and logic is joined by a tremendous confidence in it, as long as it is being interrogated in its *innocence* (as opposed to "unconsciousness"). Octavio Paz expressed this in analogical terms:

> Attraction and repulsion between syllables and words are no different from what they are between stars and bodies. Nature is language, and language the double of nature. To rediscover natural language is to return to nature, before the Fall and before history: poetry is the testimony of the first innocence.[26]

Innocence: not in the sense of a regressive movement toward a temporality of the absence of time, but in the ethical sense of *free*, unburdened by guilt. Innocence we attribute to "savage thought." As for magical thinking and its relationship to rational thought, Surrealism made intuitive connections with the position of Claude Lévi-Strauss, who often associated with the Surrealist group in the 1940s. In his linguistic theory of myths, whatever the content

of that theory, Lévi-Strauss admits no difference between savage thought and logical thought except differences of use and strategy, not structure.

The Surrealist insight about language apprehends this human function as a faculty of *symbolizing* (in the widest sense: of representing the real by a sign and of understanding the sign as representing the real), and as a faculty of predicting, programming, inventing. In this sense, there is a total confidence in language *in its power to enunciate*, insofar as our language is *also* the product of an activity in which imagination plays its part: "Does not the mediocrity of our universe essentially depend on our power of enunciation?"[27] Let us dare to say: "Once upon a time there will be," and the game of language and desire will make happen things we never had the nerve to expect.

The Surrealist philosophy of language, such as we find it—more or less implicit, more or less contradictory—takes cognizance of a privilege of language around which reality redefines itself. This stream of thought—for which being is language—seems to me to take priority at the very heart of Surrealism, once we relate it to absolute nominalism (which I have shown in the project of automatic writing) and the Surrealist insistence on releasing the programmatic or creative function of language.[28]

This question of language is at the precise center of the split between the Surrealist project and, in the strict sense, the phenomenological project, toward which so far I have been pushing Breton's thought on the subject of perception and memory. Various positivist linguists inspired by phenomenology, such as J. L. Austin (d. 1960) account for affective statements in what first looks like a very Surrealist way, since the act of speaking is, in the first place, an action, a "speech-act." And readers of Maurice Merleau-Ponty ("Le philosophe et son ombre," in *Signes*, 1960, or *Le visible et l'invisible*, 1964) might well believe they had rediscovered the driving ideas behind Surrealism in his affirmation that the truth which cuts its own path through language is *also* teleological, or in the way he insists on underlining movement in expression, and the struggle to pass from signifying intention to articulated expression.[29] But for Surrealism, there is no meaning before there is language (an assumption which is also the basis of its difference with Marxism). Intention takes shape together with its words and its signs.

Nevertheless, this does not mean that the philosophy of language outlined in Surrealism is therefore thrown toward structuralism and the "death of the subject" to which this may tend. In fact, while in structuralism the world of discourse may have the status of an absolute, in Surrealism this is not the case.

For Surrealism, the accent is on a truth on the point of being revealed. Insofar as it is *on-the-point-of*, this is a phenomenological attitude. Insofar as *there is no priority* of meaning over language, we do not find here the central insight of Husserl. But we may legitimately see that of the early Heidegger, in *Being and Time*. Elisabeth Lenk has very clearly shown this in the case of Breton.[30] The existing being can only understand itself starting from structures of anticipation. Language is nothing, it is empty, if it is not internally linked by the very manifestation of what happens when the poet or thinker speaks. Thus one can generally say that the main Surrealist philosophy of language, a philosophy for which being (to come) is language, comes close to the nonontological hermeneutic philosophy of language, which puts great emphasis on the signified and what is beyond the signified (a stream of thought most lucidly represented by Paul Ricoeur in France and H. G. Gadamer in Germany). For Breton and his friends, language is turned toward the object, and its summons ensures that it is on the vector of desire.

In relation to this majority tendency, we can henceforth distinguish more clearly the linguistically "pessimistic" leanings that surround the basic optimism of mainstream Surrealism. First of all I would like to mention Georges Bataille, whose critique of language is much more radical because it offers no way of "recapturing" *innocence*. In any case, as we know, Bataille is completely hostile to automatic writing. Intersubjective communication is, for him, transgressive communication—a cry in the silence, the nonlanguage, between lovers:

> No communication is more violent. The laceration has been hidden (like an imperfection, an existential shame); now it clings greedily to that other laceration: the lovers' meeting is a frenzy of tearing and being torn.[31]

Thus for Bataille the function of language is to describe the world—and only to describe it—for consciousness. In the straight line of logical philosophy, Bataille believes that language is imperfect and that it fulfills its function poorly. Language would be the sum of the propositions used to make known the world:

> But if language makes this known, it can only do so in successive stages developing through time. We will never be given, in a single supreme instant, the total vision which language breaks into separate

aspects linked in the cohesion of an explanation but following each other without merging in its *analytic* movement.

Thus language, assembling the totality of what matters to us, disperses it at the same time.[32]

The temporal linearity of language, then, would keep us from apprehending the world in its totality. Apart from his dizzying fascination with universality, Bataille confuses the sentence with the logical proposition belonging to scientific language.

Raymond Queneau also dreams of a word that would not be heard in time, and of a language that would not be perceived as a linear series as soon as one writes or hears it. An image that comes close to the *being* of language would be what he calls "oral language": a set of signs through which the process of communication is established (rhythm, tone, accent, gestures, the pockmarks of language). But for Queneau, this "oral language" is untranslatable. Social, literary, other conventions always throw over this rich collection a coded network that inevitably impoverishes it.

After this detour into the Surrealist conception of language, in which we have seen the priority given it in human communication, we can return to the *different* Surrealist ways of conceiving the imaginary.

Phantasm plays a role in the thinking of Breton, René Crevel, and Péret which it cannot claim in Aragon, Leiris, or even Desnos. For the first three, the imaginary constitutes itself in the process of language falling into place, a language of which the signified terms are considered to have priority. For the last three, on the contrary, language has a double priority: as the locus of communication and of invention but also as a set of signifiers, as the locus of the exuberance of its own forms, from which is born an intoxicating proliferation and dissemination.

In these unequal treatments of language I am tempted to see a fundamental mechanism that would somehow refer to the aesthetic distinctions established by Wilhelm Worringer between "abstraction" and "Einfühlung." *Einfühlung* is sometimes translated as "understanding" or "empathy," responding to a characteristic human tendency to be at one with the world. There is a place here, however marginal, for children's "scribblings" and the "works" of primitive people. Worringer is very far from seeing in "abstraction," as Kandinsky does, a freedom from all rational constraints; for him, it is the play of figuration in space, the proliferating power of forms.[33] On a less

psychological level, we can connect the tendency to give a prioritary importance to the signs of things and to the way they fit together with a primacy of the metonymic function of the mind; the tendency to insist on the signifiers of words can be related to the primacy of metaphoric function.

Despite the prestige given to disorder by Surrealists, then, there is a whole version of Surrealism that contributes to the restitution of order: this is the analogical order of language, the mysterious intercorrespondence of the signs of things, as things correspond in the universe. Michel Deguy has shown this in his discussion of the ascensional hierarchy and the *differences* maintained within the poetic of Bretonian analogy.[34]

It remains to be shown that the subject's time cannot be perceived analogously in each of these "versions." On one hand, a whole temporal discontinuity is the basis of the interplay of the substitution of signs among themselves; on the other hand, a temporality is conquered in its continuity, in its homology with the contiguity of things.

Understanding progresses, in any case, through the fabrication of explanatory models, by language thus defined. "To understand is to fabricate"— that could be the watchword of Surrealism from the beginning to the end of its history. As early as 1922, Breton said:

> A recent experience has shown that any given individual in a hypnotic state is capable of working in the most difficult genre, so long as it is a genre that has already attracted his attention. The famous maxim: "to understand is to make equal" should be taken in its strongest sense.[35]

He echoed this in 1930: "Imagination is not a gift, but primarily an object of conquest" ("Il y aura une fois"). In the same year, under the title "Les possessions" (in *L'immaculée conception*), Breton and Eluard published their attempts to simulate the discourse of people affected by mental retardation, acute mania, general paralysis, delirium, dementia praecox. The formation of a "new myth" is the last incarnation of this tendency. Through this epistemology, Surrealism is once again close to the insights of Leonardo, and also to a later English tradition of science: Newton, Hobbes, and Maxwell believe explanations come from fabricating mechanical models with bits of matter and force. This is the source of one more divergence with French Cartesianism and its geometric rationality.

An Ethics of Rebellion and Risk

In 1929, in a footnote to the *Second manifeste du surréalisme*, Breton wrote:

> Yes, I am concerned to learn whether a person has a gift for violence before asking myself whether, in that person, violence *compromises* or *does not compromise*. I believe in the absolute virtue of anything that takes place, spontaneously or not, in the sense of non-acceptance. . . .[36]

He goes on to speak of "the cry which can be wrenched from us at every moment by the frightful disproportion between what is gained and what is lost, between what is granted and what is suffered." This is also René Crevel's cry at the political spectacle offered by the bourgeois republics and their social hypocrisy.[37] Surrealism, then, starts by valorizing the power of humanity's refusal to accept *that which is*.

The projection of desire (*Eros*, but also the concern for "more justice") gather together all the violence stored up before these established facts: the denial of social justice, the sadness of affective solitude. Indeed, desire, which we have seen play out its game in the phenomena of "objective chance," gets its strength from assuming responsibility for contact with "reality" and its scandal. Breton wrote: "It has always seemed to me that great tension in the way of experienced a moral trial—refusing to be distracted by it or limit its ravages in any way—was likely to provoke such help," by which he meant "extraordinary help."[38] A whole balancing game goes on, therefore, between violent revolt and the construction of a temporality carried away by desire. This is where we find the roots of both the Surrealists' political attitude (to which we will return) and their conception of love. For Surrealism, love is a hearth of energy that exalts desire and the will to live, and thus underlies the temporal dynamics to which Surrealism is attempting to restore its creative powers.

Here we rediscover the various divisions in or around Surrealism that I was talking about earlier. There is a rough correspondence between the different conceptions of language and different mental schemas representing temporality and the great debate within Surrealism: libertinage vs. selective love; and the further split with a Sadist eroticism.

Another point that should be made clear from the start concerns the

interrelated histories of social attitudes and Surrealism. The difference here is a chronological one. During the 1920s and 1930s, Surrealists had fought the hypocrisy of custom: taboos about sexuality itself and about "perversions" in sexual practices; the restriction of women, through religious and social institutions, to a secondary role; and so forth. During the 1960s, Surrealism witnessed a total reversal in behavior: "majority" opinion now became a belief in sexual liberation. Sexuality became anodyne, love inconsequential. Surrealism now remembered that it had never sought such banalization: "systematic sexual education" confuses young people by confronting them with sexuality without leaving "intact the incentive toward sublimation," and essential component of love. The entry into sexual life is an "initiation," "with the whole aura of sacredness . . . which the word implies." Lifting taboos and restrictions, too, suddenly destroys the perception of a realm which should remain sacred: *"This is the price of love."*[39] Total liberation, yes; banalization, no.

Different objections could be raised to Surrealism, then, according to the time frame or version under consideration. A shocked reaction to the audacity of some of its propositions, to a whole erotic impregnation, is no longer fashionable. Today, in a high bid inspired by Herbert Marcuse, combining a breaking of taboos in this realm with a rejection of the Father's law for revolutionary purposes, Surrealism is reproached with being too moralistic, and not defending *all* sexual perversions.[40] We may smile at the naivety of such recent criticisms; could a "generalized" libido—homosexual and practicing all the perversions—liberate people from all neuroses and lead to the social revolution? But it remains true that Xavière Gauthier's book, written by a woman, raises telling points about the inadequacy of Surrealist opinions on love and sexuality from women's point of view. We must admit that women today will find no answer in Surrealism to the way Freudian theory shirks a discussion of their concerns.

We should now return to the question of the different conceptions of time (both individual and collective) forged by the various Surrealists.

On one hand, there was a whole comic resurgence of Zeno's paradox. During his Surrealist period, Aragon's conception of lived time was close to the Dadaists', a collection of instants equivalent among themselves, equivocal in their relative positions and forever crumbling away:

I have forgotten even the sense of time. Am I progressing toward yesterday or tomorrow, nothing can tell me. . . . If I stay the same

from one minute to the next, how can I experience the quality of what I gain from the movement of the hand of the clock?

And look at the price of a sudden "distraction":

As soon as one thinks about something else, it's all over. Impossible to get back to my starting point, and between the thread and the needle I find myself in a desert land at some undetermined stage of the universe.[41]

"Frenzy" and "shadow" are the wind blowing into the interstices of time—in other words, Surrealism, which allows us access to the "kingdoms of the instantaneous."[42] Such discontinuity permits the free interplay of the permutations of signs. This is even clearer and more systematic in Duchamp, who suggests that we actually "raise" dust on panes of glass over the course of several months, so as to find the difference between two panes carrying dust of different ages. Dust rarely shows its age to an observer: therefore, duration hardly exists. We should also practice

losing the ability to recognize two similar things—two colors, two laces, two hats, any two shapes. To reach a point where one's visual memory was incapable of moving from one similar thing to another would imprint this on one's memory.[43]

This extraordinary exercise would allow the observer to erase from memory any imprint of things seen: a "memory" that would become a succession of forgetful instants. We could find comparable examples in the work of Michel Leiris, for whom the possible is more present than the real, thanks to a negation of perceived time and the emergence of a temporality which is purely abstract, or composed of coincidences (Aurora). We could find this, too, in the work of Robert Desnos, who plays, like Duchamp, the game of substituting objects in our memory as readers. Thus, speaking of a harbor, Duchamp's text first states: "The pier is granite, the customs house white marble." But two lines further down, it says, "The pier is made of porphyry, and the customs house of molten lava" (La liberté ou l'amour! p. 45).

For Breton, on the other hand, and also for Crevel and Péret, temporality is conquered through its continuity. "I seek the gold of time," Breton writes. We must go forward—not toward the absolute, but from one landmark to

the next, making an absolute, a categorical imperative, out of this very movement. As the sunflower of the poem "Tournesol" commands, "André Breton, a-t-il dit, passe" ("André Breton, it said, pass on.")[44] Time, for Breton, is discovered in action, and in meeting woman; its dynamism and continuity are both conquered in the face of the threats of stagnation and nostalgia:

> Tu verras l'horizon s'entrouvrir et c'en sera fini
> tout à coup du baiser de l'espace
> Mais la peur n'existera déjà plus et les carreaux
> du ciel et de la mer
> Voleront au vent plus fort que nous.

> You will see the horizen open up, and all of a sudden
> the kiss of space will be all over
> But already there will be no more fear and
> the window-panes of sea and sky
> Will fly in the wind stronger than ourselves.
>
> *(La mort rose)*

For Crevel, time is also oriented, but by anger:

It is the merit of so-called decadent eras to shed an exceptionally violent light on the conflict between what is and what absolutely ought to be. . . . The sirocco, the animal with giant footprints, which may not be seen every day, then . . . crouches in public places as vast as its original deserts and gives us every assurance, with its equator-ribbon lips, that what ought to be will not be prevented from being.[45]

Trying to reduce the Surrealist movement in all its diversity to these two versions of time—the cata-strophic version and the anagogic version—would be an illusion; but they do characterize the opposition between the two visions, the two central experiences, of Aragon and Breton. Close to Surrealism, in the work of Georges Bataille for instance, the starting place for the invention of time is the idea of the game—a common factor in the experiences of ecstasy, laughter, eroticism—but time is clearly devoid of meaning. Here we find a third model for constructing temporality. Following the mathematical model of substitution of instants for each other and the physi-

cal model of the conquest of energy, this would be a perverted physical model: time, like the space of the human body, would be *indefinite*, so that vital energy could not keep itself from infinitely evaporating away.

It is no coincidence that the great debates on eroticism within Surrealism (libertinage or elective love?) and on its edges (what about perversion and the influence of Sade?) roughly correspond with these broad options, insofar as different conceptions of individuation come from them. For Breton, the swarm of teeming possibilities is what provides adventure, as long as one is "going forward." The image Breton uses is that of crystal, which he gives as equivalent to " 'figure'—in the Hegelian sense of the material mechanism of individuality," but he places its formation and destruction in a larger process.[46] For Aragon, however, the individual can discover himself only within the instant: within the moment, he discovers himself as liberty. This is a liberty due to the contingency of our existence: "I grasp the occasional within myself, I suddenly grasp how I go beyond myself: the occasional, that's me, and once I have formed this proposition I laugh at the memory of all human activity";[47] a liberty found in relation to others through the privileged experience of repudiation "when it's all over" ("lorsque tout est fini," in *Le libertinage*). This last thematic comes up too frequently in Surrealism for us to make it Aragon's private property. We may recall the end of Crevel's first novel, *Détours*, which finishes with a betrayal ("Liberty, my lovely new liberty"); or various characters of Philippe Soupault's, such as Jean (in *Le bon apôtre*, 1923), or Julien (in *En joue!* 1925). It is true that Soupault's characters do not betray others in a brilliantly pleasurable act, but rather because of what Benjamin Constant called "the fatigue, the uncertainty, the lack of strength, the perpetual analysis that surrounds all our feelings with mental reservations and thus corrupts them as soon as they are born." Soupault used this comment of Constant's about *Adolphe* as the epigraph of his own *Corps perdu* (1926).[48]

In any case, for Bataille the individual is defined only in the disorder of his body or in dis-proportion. This refusal to consider the individual within his limits and in the orientation of his body is based on a reversal of "low" and "high" ("The big toe is the most *human* part of the human body," *Documents*, no. 6, 1929) and on unnatural disproportion sought for its own sake (the illustrations for this article, Jacques-André Boiffard's photographs of a big toe, take up an entire page). The economy of the individual then becomes indefinable, basically founded on a physical model (as for Breton) but enclosed in the boundaries of a single individual and, paradoxically,

arising from experiences of *spending:* ecstasy, laughter, eroticism). This expenditure, which does not involve intersubjectivity in any way, seems as if it should use up individual energy. But no: individual energy is presented as a constant. This doubtless bears witness to the existence of a "communal being," whose resources would be inexhaustible.

These different images of the individual are the foundation of the major choices about eroticism.

We must certainly not forget Aragon's marvelous lyrical pages in "Le sentiment de la nature aux Buttes-Chaumont," after the meeting with a "lady" that revolutionizes the book of the "Parisian peasant":

> Woman you are nevertheless taking the place of all form. . . . Enchanting substitute, you are the summary of a marvelous world, of the natural world; you are reborn whenever I close my eyes. You are the wall and the hole in the wall. You are the horizon and the presence. The ladder and the iron rungs. The total eclipse. The light. . . . Just tell me, Sinbad, what did you think of the magnet that drew the nails out of your boat in the middle of the ocean? For myself, let them go, all those foreign bodies keeping me back; let my bones, my words, and their glue abandon me; let me undo myself in the blue magnetism of love! [49]

And we should remember the pages of *Aurora*, which have the same quest as Nerval's *Aurélia;* and Eluard's poem *Liberté*, which we are told was originally dedicated to Nusch.

But it is true that such lyricism is only a moment in these lives primarily dedicated to the venal, enchanting women who haunt the "Passages" of Paris. Aragon gets out of this difficulty with a paradoxical praise of prostitution:

> Well, doesn't it just have to be true that I must actually like and respect that passion [love] in what I secretly think is a unique way — since no sense of revulsion can keep me away from its humblest, least worthy altars? . . . There I pursue the great abstract desire that sometimes rises from the few faces I have ever loved. [50]

And others, like Eluard, manage by praising women who *love love:*

And it's always the same confession, the same youth, the same pure eyes, the same ingenue way of putting her arms around my neck, the same caress, the same revelation.

But it's never the same woman.

The cards said that I would meet her in life, *but without recognizing her.*

Loving love.[51]

And finally, desire, for Eluard, can arise only from the gaze of another man on the woman he loves. This was what Heinrich Eglin calls the complex of Candaule, the Lydian king who exposed his naked wife to the gaze of his bodyguard Gyges to persuade him of the queen's beauty. Breton makes some similar remarks in passing: "But I have also known pure light: the love of love."[52] And he says about Max Walter Svanberg:

I have always thought, for my part, that the purely erotic aspect of the scabrous, the kind that enraptured us so deeply in certain dreams that we retained a desperate yearning for it on awakening, has alone allowed humanity to form a notion of paradises.[53]

But it is in Marcel Duchamp, of course, that we see the free range of a libertine eroticism in which words are much more important than people, in which humor is everywhere. "A meta-irony on eroticism," Octavio Paz said of Duchamp.[54] His 1968 drawing "Extract, After Courbet" (reproduced in the catalogue of the Duchamp exhibition at the Musée national d'art moderne, Centre Georges-Pompidou, 1977) juxtaposed a bird of prey and a woman exhibiting her genitals. No puzzle here, but a wordplay on the signifiers which Duchamp had shown in all its crudity to Arturo Schwartz, "C'est un faucon et un vrai" (a falcon and a true [cunt].)[55] *Not a Shoe,* an object dating from 1950, is a modeling of a female sexual organ, but a modeling of a full form which corresponds to a hollow organ. This inversion takes the form of a sort of shoe, reminding us that the French expression "trouver chaussure à son pied," "finding a shoe to fit one's foot," is used in a very precise sexual way. Ultimately, these rather ribald games have nothing to do with eroticism *if eroticism is defined as the whole mental attitude which consists in keeping desire in a state of maximum tension, in complicity with the forbidden.* The 1947 *Prière de Toucher* ("Please Touch")—the rubber breast decorating the cover of the catalogue of the Surrealist exposition—clearly

shows that the comic obligation outweighs the taboo. No eroticism here, or a critical eroticism which relativizes the difference between the sexes without denying it. (The attitude that consists of repudiating or denying the difference between the sexes, knowing it and disregarding it, is that of perversion.)

I have given in passing a definition of eroticism. According to the limits assigned to it, eroticism is perceived either as a surplus of life or as a brush with death. A surplus of life—this is the way Breton sees the erotic. And Robert Benayoun, who was part of the last Surrealist group, quotes Schwaller de Lubicz in *L'érotique du surréalisme:* "eroticism is the magic of vitality, expressed mainly through the awakening of sexual power." A brush with death—this is the way Georges Bataille sees the erotic: "It is possible to say that the erotic is the approval of life up to and including death"; or "Eroticism is that which, within man's consciousness, puts within himself the being in question"; the mortal cut of consciousness. Eroticism seems to be one of the places in which death and life do not present themselves as antithetical but which we experience as coexisting. Moreover, if sexuality designates a relational intention in the physiological order, eroticism is a sort of stylistic figure of sexuality. Figure of style, figure of speech: that is where we find Aragon, Leiris, Duchamp. And we might add Desnos's games with Rrose Sélavy ("Eros, that's life")—inspired, indeed, by Duchamp: "L'acte des sexes est l'axe des sectes" or "Les lois de nos désirs sont des dés sans loisir" ("The act of the sexes is the axis of sects" or "The laws of our pleasures are dice without leisure)."

As for André Breton, however, or Benjamin Péret, or even Robert Desnos (the scattered threads of whose texts are connected by lyricism, as those of his life are connected with love), they are quick to glorify the perfect *completeness* found in meeting a fully beloved woman. The woman is "the keystone of the material world" (*Les vases communicants*, p. 83); *earthly salvation* can be found through her (*Arcane 17*, p. 48). Ultimately, "all the regenerative possibilities of the world lie in human love" (*ibid.*, p. 54). A counterweight to the millstone of the fall of Babylon in the Old Testament prophecy, a stone *rises*—the love between man and woman. At this magnetic point

love lives only on reciprocity, which does not mean that it is always reciprocal. . . . But reciprocal love is the only kind that establishes the conditions for total magnetism, invulnerable, which means that the

flesh is both sun and radiant impression on flesh, and that the spirit is an ever-fresh spring, unchanging and always living, whose water forever flows between concern and wild thyme. [*Ibid.*, p. 28.]

The monogamous heterosexual couple is thus on the horizon of these nostalgias, in a reversal that amuses those who find this way of life synonymous with a whole petty-bourgeois, antirevolutionary world. But the prospect of this *idea* of the couple should rather be sought in the myth of androgyny, in the climate characteristic of the esoteric tendency of Surrealism. Benjamin Péret affirms: "The very notion of the sacred flows so directly from love that, without it, no sacredness is even conceivable."[56] Albert Béguin explains it in an article on the androgyne ("L'androgyne," *Minotaure*, no. 11, May 1938). From Jacob Boehme to Balzac, through Ritter and Novalis, this myth reflects a nostalgia for the return of Unity. For Jacob Boehme, woman will be called "man-woman because she was drawn from man" when Adam knew desire and a companion was created for him. Desnos sings of this:

Her lips make tears come to my eyes. She is there. Her words strike my temples with their intimidating hammers. Her thighs I imagine as invitations to a promenade. . . . Your lips make tears come to my eyes; you lie naked in my brain and I no longer dare sleep.

And then, you see, I have had enough of talking aloud about you.[57]

In the last analysis, Breton writes, quoting Engels, "what each person is seeking in others is one's own essence."[58] It is useless to reproach Breton with the number of women he loved; he sees in this multiplicity an increasingly selective choice "through the always increasing subjectivization of desire" (*L'amour fou*),[59] the trail of which everyone would recognize if the social conditions of life offered us wider possibillities for meeting others. The break with *X*, the woman whom he celebrated meeting at the end of *Nadja*, is attributed in *Les vases communicants* to the "underestimation of the need for material comfort that may exist naturally, and almost unconsciously, in a lazy woman who lacks the independent means to provide herself with such comfort."[60] Social barriers and material needs confuse the accurate perception of a desire. But on the other hand the individual is too closely linked to the "mirror flashes" of the universe for the meeting between man and woman not to be "overdetermined" by some astral influence:

For indeed passion, with its magnificent wild eyes, must suffer at having to mix in the human struggle. One must admit that even when it is the surest of itself, it may occasionally trip up in the corridor of minutes, hours, days following each other and *not being alike*. This corridor, with variable stars above it, is successively inundated with light, crepuscular, or totally dark.[61]

The esoteric vocabulary, in certain religious cases, should not veil a movement of sexualization of the universe, linked to "sublime love" as its natural development. For Péret, "Desire, while remaining linked to sexuality, thus sees itself transfigured. . . ; far from losing sight of the corporeal being who gave birth to him, he tends to sexualize the universe."[62] And in any case, idealist sublimation is controlled by the appeal to relational sexuality. The inquiries into love and sexuality in *La Révolution Surréaliste* appeared in consecutive issues (March 1928 and December 1929). *L'union libre* (1931) is a celebration of transgression ("My woman with her tongue like a stabbed sacrificial host"). And "mad love" is carnal love:

> carnal love, I adore, I have never ceased to adore your lethal shadow, your mortal shadow. A day will come where man will be able to recognize you for his only master, honoring you even in the mysterious perversions you surround him with.

This guilt should be slowly worn away, so that one will have "unlearned the dualism of good and evil."[63] The author of the *Anthologie de l'amour sublime* also wrote *Rouilles encagées*. And sentimentality is always ridiculed, as we see if we reread the savage "lonely hearts" column run by Joyce Mansour in the review *Bief* (starting in 1958).[64]

At the same time, the "child-woman" is celebrated as mediatrix—and with no sense of contradiction. Achim Arnim's cabalistic friend Ritter is quoted by Breton, who finds it odd of him to claim that "one loves only the earth, and through woman the earth loves us back," but Breton concludes his own text with another quotation: "Know woman, and everything else will fall into place."[65] In tarot cards, "Arcana 17" is Woman, the child-woman Melusine, who through her childhood participates in a prelogical, magical world, but also, part sorceress, is not afraid of appealing to the Powers and the Dominions. Victor Brauner portrayed this sorceress–child woman in his painting "Mythotomie" (1942), holding in one hand a serpent

(Woman, or Time) and in the other the Egyptian tau (symbol of life and death); stripped bare, she is an object of desire. Brauner painted *Stable, instable* in the same year, commenting on it: "The Somnambulist, in her sunrise ceremonial, transforms her hair into a fantastic animal which holds in its forepaws the arrow which will kill, once and for all, the image of reality."[66] The child-woman Toyen painted herself from the back as a little cardboard girl ready to catch things in her butterfly net *(La dormeuse,* 1937). And Leonora Carrington painted herself as a young half-animal woman: a filly in love with the white hobbyhorse of her childhood, her puffy hair spread around her like a mane *(Self-portrait,* 1937).

The role of such a woman, defined by the words of men (even if the person doing the painting or writing is a woman), remains an intermediary role. Her limitation is in her aptitude for metamorphosis, whether she is escaping definition or letting a man replace her with another woman. Surrealist eroticism here comes close to that of the troubadours, even if courtly eroticism is less sublimated than was claimed by René Nelli (who was asked to collaborate on late Surrealist reviews). The courtly practice of "senhal"— the false name—consists in obscuring, out of devotion, the name of the impossible object of love. It is an extreme form of love of the name of the beloved.[67] This is because all naming is already murder ("the symbol first manifests itself as murder of the thing"), but it perpetuates the desire of the other, by the word itself: "This death," continues Jacques Lacan, "constitutes in the subject the perpetuation of his desire." This is perhaps the reason why women's names are very rarely pronounced by the Surrealists; *Arcane 17* itself, under the banner of a dream of "Elisa," poses precisely this problem. Breton speaks of a "mystery" in this text: "love called upon to be born again at the loss of the love-object and only then rising to its full consciousness, its total dignity." The resolution to this contradiction, he says, demands the instrument "which the Hebrews represented hieroglyphically as the letter *Pe,* resembling a tongue in a mouth and signifying, in the highest sense, the word itself."[68]

In her transmutation from "love-object" into word, even the Hebrew name for the word, it is hard for woman to recognize herself as she herself sees herself socially, affectively, sexually. And there was a stream of Surrealists, masculine and feminine, who tried to respond to this expectation. Avoiding Lenin's option ("Revolution does not tolerate orgiastic states"),[69] Surrealists followed the nineteenth-century French Utopians such as Charles Fourier. In Rimbaud's prophetic words:

When the infinite slavery of woman is broken, when she lives for herself and by herself, having been dismissed by man—who has been, so far, abominable—then she, too, will be a poet! Woman will discover the unknown! Will her worlds of ideas be different from ours? She will find strange things—unfathomable, repulsive, delicious; we will take them, we will understand them.[70]

In 1942, Breton outlined a plan: "The problem of the relations between men and women must be gone over from top to bottom, with no trace of hypocrisy and in such a manner as to brook no delay."[71] In 1944, he continued:

The time has come to valorize woman's ideas at the expense of those of man, whose failure has come to a rather stormy consummation in our time. In particular, it is the artist's task . . . to give the greatest priority to everything that comes from the feminine system of the world, as opposed to the masculine, and, even better, to appropriate to his own jealously defended use everything which distinguishes woman from man with respect to appreciation and volition.[72]

And we may observe that Surrealist women painters—Toyen, Leonora Carrington, Remedios, Judit Reigl, Frida Kahlo, Mimi Parent, Yahne Le Toumelin—were *inventing* without waiting for these pronouncements.[73] Leonora Carrington, in particular, constructed from esoteric elements a whole philosophy of the universe through which woman rediscovers herself. Paradoxically, however, the last generation of Surrealist women *writers* (including Joyce Mansour and Nora Mitrani), reacting perhaps to the oversimplifications of the sexual liberation of the 1960s, praised Pauline Réage's *The Story of O*, in which the author unrolls fantasy after fantasy of absolute obedience of woman to man—perhaps less a Sadian discourse than a negative theology invented by a woman in *absolute* homage to the man-god.[74]

The discourse of Breton and Péret is considered idealistic from Georges Bataille's point of view, though they both revered Sade's work, published in part thanks to them. But it is true that Breton and Péret erase the apology for perversions and replace it with sexual "liberation," thanks to which, through revolutionary contagion, social and political liberty could be achieved. Bizarrely, in the introductory notice to the *Anthologie de l'humour noir*, Breton treats Sade as the predecessor of Freud. For Breton and Péret, a great

interrogation revolves around Sade, to whose work they add an aura of black humor. They find in him, ultimately, an enigma: "So far as I know, the sexual world, despite the memorable ways in which Sade and Freud have probed into it in modern times, still has not stopped opposing our will to penetrate the universe with its unbreakable kernel of *night*."[75]

But Bataille interrogates himself very differently about the implications of Sade's work, particularly after the war and under the influence of Maurice Blanchot.[76] According to Blanchot, Sade builds on the primary fact of human solitude; in a world of affective monads, intersubjectivity does not exist. Apathy, he adds, using one of Sade's central terms, is thus both the cause and the driving principle of the man who has chosen to be sovereign:

> Sade demands this: for passion to become energy, it must be compressed, mediated in passing by a necessary moment of insensibility; only then will it be the greatest possible passion. . . . All those great libertines who live only for pleasure are great only because they have annihilated any capacity for pleasure within themselves.[77]

And he quotes Sade: "The soul passes to a kind of apathy which soon metamorphoses into pleasures a thousand times more divine than those procured by weaknesses." This Sadian morality, reconsidered by Bataille, leads to an apology for expenditure and play, but with no risk of exhausting the energy of a truly infinite being. And ultimately, for Bataille, this being is beyond individual limits, like a continuous field on which individualities arise. "Continuity remains, like a basis for beings."[78] The individual exists only in relation to this "communal being"; but intersubjectivity is never a relationship. Laughter and tears make this clear: to go beyond one's limits in order to transgress the prohibitions (of eroticism, of death, of sacrifice) makes it possible "to open discontinuous beings to the feeling of the continuity of being" (*L'érotisme*).

Along with these writings of Bataille's, we should consider the novels he had already published, some under a pseudonym, like the first, *Histoire de l'oeil*; certain pages of Robert Desnos, Marcel Duchamp, or Aragon (*Irène*), the work of Joyce Mansour; the paintings and drawings of Hans Bellmer, Salvador Dali, and Pierre Molinier.[79] Surrealism is impregnated with an extremely strong eroticism, within which is revealed an apology for perversions: minor, belated, sometimes outside its historical margins, but existing all the same. Xavière Gauthier has made a study of this, a particularly

copious one since she adds to historical Surrealism the work of painters who were never (or only briefly) recognized as such and whose apology for perversion is the only thing that makes them "Surrealist" (Clovis Trouille, Léonor Fini). Examples of onanism, fetishism, necrophilia, bestiality, coprophilia, fellatio, and sodomy can be found in the fictions of Desnos, the novels of Bataille, and the work of Dali and Bellmer. The game of telling the truth about sexuality, played by the Surrealists on a few evenings in 1928 (*La Révolution Surréaliste*, no. 11), does not give these practices a major role, but it *recognizes* them. On the other hand, in these same pages neither sadism nor masculine homosexuality are seen as liberating either men or women. We know, however, that homosexuality, recalled in passing by Aragon, was part of Crevel's life and depicted in his novels as a painful passion. Sadistic scenes are present in the writings of Desnos or Bataille; they are frequent in Joyce Mansour, in Bellmer's drawings and on Molinier's canvases.

Finally, it is not surprising to see castration anxiety projected in Surrealist films and paintings, all the more free because it is expressed in fantasy. No "perversion" here, but crude anxiety, spoken by the cut-off hands and detached organs presented to our gaze by Buñuel's films and the canvases of Dali, Brauner, and Magritte.

This last erotic current in and around Surrealism seems tied to a game with bodies in which the signified is intensely present—but not, at first, the signifiers. I have traced two strictly erotic tendencies in Surrealism: the first connected to Aragon (especially *Libertinage*, despite his wish to divert the term to its seventeenth-century meaning); the second, that of Bataille and Desnos (especially *Histoire de l'oeil* and *La liberté ou l'amour!*). The first kind of eroticism finds in anagrams, spoonerisms, or the *incipit* game of famous first lines, the pleasure of transgressing certain laws of language. The second finds in the substitutive shift between bodies, between places on the body, in the permutation or the circulation of object parts, the pleasure of disturbing common uses, meanings, spaces, characteristics—in which consists another form of breaking prohibitions.

But even if the liberation of sexuality and love takes place through a recognition of the diverse forms taken by human desire, obedience to this polymorphism (a "generalized libido"?) does not automatically liberate men and women from the intimate bonds that time has forged between them. Jean-Bertrand Pontalis asks:

Isn't there, more compelling than any instinct, a "compulsion to synthesize" impelling us to find in a figure of the other, a person or work of art, the "total object" without the guarantee of which we ourselves would be doomed to the breaking up, the breaking loose of the death instinct? For if the sexual instinct does not find its goal in a form, it either floats free or settles into obsessional fantasy (the repetitive scenario of the perverse). Left to itself, it ends by merging with the death instinct. . . . In its most discreet, least spectacular aspects, it has become the negation of the other person in favor of acting out a construct or a well-organized fantasy. . . .

[In Surrealism,] even perversion itself goes through a deliberate reversal in respect to signs. Whereas sexual perversion in the strictest sense is subject to the body, is chained to it, twists it, decomposes it, tries to disjoint it into signs, Surrealist "perversion," on the contrary, aims at sexualizing verbal or graphic langauge, to make of it a substitute for the body. It is words that are making love.[80]

The quest for the "total object" guaranteeing that our time would remain *continuous* is in fact the special characteristic of the quest of Breton or Péret, in an eroticism the language of which is freely borrowed from esotericism. This eroticism recognizes the power of the *other* to form and animate the self. Perversion turned toward signs is the meaning of the quest of Aragon and Duchamp, and sometimes of Desnos. As for the perversion attached to the signified, which runs throughout Surrealism as well as on its margins and in its interstices, I do not think it should be confused with the Surrealist erotic as a whole. It is the a-cultural fringe. It can neither be ignored in silence nor be allowed primacy over the other forms of the Surrealist erotic.

A Libertarian Politics: The Status of the Revolutionary Work of Art

The ethical reflection underlying Surrealism has shown us how Surrealist action is motivated not only by a refusal of *what is* but also by a confidence in the power of human invention, sustained by desire. *What is:* the denial of

social justice, the capitalist exploitation of work. *What ought to be:* an abundance of justice; no more alienation on the part of the workers; a recognition of the artist's place in society. The violent demand for more justice connects the Surrealists to all egalitarian political streams of thought fighting the established order.

But Surrealism invariably goes beyond them. The Surrealist demand, poetic in the etymological sense, is conveyed by a revolt in every sense— moral, aesthetic, social—the applications of which are not limited to the political and social order of things and are certainly hard to subordinate to party discipline.[81] Anyone familiar with the discipline of the French Communist Party (PCF) during the 1920s, after the split at Tours, can imagine the confrontations that took place between two such divergent frames of mind: between the notion of a Party "line" (a rigorous conception of obedience with the goal of a greater ultimate good) and the absolute commitment to liberty found in Surrealism. We have already seen that after the summer of 1935 the rupture with the PCF was an irreversibly accomplished fact. No matter how the Party had behaved, however, the Surrealists' position would probably have been unshakable: "Surrealism, a revolutionary attitude, goes infinitely farther than political prescriptions in aid of the Revolution" (*Au grand jour*, 1927). As Jean Schuster said at Cérisy-la Salle in 1966:

> The Surrealist cause being the cause of liberty, Surrealism means to claim this liberty at a height the rest of the world thinks impossible. If we do this by using accessible modalities [and political options], it should be clearly understood that, for us, they are only means.

In any revolutionary party, the political will ultimately comes second to reason and logic. And we know how Breton and his friends despised logic, which they considered barely capable of "solving problems of secondary interest," as Breton says in the *Manifesto*.[82] Dreaming and imagination, the inventive powers, are individual faculties: a hard truth.

But Surrealists also postulated the future resolution of this depressing discrepancy—the "irreparable divorce between action and dream"—as early as *Les vases communicants* and right through the postwar years, when Breton endorsed the taut statements of Dionys Mascolo:

> For the time being we must choose [between the actuality of being artists and being revolutionaries]. But in this very choice, we must

somehow, no matter how, find a way to keep the primary theoretical indivisibility: the fundamental identity of the meaning of the materialist revolution and the meaning of any work of art, which is to ensure communication.

And Mascolo went on to say (this was in 1953): "There is no such thing as a Communist intellectual. There is no possible non-Communist intellectual."[83]

Their political position was therefore a stance of alerted witnesses continually alerting public opinion about the endless threats to individual liberty. At the same time, though, this position involved engagement in political movements tending to modify the political situation—through language, which is a form of action within political action, and often through acts as well.

A Constant: The Attraction of Anarchism

For Surrealism before 1925, the above historical account has not emphasized political propositions. This is because they were not in the foreground and remained contradictory, though generally libertarian. In his reading of symbolism, Breton found points of agreement with anarchy in Saint-Pol Roux, in the Barrès of L'ennemi des lois, in Mallarmé, in the words of Marcel Schwob's Monelle, above all in Alfred Jarry. The year of the Bonnot Affair (1913) was reminiscent of the "black terror" of 1892. Breton did not wait for this date to read the anarchist or near-anarchist press (Le Libertaire, L'Anarchie, and, after it was founded in February 1913, L'Action d'Art). His political consciousness is an emotional consciousness of rebellion, passionately pro-rebel. As Victor Crastre notes, "the meaning of rebellion, for Breton, is not an artificial feeling intended to maintain an ideology drawn from books rather than life."[84] In Arcane 17, as Crastre points out, Breton gives us a childhood memory:

> I will never forget the relief, exaltation, and pride I felt, one of the first times I was taken to a cemetery as a child, . . . at the discovery of a plain granite tombstone engraved in red capital letters with the superb motto: NEITHER GOD NOR MASTER.

And Breton also gives us his adolescent memory of the "countless tongues of fire," the red flags unfurled at a great trade-union demonstration in 1913 against the armaments race, among which there was a sudden "flurry of black flags." More than ever, Breton adds, "it seemed to me that waves of sympathy and antipathy were strong enough to control ideas."[85] And we must use all our strength to call for "the revolution—any revolution, as bloody as you like. . . . It wouldn't be a bad idea to reinstate the laws of the Reign of Terror, on an intellectual level."[86] During Aragon's adolescence we find no such emotional weight given to the political order. Long afterward, in *Le mentir-vrai*, Aragon was to portray his double, Paul, as a youth in serious political disagreement with his most intimate friend, Guy (Guy Renaudot d'Arc). Aragon considered himself a "man of the left"; as Pierre Daix comments, "the political position of his godfather [Louis Andrieux, a radical in the contemporary sense, that is an anticlerical republican but a social moderate] rubbed off on him" *(Aragon, une vie à changer*, p. 30).

During the whole period preceding the Rif War, the Surrealist enterprise was influenced first by Vaché and his nihilism and then by Tristan Tzara (see the *Manifestes dada*). Carrying the day over the revolutionary will is this subversive spirit, a subversion too broad to deserve the name "program," because what is at stake baffles any attempt at structuration. We thus see Jacques Rigaut, in the Barrès "trail," rejecting even the "early" Barrès, the anarchist Barrès of *L'ennemi des lois*:

> Revolt is a form of optimism scarcely less repulsive than the optimism prevalent today. Any possible revolt presupposes our being able to envisage the chance to react, which implies the existence of a preferable order of things in the direction of which we must move. . . . I cannot believe that anything satisfactory exists.

Or, again, look at no. 3 of *La Révolution Surréaliste*, the "letter to the medical directors of insane asylums" prepared by Robert Desnos, who affirms: "All individual acts are antisocial. The insane are the supreme individual victims of the social dictatorship"; and see, in the same issue, Eluard's declaration: "There is no revolutionary order. There is only disorder and madness." It would be a mistake, however, to argue from the suicides of Jacques Vaché and, later, Jacques Rigaut to pick away at all the suicides committed by Surrealists and their friends, and see in them the sign of an essential pessimistic distress.

An anarchist rather than nihilist stream of thought runs throughout historical Surrealism; it crops up again after the war in a newly attractive form. Let us recall the steady contributions of Breton's group for a year and a half to the publication of the anarchist federation, *Le Libertaire* (October 1951–January 1953). In 1952, Breton recalled in a personal contribution to *La Claire Tour:*

It was in the dark mirror of anarchism that Surrealism first took cognizance of itself, long before it was defined in its own eyes, when it was just a free association between individuals who were spontaneously and simultaneously rejecting the social and moral constraints of their time.[87]

Many of the characteristics of this anarchism are present in Surrealist texts, and at all stages of Surrealism. We can see the basic antistatism, the absolute refusal of hierarchy and system in declarations such as those of Benjamin Péret and, later, Jean Schuster. For Péret:

It's not the poet's responsibility to give other people illusions of earthly or heavenly hope, or to weaken people's minds by inflating them with a limitless confidence in a father or boss of whom any criticism becomes sacrilege. On the contrary, the poet is supposed to keep on saying sacrilegious words and permanent blasphemies.[88]

And Schuster wrote in 1950, in response to a survey about intellectual youth (*Réponse à une enquête auprès de la jeunesse intellectuelle*):

Our aggressive suppression of a deliquescent society and our hostility toward its degrading ideals find their corollary . . . in our desire for a great atheist wind, purifying and revolutionary.

And he went on to say in 1967:

What is the system? It is an extremely complex collection of principles, institutions, laws, customs, prohibitions, myths, dogmas, ideas, and symbols which separate us from our own thinking.[89]

We might compare this remark with Georges Bataille's comments on the necessary *subversion* of culture, which can happen only at the price of a reversal of values. This refusal of various forms of patriotism is a constant element from the Rif War to the 1960 declaration of the right to protest against the war in Algeria and its corollary, active internationalism, so clearly visible in the pictorial activity recognized by Surrealism. Active antimilitarism is another result of this tendency, and Aragon's 1928 words still sound fresh:

> they blame us for yelling "Kill!" and laughing at them. I must point out that what I am yelling is not a result of spontaneous generation: I do not believe in the parthenogenesis of my violence, but in its determinism. . . .
>
> I think the government and justice in France are committing an obscene abuse of power in forbidding people who hate the army to express in writing, with whatever commentary they please, their loathing for a revolting institution, against which any action is humanely legimate, every attempt commendable.[90]

All the same, the Surrealist appeal to individual autonomy is not as utopian as in historical anarchism, at least in its Proudhonian form and in its continuation in Bakunin. The longed-for, hoped-for confusion between the liberty of each and the liberty of all is not really an integral part of the Surrealist state of mind, which makes much of the virtue of *violence*. An anxious tension is manifest, from Breton's statement of "the simplest Surrealist act," measuring human ability to *refuse*, to Jean Schuster's 1966 Cérisy-la-Salle affirmation of a "fundamental pessimism about the fate of liberty." The apology for political violence that we find in the propositions of the *Contre-Attaque* group, including Breton, Bataille and their friends, tended to struggle against Fascist violence in 1935 *by using the means of human violence*, insofar as the democratic spirit seemed unable to stop the rise of the danger:

> Violently opposed to any tendency of whatever kind to use the Revolution in favor of nationalistic or patriotic ideas, we address ourselves to those who are resolved to bring down capitalist authority and its political institutions by any means and without reserve. . . .
>
> We affirm that the present regime must be attacked with new

tactics. The traditional strategy of revolutionary movements has never been valid except when applied to the liquidation of autocracies. . . .

We state that the nationalist reaction has been able to profit in other countries from the political weapons created by the worker movement: we intend in turn to make use of the weapons created by Fascism, which has been able to use the fundamental aspiration of human beings for emotional exaltation and fanaticism. But we affirm that the exaltation which should be placed at the service of the universal interests of humanity should be far more important, more explosive, great in a very different way from the exaltation of nationalists chained to social conservatism and selfish party interests.[91]

But here we have reached another aspect of libertarian violence: *moral exaltation.* This individualist and aristocratic tendency is strongly opposed in Breton's mind to the anarchism perpetuated by the tradition of anarchistic syndicalism. In *Arcane 17*, Breton makes distinctions among the participants in the trade-union demonstration of 1913. For some, hope remained "reasonable" while the flame of passion

> burned others, fewer in number, on the spot in an inexorable stance of sedition and defiance. . . . This last attitude, which has had illustrious adherents in intellectual history, including Pascal, Nietzsche, Strindberg, and Rimbaud, has always seemed to me perfectly justifiable on the emotional level, disregarding all the utilitarian reasons society may have had for repressing them. We must at least acknowledge, leaving ourselves out of the picture, that *it alone is marked with an infernal grandeur.*[92]

All this also has its aristocratic, anarchist side, however, which was in fact the cause of the estrangement between Breton and Bataille after the publication of the first *Cahier* of *Contre-Attaque.*

Such libertarian, anarchist, even nihilistic tendencies became the target of Jean-Paul Sartre and then of Albert Camus in 1947 and 1951, in a time when the building of a new society in France seemed a real possibility. Their criticisms look quite dated to us today. This is partly because, inspired by a vague Marxism, they point to the Surrealists as irritating hindrances within a society whose unity was very provisional; then, too, because Sartre's criticism, inspired by psychoanalysis and philosophical analysis,

remains at a very primitive level despite its formal elegance.[93] The Surrealist revolt? A revolt against the Father, and the *bourgeois* father. He also sees a purely idealist and subjective tendency in Surrealist art, referring to works of genius but unclear intentionality, such as Duchamp's *Why not Sneeze?* Sartre does not place the Surrealists' artistic activity or political positions in the current of Surrealist ethics. As for the critique formulated by Camus, this draws its strength from the word "revolt," but by taking away from it all its original meaning. If revolt is pure creativity, it is no longer a revolt: it is perhaps a revolution; it may become a "made-to-measure" revolt (as the Surrealists showed in a special issue of the Marseilles review *La Rue*, June 1952)—and even, as Gérard Legrand says, a "measure of nothing"!

1925–1935: Is Agreement with the Marxists Possible?

In 1935, when the Surrealist-Marxist dialogue was almost over, Breton took up Marx's motto, "Transform the world." And even if he added to it Rimbaud's "Change life," he made it very clear: "For us, these two commands are one and the same."

Ten years of efforts and misunderstandings went on between the 1925 Rif War (which prompted indignant reactions in the reviews *Clarté*, *Philosophies*, and *La Révolution Surréaliste*) and the year 1935 (which saw the publication of *Du temps que les surréalistes avaient raison*, repeated in *Political Position of Surrealism*); I will note the milestones here. Five Surrealists were members of the Communist Party between autumn 1926 and spring 1927; but, as they say in *Au grand jour*, they had joined mostly because "not to do so might imply a reserve on our part that really wasn't there, an ulterior motive that could be useful only to their enemies (who are our worst enemies too). . . ." Surrealism includes political revolt and revolutionary construction; it is not subject to them. However, the Surrealists also avoided every kind of utopia and kept their distance from anarchism (see Aragon, *Clarté*, November 1925), Breton wrote an enthusiastic account of Trotsky's *Lenin*, which he read in 1925. In the *Second Manifesto*, he affirmed the congruence of Surrealism with dialectical materialism; but this is only one of the text's two main propositions, the other being to affirm the existence of the spiritual "point" at which all contradictions are resolved. Breton tried to demonstrate this congruence in *Les vases communicants*, although he does not resist the pleasure

of castigating the pragmatism of "professional revolutionaries" (that is, the various Communist parties). He strongly reminds us that a radical transformation of the world, which is their immediate plan, has no priority over our need to "interpret it as completely as possible." "Resignation is not written on the shifting stone of sleep."[94] And finally, profound disagreements were revealed by a number of events, not all of them equally important. Aragon and Sadoul broke with the Surrealists after the Congress of Kharkov, and in 1933 the Communist-oriented Association of Revolutionary Writers and Artists (AEAR) expelled Breton, Eluard, and Crevel. The signing of the Franco-Soviet defense pact in May 1935 poisoned the "International Congress for the Defense of Culture" (June 1935) and made the Communists rather patriotic. The first lucid analyses were published of the "Moscow Trials," which had begun in 1929. There were thus two adversary camps after June 1935, although the Spanish Civil War saw Péret reunited with the Communists, and Crevel kept tying all his life to keep his dual commitments (he returned to the Communist Party only a few months after being expelled from it). If Tzara left the Surrealist camp in 1935 and Eluard in 1938, it was to join the *other* camp.

We should note the extent to which the Surrealists consistently devalorized the humanitarian and pacifist position of Henri Barbusse. The Surrealists considered his literary work mediocre and suspected his conciliatory spirit, especially when he joined Romain Rolland in calling for the "Amsterdam-Pleyel" Congress in 1932. The Surrealists' response was the tract *La mobilisation contre la guerre n'est pas la paix:* "Mobilization Against War Is Not Peace." At a time when the USSR and its supporters believed that capitalism's only way out of its economic crisis would be to attack the Soviet Union, the Surrealist group even tried to show its absolute and orthodox solidarity with the Party in Russia, *against* the French pacifist tendency represented by Barbusse. (See the Surrealist response to the telegram sent from Moscow by the "International Bureau of Revolutionary Literature," in *Le Surréalisme ASDLR,* no. 1, July 1930; this is also one of the meanings of Aragon and Sadoul's complex mission to Kharkov).

In 1947, during another period of national unity and political liberalism in the French Communist Party, when Sartre was attacking Surrealism from a pro-Marxist point of view, a nostalgic desire for togetherness appeared in artists who claimed to be in the forefront of Surrealism and were also members of the French Communist Party. This was "revolutionary Surrealism," a short-lived attempt begun in April 1947 by Christian Dotremont,

mostly involving a small international group: a few Belgians, a Hungarian, some Czechs, some Danes, Dutch, German, and Swiss. A few Frenchmen such as Noël Arnaud and Edouard Jaguer also lent their support. This brief attempt was followed by even more bitter breakups and tensions, since for Breton an alliance with the Communists could no longer be excused by an ignorance of Stalinist crimes.

The most interesting debate within Surrealism itself was certainly the dispute between Naville and Breton during 1926. In the spring of 1926 Pierre Naville, still a member of the Surrealist group after his military service but also a militant member of Communist Youth, published a brochure, *La révolution et les intellectuels (que peuvent faire les surréalistes?)* in which he denied that anyone could carry on revolutionary intellectual activity while living in bourgeois circumstances. Its title asked, "The Revolution and Intellectuals: What Can Surrealists Do?" Can we envisage "a revolution of the mind before the abolition of the bourgeois conditions of material life and to a certain extent independent of it?" This is a radicalism which rejects, in the name of the prior necessity of revolution, everything that does not lead to it *directly*. Echoes of this attitude can be found in the criticism Jean-Paul Sartre addressed to the Surrealists in 1947, and very clearly in all kinds of propositions in 1968. The ghost being raised is that of individualistic anarchism: to avoid it, according to Naville, "we must realize that spiritual strength, a thing which is all and part of the individual, is intimately connected with a social reality which it actually presupposes."

Breton answered this in *Légitime défense* (Autumn 1926, reprinted in *Point du jour*), pretending to consider Naville as an official representative of the French Communist Party. He refused to allow any validity to Naville's "opposition of an interior reality to the world of facts." Naville had given the Surrealists a choice between purifying their inner lives, sacrificing to contemplative theories—of which the appeal to the orient would be a notable symptom—and turning to *action*. For Breton, the cogency of "the opposition of act to speech, of dream to reality, of present to past and future . . . cannot be defended for a moment." This protestation, rigorous from the Surrealist point of view, allowed Breton to call for the pursuit of experiments concerning the inner life "and do so, of course, without external or even Marxist control."[95] It also allowed him to refuse any Surrealist collaboration with the review *L'Humanité* which, through Henri Barbusse, had asked the Surrealists to contribute a literary column (a "story" a day). Impossible for the Surrealists to sacrifice to "propagandist" art and litera-

ture. On the other hand, in late 1925 and 1926 Roger Vitrac, Antonin Artaud, and Philippe Soupault were being banished precisely because of their *political* tepidity and *artistic* deviation. This is one of the times when the intellectual and political independence of Surrealism becomes perfectly explicit in its splits and tensions.

Finally, the themes which Surrealist and Communist thinking really had in common were so broad that they were not always immediate calls to action. For example, the commitment to internationalism sometimes seemed a secondary theme to those who saw, in the USSR, a Socialist state perpetuating itself in obedience to all the constraints of nationalism (instead of the long-awaited emergence of a stateless communist society). All the same, Eluard wrote:

In 1925, at the Moroccan war, Max Ernst and I both supported the shibboleth of the brotherhood of the French Communist Party. . . . Why wasn't it possible for us, during the war, to move toward each other, to reach out our hands spontaneously, violently, against our common enemy: the International Profit Conspiracy?[96]

Exactly: the attacks on the "International Profit Conspiracy," capitalism in all its forms and its ally Religion, constituted yet another theme which the Communists and the Surrealists had in common. Let us recall the postscript to Eluard's speech:

That's what we're all fighting against together: notions of the "good" and "beautiful" chained to ideas of property, family, religion, country. Just like proletarians, poets worthy of the name refuse to be exploited. Real poetry is included in everything that refuses to conform to a morality which, to maintain its order and prestige, is capable of constructing only banks, barracks, prisons, churches, brothels.

We should reread René Crevel, too, and Pierre Mabille's *Thérèse de Lisieux*.[97]

But there is no denying that there is a fundamental ideological opposition. This opposition primarily concerns the conception of the relationship of the individual to the social group. In the Marxist view, work in a Socialist society may no longer be alienating, whereas for the Surrealists work is not a moral value: it tends to prohibit the active mobilization of the imaginary. The individual, in the Surrealist sense, remains a free spirit whose adventure

does not coincide with anyone else's—not even with the adventure of the liberation of the proletariat. As Breton wrote about the poet Mayakowsky:

> It would be completely pointless for us to try to make one drama of these two different stories: the inspiring life of the struggling proletariat; the stupefying, destructive life of the mind devoted to its own beastly ideas.[98]

The Marxists, for their part, at the time of the Second International Congress of Revolutionary Writers (November 1930), condemned Freud's theories as "dangerously idealist." This was one of the points that the organizers of the Congress managed to make Aragon and Sadoul sign; whereas Surrealism, whatever its reservations about some of Freud's ideas, always referred to him as a precursor. Ultimately, the Surrealist and the Marxist conceptions of the role of art and even their conceptions of language are not comparable. Language is not at the center of Marxist philosophy; according to Marxists, art can, at its maximum, become propagandist, which is a scandal for Surrealists. Breton's *Misère de la poésie*, in which he defends Aragon from the charge of having written the *words* of the poem *Front rouge*, is not just a text written for the occasion. The function of the *word* of a poem has ultimately nothing to do with action or, to put it another way, with the word of prose. Here the Surrealists cannot be speaking the same language as Sartre, who defines the action of the engaged writer as a "second action," his word, precisely, being action. But neither did the Surrealists wish to disassociate art from political action. Paradox? Inconsistency? Trotskyite thought seemed to offer a solution to this problem.

The Encounter with Trotskyite Thought

We should begin by saying that the Surrealists' recognition of Trotskyism as the political philosophy most likely to account for their vision of the world was a very gradual one. Trotsky was ejected from the Party in November 1927, quickly exiled to Alma-Ata, and then expelled from Soviet territory in February 1929. In the winter of 1928–29, Stalin began deporting refractory peasants by the thousands; in May–June 1929 the Chakhty trial—the first "Moscow trial"—took place, the meaning of which very few intellec-

tuals, even in the USSR, were able to analyze. Afterward, in *Entretiens*, Breton was to insist that when he read Trotsky's *Lenin* in 1925, a book which facilitated a lasting reconciliation with the French Communists, it was Trotsky's writing that had won him over as much as anything else:

> I was really taken by his sensitivity. Both from his *human* side—Lenin as the author had known him personally and so well—and from the *superhuman* task he had accomplished, arose a very engaging quality which immediately made his ideas extremely attractive.[99]

The Trotskyite movement started in France in 1924, about the same time as the opposition within the Communist party in the USSR (at Souvarin's expulsion); it grew stronger when Trotsky began his wanderings through the world. We must recognize, however, that this Trotskyite movement made no attempt to form an alliance with the Surrealists. Pierre Naville met Trotsky in Moscow in October 1927, just before his expulsion from the Party, and himself broke with the French Communist Party in 1928; now that he had become a responsible Trotskyite he made sure to keep his distance, at any rate, from the Surrealists, who took their revenge in Breton's *Second Manifesto*. It is impossible to deny that at this time (1929–30) Breton and his friends René Crevel and Georges Sadoul still trusted the USSR (see *La Révolution Surréaliste*, no. 12, December 1929), and Breton quotes disapprovingly an imprudent statement of Trotsky's about Mayakowksy: "Mayakowsky took the shortest way to the Revolution, that of a rebellious bohemian."[100] But Breton had already read in *Clarté* Trotsky's lucid analyses of the so-called "proletarian culture," and quoted them in the *Second Manifesto* (December 1929). And in April 1934 Trotsky's expulsion from French territory, after a year in residence, provoked the tract *La planète sans visa*, which was certainly aimed at the French government as much as at the French Communist Party. The text celebrated the Trotskyite formulation of socialism; "Socialism will signify a leap from the reign of necessity into the reign of liberty, especially in the sense that today's man, contradictory and unharmonious, will clear the way for a new, happier human race." The end of the Surrealists' hopes in the Communist Party, after the "International Congress for the Defense of Culture" in June 1935 (see *Du temps que les surréalistes avaient raison*, August 1935), definitively authorized Breton's closer personal and political relationship with Trotsky. In 1938, Breton's trip to Mexico and their joint drafting of *Pour un art révolutionnaire indépen-*

dant made possible a link between Surrealist thought and political thought, thanks to the concept of permanent revolution and the fact that Trotskyism did not consider Freudian analysis idealist.[101] This was a meeting of opinions, not minds, since Trotsky's poetic and artistic sensibility bore very little resemblance to the ideal of his friends Breton and Diego Rivera. And these opinions had the same internal dynamics: for Trotsky, "the artist has received *information* from the revolution which has changed his sensibility and is present, though hidden, in his work. The axis, invisible [like the Earth's], should be the Revolution itself."[102] The artist's work is permanent revolution—turning around this axis—permanent as the work of the proletarian Revolution.

The 1938 text established the connections between Surrealism (as artistic activity) and politics. To achieve the transformation of the world desired by Marxism, Trotsky and Breton declared, we must return to Marx: "The writer in no way considers his work as a *means*." From this it follows that we must

> guarantee the respect for the specific rules by which intellectual creation is limited. . . . If, for the development of productive material forces, the revolution has to build a centralized *socialist* regime, for intellectual creation it should immediately establish and ensure an *anarchist* regime of individual liberty. No authority, no constraint, not the slightest trace of a command![103]

But "we have too high an idea of the function of art to refuse it any influence on the fate of society. We believe that the supreme task of art in our time is to participate consciously and actively in preparing the Revolution."[104] And again: "The need for intellectual emancipation has only to follow its natural course to be melted and forged anew in this primordial necessity: the need for humanity's emancipation." This assertion is supported by Freudian thinking, which would like to connect the ego ideal and the "self" we call the id:

> The goal of sublimation is to reestablish the broken equilibrium between the coherent "ego" and the repressed elements. This restoration works to the advantage of the "ego ideal" which opposes itself to unbearable present reality, the powers of the interior world, of the

"self," *common to all men* and constantly in the process of expanding into the future.

Thus "the Communist revolution has no fear of art."[105]

On the contrary: from a revolutionary point of view, the *chance* of the philosophical, sociological, scientific *or artistic* discovery overlaps with a "more or less spontaneous manifestation of necessity."[106] The artist serves the struggle for emancipation "if he is subjectively imbued with its social and individual content, . . . if he has filled the marrow of his bones with the meaning and the drama of it, . . . and if he freely seeks to give an artistic incarnation to his inner world."[107] The artist formulates, through prospective visions, the meaning of a historical necessity that tends to manifest itself through a given society.

The assimilation of philosophical (or sociological or scientific) reflection with artistic activity is a question that would need further development. But the essential thing was that the keynote expression could be formulated and explained: "all license in art." And a serene conclusion: "What we want: *The independence of art, for the revolution; the revolution, for the definitive liberation of art.*"

Art in Revolution

The question of the connection between art and politics becomes a particularly keen one when a society seems to give every guarantee of being founded on socialist principles, like the USSR after 1917. Can the revolutionary struggle combine forces with a subversive art in the context of this "concrete model"? And *how?* How can the intellectual and the artist contribute to the activity of the proletariat?

In this respect, Surrealism does not contradict the legacy of Hugo or Vigny, for whom the poetic revolution certainly includes the political revolution if the poet—fire-stealer and thief—shows the way on a spiritual level. But in a revolutionary context the problem of the relationship between the individual and society—between individual and collective creation—grows trickier. If art is a reflection of the dominant ideology, is such an art capable of freeing itself from that ideology in prerevolutionary times and of forging the class consciousness likely to hasten the coming of the Revolution? But in

this case it can free itself only with the help and consciousness of political revolutionaries; it must follow their suggestions while simultaneously impregnating itself with an ideology that is radically *other*. This is the meaning of the question the review *Monde* asked its readers in 1928: "Do you believe that artistic and literary production is a purely individual phenomenon? Don't you think it can or should be the reflection of the major currents determining the economic and social evolution of humanity?" Breton responded to this in the *Second Manifesto;* an affirmative answer to this second question

> would be offering a rather unrefined judgment, implying the purely circumstantial awareness of thought and giving little credit to its fundamental nature: both unconditioned and conditioned, utopian and realistic, finding its end in itself and aspiring only to serve, etc.[108]

What Breton calls this "vulgar" position is coupled with a systematic devaluation of the literature and art of the past—reflections of a nonrevolutionary, bourgeois ideology. The same tendency crops up in naturalist thinking about progress in art, which would occur at the same rate as the general progress of humanity (Breton notes this elsewhere, just before quoting his reply to an inquiry he characterizes as "neonaturalist.") We may recall Emile Zola's contention: "assuming an equal level of genius, a Homer or Shakespeare born today would find a broader, stronger framework and would leave greater works; at any rate these works of art would be truer and tell us more about the world and humanity."[109]

On the other hand, the Surrealist glance over the past, however selective it may be, finds all sorts of streaks of illumination: authentic art is revolutionary in *both* form *and* content. Even the novel—which is guilty of giving us the narrowest views of "reality," and allowing very little formal innovation—even the novel, if it is "black," reflects the disturbances within feudal society; if it is "marvelous," it invites us to overturn the relationships of the powers structuring our society. The problem is thus primarily aesthetic.

In this debate, the French Communists, clustering around Henri Barbusse, showed a strong tendency between the two world wars to preach in favor of a search for "proletarian art." Individual Surrealists were asked to contribute to both *Clarté* and *L'Humanité*, and sometimes did so. Benjamin Péret signed critical pieces in *L'Humanité* during 1925–26. At the same time, less frequently, Marcel Noll was writing a "review of reviews." But Breton

radically refused to commit himself to collaborating with a *story*. The naturalist, petty side of a detested genre! Péret proclaimed this in Mexico in 1942: "The *ivory tower* is only the flip side of the obscurantist coin, the face of which is proletarian art; or the other way around, it makes little difference."[110]

Trotsky gave an entirely relative value to this problem in his *Literature and Revolution* (1924) and in previous texts preparing for this work and translated into French in *Clarté*. Trotsky becomes ironic about "the vague theories about proletarian culture conceived by analogy with antithesis to bourgeois culture" (*Clarté*, November 1, 1923, quoted by Breton in the *Second Manifesto*). He develops the idea that a classless society will engender a culture which will be neither proletarian nor bourgeois, but simply human: "the dynamic nature of the culture will not be comparable to anything the world has ever known in the past"[111]

We know only too well that the intellectual evolution of the USSR was to go in an opposite direction, toward "socialist realism"—what Breton described in 1952 as a "means of moral extermination." The resurgence of these "theories" after the Stalin era made way for Aragon's "realism without riverbanks," which functions in his thinking as an epistemology of poetic invention.

The Surrealist conception of art in the revolution thus remains prudent in detail and rigorous in a Trotskyite way in general. Prudence: the process of assimilation of culture by the masses will be extremely slow. This is a painful truth, as Jean Schuster would write in Cuba during 1967. But the internal dynamics of the inventor must keep on working ceaselessly if he wants to keep in step with the principle of permanent revolution. Conformity is a threat even among the Surrealists, Breton emphasized in 1942: "More than ever, the *opposition* must be strengthened at its very base. All ideas that win out hasten to their downfall."[112] This is certainly the *political* lesson to be drawn from a reflection on the finality of art. But, as we can see, if such reflections were inspired by Trotskyite thinking, they did not remain dependent on it. During the 1950s, the Surrealist reflection on art in relation to politics often rediscovered its anarchistic and Hegelian origins, or traced its roots in Fourier's socialism.[113] José Pierre mentions Hegel's influence, referring to the theory of art Breton suggested in his 1935 *Situation surréaliste de l'objet* rather than in the Breton-Trotsky manifesto of 1938.[114] As for Fourier, in 1965 the last international exposition of Surrealism organized in Breton's lifetime, *L'écart absolu* (a title borrowed from Fourier's expression

"the absolute gap") preached the "radicalization of Cartesian doubt" as a method of invention. As Jean Schuster said in 1967,

All civilization is questioned once again, all everyday ideas are con-
tested, all conventions are reconsidered to make them more equivalent
to the passions, all solutions give birth to an inverse solution, the trial
of which was recommended by Fourier. . . . In 1967, Surrealism
recognizes itself totally in this method and puts the odds in its favor to
realize the two indissolubly united goals of Marx and Rimbaud: "To
transform the world and to change life." [115]

The poetic includes the political, or, to speak in Marxist terms, the
immense confidence placed by Surrealism in the power of the imagination is
already working as if in a classless society.

Aesthetics and Poetics

As for the idea of the beautiful and its embodiment in works of art, we have
already seen the stream of thought within which Surrealism consciously
placed itself. The attention it paid to esotericism, its consideration of magical
sources of human thought and conduct, the revelations it found in art
outside Europe and beyond the norms—everything alienated it from the
most acutely intellectualized thought of the early twentieth century, which
conceptualized the work of art as project. (In France, we might mention
Valéry, Gide, the *NRF;* in Europe, the rise of abstract art: Kandinsky
published *Du spirituel dans l'art* in 1911). In this sense, Surrealism founded
an *other* history of art and poetry, casting a different eye on the productions
of the past.

Moreover, if indeed love and the discovery of the unusual call forth an
enchanted glance at the everyday, and restore "to all things the lost colors of
the times of ancient suns," [116] this lyric strangeness is the basis for the
creation of all poetry and all aesthetic creativity. Breton sees only a differ-
ence of degree between aesthetic and erotic pleasure, in part because of a
connection (though certainly not one of cause and effect) between the state
of being in love and poetic "furor":

I confess without the slightest embarrassment my profound insensitivity in the presence of natural spectacles and of those works of art which do not straight off arouse a physical sensation in me, like the feeling of a feathery wind brushing across my temples to produce a real shiver. I could never avoid establishing some relation between this sensation and that of erotic pleasure, finding only a difference of degree.[117]

This circular game between love and creativity (where an amorous glance is the basis for poetic metaphor, where the beautiful makes one shiver with pleasure, where the beloved child is the product of a love for words) is a nexus of Surrealist thinking. Some may consider it confusional. Let us rather try to unravel its implications. We should certainly not make Surrealism say that every emotion or every erotic pleasure creates the beautiful:

I say that subjective emotion, whatever its intensity, is not directly creative in art, that it has value only insofar as it is reinstated in, and indistinctly incorporated into, the emotional depths which the artist is called to draw upon.[118]

This emotional depth constitutes the hearth of the imaginary. The aesthetics of Surrealism are in direct relation to the philosophical conception of the subject which places the imagination at the center of human faculties. We may even think that the Surrealist "theory" of the subject may be *made for* its aesthetics; but suffice it to say that there is a complete and functioning homology between the knowing subject, the acting subject, and the "inventing" or "creating" subject. As Aragon said, "Everything depends on the imaginary and everything reveals it."[119] To be unfaithful to this—to bury oneself undemandingly in everyday life—is to run the risk of going through life brushing past a multitude of possible events: *missed* events. "Beloved imagination," Breton wrote, "what I most like in you is your unsparing quality."[120] And again, there are all sorts of "missed" events. Such an event might be an understanding of the world and the "bizarre attraction of arbitrary dispositions," an attraction that made Aragon's gaze linger, astounding him with the power of God's imagination: "Imagination attached to minute and discordant variations, as if the main point were someday to bring together an orange and a thread, a wall and a glance."[121] Or it might be an understanding of the Other, a decisive meeting with him or her; or,

finally, the aesthetic object, an inseparable element in this complex whole. The *act* of Surrealism (in knowing, acting, or creating) always offers the quality of manifesting its originary link with imagination. This general model and this quality imply an obvious democratization of the poetic and artistic function. In this sense, Lautréamont is always quoted: "Poetry must be made by all. Not by one." [122] Poetry and art must escape the grasp of specialists and of talents duly catalogued by criticism and the marketplace. We have already seen this with respect to works of art produced by "mediums" or the so-called insane. When Marcel Duchamp drew a moustache on a reproduction of the Mona Lisa and called it, irreverently, "LHOOQ," [123] or when he suggested using a Rembrandt as an ironing table, he was following the same goals as Breton when, through automatic writing, he was hoping to devalorize literary work by the abundance of written pages, like dumping stock. This is also true of the texts admired or proposed by the Surrealists: such works, curious in themselves or curiously distributed in time (the work of Stanislas Rodanski, of Pierre Mabille, of Maurice Fourré), are not the works of *professional* writers. But they are "inspired" works:

> There is no point in resorting to subtleties on this point; we all know well enough what inspiration is. There is no way of mistaking it. . . . We can easily recognize it by that total possession of our mind which, at rare intervals, prevents our being, for every problem posed, the plaything of one rational solution rather than some other equally rational solution. . . . [124]

It is for these same reasons that Surrealists think that inspiration can be spread beyond the sociological groups within which its appearance is officially licensed; that it can be limited, in any given writer, to a few works; that it can establish hierarchies that do not conform to historical and cultural norms. Inspiration is distributed at random, but it is identifiable by the quality of the emotion it arouses in the creator as in the "observer." Between the two world wars, ethnology was prone to this kind of selective generalization and displacement of the idea of the "beautiful," as one can see by simply leafing through the review *Documents* (1929–30), to which ethnologists as well as dissidents from Breton's group contributed.

This does not mean that the "beautiful" is whatever comes to hand; it retains an objective meaning, even if it is relativized and displaced from "good taste" toward that which procures aesthetic pleasure. Following Tzara

and Picabia, Breton made fun of good taste. Tzara wrote in 1918: "A work of art is never beautiful by decree, objectively, for everyone" *(Manifeste dada 1918)*. Breton wrote in the *Manifesto:* "[My] notion of taste is the image of a big spot. Amid the bad taste of my time I strive to go further than anyone else. It would have been I, had I lived in 1820, I 'the bleeding nun.' . . ."[125] The beautiful is thus displaced from "good taste" toward an aesthetic pleasure aroused, for Breton, by the sensation of the *marvelous* ("Let us not mince words: the marvelous is always beautiful, anything marvelous is beautiful, in fact only the marvelous is beautiful")[126] or by the sensation of the feathery wind brushing across one's temples. For Aragon, the beautiful is aroused by a journey out of everyday routines:

> the bizarreness or absurdity of the words evoked plays within me the role of what's called a cloverleaf, directing my mind toward an unexpected road and, with a diverted wave, determining *me*, as a man or a creator, in the invention of living or writing.[127]

In this, Aragon adds, "creating, as they say, is a habit: like making love."[128]

The beautiful thus keeps an "objective" meaning even if it is displaced from good taste toward whatever procures aesthetic pleasure. We should add: even if it is displaced from the poem or the work of art (which it had characterized) toward the *act* of poetry. Uncertainty on this point governs the "aesthetics" of the *gesture* in Dadaism: a refusal of the aesthetic. In my opinion, the gesture had already regained an aesthetic value for Marcel Duchamp, who, signing his "readymades" ("chosen" manufactured objects), spoke of the "personality of choice." Choice is certainly an aesthetic act, and the act of signing is the minimum aesthetic act. Tristan Tzara developed this tendency more explicitly in his Surrealist period: "Poetry can exist elsewhere than in the poem" (*Le Surréalisme ASDLR*, no. 4, "Essai sur la situation de la poésie"). And in the same article Tzara opposed poetry as a means of expression to poetry as an activity of the mind. Here Tzara was returning to a distinction he took from Jung between directed and undirected thought, the first being a psychic process of adaptation to the milieu, the second, on the contrary, a form of thought which "turns away from reality, liberates subjective desires, and remains absolutely unproductive, unwilling to adapt in any way" (C. G. Jung). "Such thinking," Tzara commented, "consists in an apparently arbitrary linking of images; it is supraverbal, passive; within its realm are dreams, fantasy, imaginative think-

ing, and daydreams." Altogether, Tzara displaced the quality of the beautiful from the object to the subject, which becomes apt to produce the beautiful in certain conditions. Such a formulation ties up with some of Breton's 1923 statements about "this poetry, without poems if necessary" ("La confession dédaigneuse," in *Les pas perdus.*). But with the respect to the more general Surrealist conception of the relationships between subject and object, Tzara developed only a single moment in a multiple-stage problematic.

In fact, the definition of the aesthetic object generally clings to a number of poles. For Breton, "Beauty will be convulsive," "fixed-explosive," perceived in the movement of its forms and its link with the emotional center of the subject *(L'amour fou).*[129] Similarly, Aragon writes in the *Traité du style,* "all poetry is Surrealist in its movement." Moreover, Breton adds, poetry depends on the talent for expression of the person constituting it as an object: "The work of art seems to me devoid of value if it does not offer the hardness, the rigidity, the regularity, the luster on every interior and exterior facet, of the crystal." And he immediately opposes this to any notion of beauty as "a willed work of voluntary perfection."[130] Before him, and in the same tradition, Aragon had said: "Writing well is like walking straight ahead. But if you are staggering around, don't show me that frightful spectacle. . . . In Surrealism, everything is rigor. Inevitable rigor."[131]

But the object is also trapped in the network of objective chance—a movement in which it ultimately loses its "aesthetic" character. It can be used to signify that which it is not, in appearance or at first glance. It is inserted into a network of indefinite significations: indefinite because they can use the object to support a form, a customary expression, a word, various meanings of this word. The shoe-spoon found by Breton strolling through the flea market (probably an absinthe spoon) is also, through its form, a high-heeled slipper "like a dancer's" (Cinderella's slipper); there is a bewildering dimension to it if its heel is itself a miniature shoe that could, in turn, have such a heel, and so forth. And this multiplying activity involves a whole implied movement, a promised step of the shoe: the tiny steps of Cinderella. Finally, through its use as a spoon, it is also the cooking utensil of the modest Cinderella. The Surrealist object is thus the center of multiple significations, all subjective, while simultaneously it is a network of forms perceived in their possible movement, and finally it is the point of convergence of these forms and meanings. We must always be aware of this triple vocation. I have used the word "object" here in its broadest sense. Although

I took the example of a "found object," I was including all "Surrealist objects" (fabricated dreamed objects, even the poem-object) and also the poem (or nonpolemical, nontheoretical prose texts).

The differences between this and classical aesthetics are radical: the classical concerns for figuration and for obedience to rules (sometimes transcendent rules) which would allow one to achieve the "beautiful" are foreign to Surrealist aesthetics. But the differences between Surrealist aesthetics and nineteenth- and twentieth-century aesthetics are equally great. Surrealism abandons the very idea of an aesthetic project, if "project" is understood to have a rational meaning; Surrealist writing and art are defined neither by style nor by workmanship. To take the comparison further would just result in paradoxes.

At this time we should, at least as a first step, return to the center of the Surrealist intuition, which insists that the bridges have now been rebuilt between dream and reality, subject and object, imagination and nature. As Eluard writes in *L'évidence poétique:* "there is no dualism between imagination and reality. . . . everything the mind of man can conceive and create comes from the same source, is the same *matter* as his flesh, his blood, and the world surrounding him.[132]

The proof of this is the existence of the "Surrealist object." Revealing his own desire for and to the person who fabricates it, it is no less disturbing for the observer. The forerunner here is Marcel Duchamp, who in the 1910s "invented" the *readymade:* a manufactured found object, but *chosen* and *signed.* The first was no doubt the "Roue de bicyclette" ("Bicycle Wheel") arranged upside-down on a footstool, "fabricated" by Duchamp in 1913 in Paris. Two years later in New York he reconsidered its implications entirely. The name "readymade" began to be used only in 1916; meanwhile other objects were thus "chosen." A tangency and a threshold take shape here. Choosing and signing constitute the minimal aesthetic act, its point of tangency with "nature"—its point of rupture with it. Duchamp insisted on "bringing the idea of aesthetic consideration back to a mental choice and not to manual capability or intelligence, against which I rebelled, finding it in so many of the painters of my generation."[133] However, this is not a preview of the Bauhaus aesthetics to come: the function of the object is denied. The wheel is stuck fast, rendered useless; the bottle carrier (1914) no longer carries bottles. As Duchamp goes on to say, "This functionalism had already been changed the minute I took it in this world to carry it to the planet of

aesthetics." According to Duchamp's own testimony, the first *readymade* also involved a substitution: instead of the habitual movement of the "observer" around the contemplated object, what we have is the movement of the wheel itself, in an ironic substitute, an "antidote." Duchamp: the preventer of circular motion.

There is in Duchamp and his work the foundation for an avant-garde denying art, as well as for the establishment of a sort of "tradition of rupture." This tendency was to be fully exploited in the 1950s and 1960s, in a non-Surrealist sense. And the cult of indifference, Duchamp's only religion, had its own ambiguities. The Surrealist group was stunned by the fact that although Duchamp and Breton were both responsible for the great Surrealist exposition held in New York in 1960 (D'Arcy Galleries), Duchamp took it upon himself to invite Salvador Dali to participate—Dali the apologist for Fascism, turned to Catholicism, anxious to harvest his talent, nicknamed "Avida Dollars." Duchamp was sent a tract, "We don't EAR it that way."[134] What did Duchamp want? To pay real homage to a painter whose workmanship remained admirable, as opposed to his own abandonment of "olfactory" painting? To make fun of "Surrealist seriousness" to the point of contradicting its ethical implications, which he himself respected with total detachment? The first hypothesis is probably correct. Nevertheless, one of the farthest reaches of the Surrealist investigation of objective chance remains his quest to give back to chance its *tangibility* ("A bruit secret," 1916; "Trois stoppages-étalon," as well as his *obedience* to chance—"Tails I leave for America tonight, heads I stay in Paris" ["Pile je pars ce soir en Amérique, face je reste à Paris"], a statement quoted by Breton in *Littérature*, October 1922).

In contrast, the Dadaist object (Raul Hausmann's *Mechanical Head* or Kurt Schwitters' "merz" objects, works composed of thrown-away objects) responds to a negative and ironic intention which is in no way Surrealist.

The 1930s saw the fabrication of "Surrealist objects" and theoretical reflection on them. In his *Introduction au discours sur le peu de réalité*, Breton had proposed fabricating objects seen in dreams (1924). Alberto Giacometti's *L'heure des traces* gave a new impetus to the quest for "objects with symbolic function" (1930); we know how troubling the erotic implications of such an object can be. And Salvador Dali made particularly astounding oneiric objects *(Veston aphrodisiaque)* and reflected on this enterprise *(Le Surréalisme ASDLR*, no. 3, December 1931). Texts by Giacometti and Breton in the same issue made essential contributions on the theory of the object. Finding

or fabricating "objects" entered the realm of Surrealist activity at this point. At the same time, Breton invented the *poem-object*, which tends to combine "the resources of poetry and plastic art, and thus speculates on the capacity of these two elements to excite each other."[135] It is an object on which phrases inscribe themselves, sometimes in rebus form.

We now have all the terms of an indefinite combinative, ranging from the subject's *choice* of a preexisting object to the laborious realization of a dreamed object; from a borrowing of signs from other systems (mathematical objects) to the disturbance of the homogeneity of such a system (poem-object—at once language and plastic object); from a respect for the found form to its voluntary modification. Breton and his friends discussed the meaning of this manipulation over and over again. In 1934: Breton's "Equation de l'objet trouvé," reprinted in *L'amour fou*. 1935: "Situation surréaliste de l'objet, situation de l'objet surréaliste," a lecture delivered in Prague. 1936: Eluard's "l'evidence poétique" and Breton's "Crise de l'Objet," which was reprinted in *Le surréalisme et la peinture*. 1937: "Gradiva," reprinted in *La clé des champs*. 1941: "Genèse et perspective artistiques du surréalisme," reprinted in the last edition of *Le surréalisme et la peinture*.[136] Breton was eager to put himself under the protection of Hegel and his hierarchy of arts, culminating in poetry. But for Breton, poetry—a way of drawing one's sustenance from the irrational and emotional center of the human self—was involved in a canvas of Max Ernst, Miró, or Tanguy just as much as a poem of Eluard or Péret. The painter Victor Brauner's term "picto-poetry" was another attempt to present the same idea.

Let us not forget that this combinative allows us to include "savage" objects and those of the "insane," as we saw earlier, as well as *natural* objects: art confronts the forms and signfications of nature as well as "primitive" culture and "madness." The lists established by Breton, going from "mathematical objects" to "natural objects," from "found objects" to "Surrealist objects" (*Cahiers d'Art*, 1936; *Gradiva*, 1937) thus constitute much more than a nomenclature: the surreal is showing its points of multiple opposition to the real—of inventing the real.

In any case, Surrealism is the privileged locus of a meeting between *two* systems of signs to which it has given more importance than to others: the linguistic sign and the plastic sign. It is certainly not the only arena in which this issue arises at the beginning of the twentieth century. In a very general way, while a "crisis of images" shook painting, the "dream of an ideogrammatic, visual, incarnate language" fermented in poetry. Eliane Formentelli

defines this "perversion" as a "chiasmus" in which the reader is led to *see* where he should be reading, to *read* where he should be seeing. The close game being played here by Surrealism in relation to a very widespread inquiry can be seen in paintings such as Miro's "Oh! un de ces messieurs qui a fait tout ça!" ("Oh! one of those gentlemen who did all that!" 1925) and Max Ernst's "Qui est ce grand malade . . ." ("Who is that great big invalid. . . ," 1923–24).[137]

The early cinema, as the Surrealists knew it, was also a locus for this meeting, since silent films alternated images and "intertitles." Movies were a popular art, running serials in installments: in *Nadja* Breton evokes the "great mysterious 15-episode serial, *L'étreinte de la pieuvre*. Michel Leiris describes his addiction to movies in *L'âge d'homme*. And movies were in *bad taste*.[138] All this meant that movies allowed the viewer to cultivate a sense of disorientation to create a hallucinatory effect: the cinema became an intellectual stimulant because of its links to reverie or dreams (as Robert Desnos emphasized); its impregnation with eroticism and the role of mad love (as in the film *Peter Ibbetson*); and the disorder erupting in American burlesque comedies.[139]

Man Ray's ability to play with film in a semiconscious state made the creation of an "automatic" cinema seem entirely possible. Nostalgic for painting, Man Ray made little use of it (*Retour à la raison*, 1923; *Emak Bakia*, 1926). German Dadaists like Hans Richter and French Dadaists such as Georges Hugnet made attempts at montage films, but few examples of these still survive. While waiting for these chances to "play," Surrealists such as Péret and Desnos wrote scenarios; some were published in *Les cahiers du mois* (1925) and *Les cahiers jaunes* (1933); among the Dadaists, Georges Ribemont-Dessaignes wrote some as well.[140] But it was not in vain that Man Ray came to the rescue of Desnos (in *L'étoile de mer*, 1929) and of Duchamp (in *Anémic cinéma*, 1925–26; *Le mystère du château de dés*, 1929); or that René Clair helped Picabia (*Entr'acte*, 1923). It may have been unfortunate that Germaine Dulac lent a hand to Antonin Artaud for *La coquille et le clergyman* (1927), but without her, would the film ever have been produced? The collaboration of Dali and Buñuel on *Un chien andalou* (1928) and *L'âge d'or* (1930) remains exemplary.

Between the two world wars, the unwelcome appearance of talking pictures disrupted the technqiues, the economic conditions of production, and finally, in the Surrealists' opinion, the aesthetics of film, insofar as they felt the effects of "realistic" facility and because a politically "reactionary" fan-

tasy was perverting the use of collage, special trick effects. (René Clair's *A nous la liberté* was savagely attacked by Crevel and Eluard in *Le Surréalisme ASDLR*, no. 4, December 1931.) The "realism" hitherto characteristic of novels or mainstream theater had reached the cinema; now that, too, was tainted by "parrot-like" speech.

From that point on, Surrealist work in the cinema was reduced to a few occasional minutes. Man Ray said in 1951: "The worst films I ever saw contained ten or fifteen marvelous minutes; the best, ten or fifteen worthwhile minutes."[141] At that time, to be sure, Breton was celebrating the cinema's power to disorient the viewer.[142] And among the Surrealists of the last generation were fans and fervent critics who, with Adonis Kyrou's help, created the review *Positif*, after *L'Age du Cinema:* Gerard Legrand, Georges Goldfayn, Robert Benayoun. But Breton felt it had been "highway robbery" of everything the cinema might have done and had not accomplished.[143]

But there was one system of signs that remained completely neglected by French Surrealism: the whole field of music. Poetry as phonic listening seems to have restricted or obscured paths which might have opened:

> Reliance on the *tonal* value of words has never been so complete as in Surrealist poetic writing. . . . The "internal word" which Surrealism has chosen to take pleasure in manifesting . . . is absolutely inseparable from the "internal music" which carries it and, most probably, conditions it.[144]

The distinction between the word and the song was erased by Breton; and we know that physical science cannot define it. Poetic Romanticism and Symbolism had picked endlessly away at this transition, this analogy, working on sound and rhythm; in musical dodecaphonism, attempts were often made to cross chromatics with human speech.

But the opportunity for any meeting between music and Surrealism seems, from a historical perspective, to have been irretrievably missed. Breton was tone-deaf, according to the musician and musicologist André Souris.[145] The only musicians to have participated in the activities of a Surrealist group were Souris and Paul Hooreman, in Brussels (while E.L.T. Mesens renounced music for poetry, under Breton's influence). They explored the resources of chance: one of their experiments consisted of using *the wrong side* (playing sharps as flats and inverting intervals) of the perforated

rolls meant for street organs—which, the right way around, would have produced well-known tunes. In a Dadaist spirit, Georges Ribemont-Dessaignes took bits of musical scores at random, thus constructing musical *montages*. As for Kurt Schwitters, he had written "presyllabic" sonatas around 1920: this was a variant of Dadist "recitation."

An analysis should be made of the 1927 score by Souris *(Quelques airs de Clarisse Juranville mis au jour par André Souris)* and the scores of Igor Stravinsky before his twelve-tone period, to find out if this music, instead of simply playing a game of reversal and disruption, is inventing the equivalents of *collage* and of metaphor.[146] Besides montage (ironic, metonymic in its mechanics, spiritually Dadaist), is musical collage (irreverent, the creator of "meaning") even possible? Can the random encounter of a musical object be equivalent to "objective chance"? These two questions remain open (although I once believed, under the influence of René Leibowitz, that it was impossible to find a phonic or musical equivalent for objective chance).

A generation of musicians maturing around 1950 explored "concrete" electroacoustic music in a spirit close to that of Surrealism: Pierre Henry, Pierre Schaeffer. Younger ones such as François-Bernard Mâche believe that Surrealist forms of music could still arise, seeking the gold of sound as Breton sought "the gold of time."[147] These suggestions give a very partial analogy with Surrealism, or indicate very vague points of tangency. As for jazz, it was highly esteemed by Michel Leiris, Robert Desnos, Jacques Baron, Alejo Carpentier (see *Documents*): and then by the group of "La main à plume." Only Gérard Legrand, in *Puissances du jazz* (Arcanes, 1953), tried to connect Surrealist thinking with this mode of expression.

Meanwhile, Surrealism was devoted to exploring the furthermost limits of certain systems of homogeneous signs.

Under the pretext of continually retracing the sources of the "imaginary," it would be a mistake to lose the whole Surrealist aesthetic in a maelstrom of genres and means of expression. Certain genres remain distinct: we are most familiar with Eluard's reservations on the subject. In the publication notice for *Les dessous d'une vie* (1926), Eluard clearly distinguished among "dreams, Surrealist texts, and poems" *by their intention:*

> Nobody could mistake dreams for poems. For a mind preoccupied by the marvelous, dreams are the living reality. But as for poems, through which the mind tries to desensitize the world, to create adven-

ture, and to experience enchantments, we must realize that they are the result of a well-defined will, the echo of formulated hope or despair.

The uselessness of poetry: the tangible world is excluded from Surrealist texts, and the coldest, most sublime light illuminates the heights at which the mind enjoys a liberty so great that the question of verification never even arises.[148]

And the modifications he made in 1937 did not change his essential point. Dream narration should retain the greatest possible "scientificity." Aragon spoke ironically about this: "The dress must not turn into a twin of the prose poem, a cousin to spluttering nonsense, or a brother-in-law of haiku" (*Traité du style*, p. 186). While the distinction between poem and automatic writing was judged harshly by Breton (*Entretiens*), and corresponds to a completely non-Bretonian conception of language, it is not contradictory in practice. Even if Breton regretted it, he himself modified the "Surrealist text" of "Tournesol" in the sense of arranging it.[149] And his poetry uses automatism as a springboard: it does not coincide with automatism.

Finally, Breton himself singles out the novel and the theater. Condemning realistic use of them, he believes that these genres lead almost inevitably to literary speculation, whim, fantasy. In the "Introduction au discours sur le peu de réalité," he writes:

The imagination has every power except that of identifying us despite our appearance with someone other than ourselves. Literary speculation is illegitimate as soon as it sets up in front of an author characters he calls right or wrong, after inventing them from scratch. "Speak for yourself," I would tell him, "speak about yourself, you will tell me a lot more. I don't recognize your power of life and death over pseudo-human beings, who come armed or disarmed from your whim.

Breton denies both the novelist and the dramaturge the possibility of speculating on the psychology of others and of projecting an image of the living; he also denies the actor the possibility of "doubling" himself.

In writing, how do we invent or "find"? In a few pages of summary, any birds-eye view would irreversibly distort our understanding of Surrealism in all its diversity.[150] On one hand, some Surrealists join Breton in thinking that the true poet is the seer, in the image of Rimbaud's seer, one whose

obligation is to bring back from his trips into the Beyond a certain perception of the links connecting humanity to the universe. The first priority of the image—analogic and with a rising sign—is to translate this conjuncture: whereas automatic writing, in its very arbitrariness, tends to rejoin the stream of the subconscious. Sensation governs *both* these practices; but always in a semiconscious state. The point of Breton's stubborn quest lies in the general direction of metaphor: totally arbitrary, if it is "Surrealist," the image produces an effusion of the senses. But rethought as an analogy, and with a rising sign ("its mortal enemies are the depreciatory and the depressing"),[151] it tries to account for an order of things, whether in the present or in the future. Michel Deguy speaks eloquently of the "ascensional" sense of direction of this poetics which "does not erase differences."[152] And the "given" phrase—the one "knocking at the window," from which the automatic text takes off—is totally arbitrary, without sense or direction. But it is either accompanied by a faint mental image (a visual sensation), or used as a springboard to writing. The phrase "There is a man cut in two by the window" is accompanied by "the faint visual image of a man walking cut halfway up by a window perpendicular to the axis of the body."[153] Here Breton interrupts the experiment. In other cases, he gives himself to the exercise of automatic writing: but then language is perceived, in the process of writing, as a *res:* "the act of having written the first sentence entails a minimun of perception."[154] A nonsignifying object, language is nevertheless the boundary of a sensation, as if one were feeling its "germinative power."

The other answer to this question is the response of Leiris, Desnos and, most of all, Aragon.[155] This response consists in perceiving the "given" phrase as a kernel destined to disseminate in a more or less algebraic or rational way. (I use "algebraic" to evoke Desnos's play on words, "rational" to refer to the way Aragon develops the givens of the incipit in the short narratives of *Le libertinage*.) The arbitrariness of the written sign and the combinative power of language are the origin of a sort of intoxication. Similarly the game of pastiche, which the Surrealists returned to a place of honor, formerly redoubled the cultural pleasure of reading the pastiched writer. In Surrealism, the intention is to deny all culture by pastiching a given cultural work, and to deny a meaningful content by slipping into the realm of fantasy. In any case, creativity proves, through this medium, that it works primarily starting from *words*. As for the exercise of literary collage, particularly for Aragon, it establishes a metaphoric name between the "imaginary" (the narrative prose of the *Paysan de Paris*) and the sign of the

real (the "collage" of the menu at the café Certâ). Surrealist collage is really a semantic game of a metaphoric nature.

The movement thus goes from the signifier to the signified in both these responses. But in the first case the weight of the importance is placed on the signifieds—whose shifts in meaning and gaps, metonymic in form, are a source for invention; in the second case, the emphasis is on the signifiers— on their relative autonomy and on the games of metaphor.

Comparable problems confront us in the visual realm. In a first stage, suggested as a hypothesis and then adopted by majority rule in the group, the notion of the "internal model" prevails, clearly formulated by Breton in the early pages of *Le surréalisme et la peinture* (*La Révolution Surréaliste*, no. 4, July 1925):

> When I know what will be the outcome of *the terrible struggle within me between actual experience and possible experience*, when I have finally lost all hope of enlarging to huge proportions the hitherto strictly limited field of action of the campaigns I have initiated, *when my imagination recoils upon itself and serves only to coincide with my memory*, then I will willingly imitate the others and grant myself a few relative satisfactions. I shall then join the ranks of the embroiderers. . . . But not before! . . .
>
> Nonetheless, to make the magic power of figuration with which certain people are endowed serve the purpose of preserving and rein- forcing what would exist without them anyway is to make wretched use of that power. . . . In order to respond to the necessity, upon which all serious minds now agree, for a total revision of real values, the plastic work of art will either refer to a *purely internal model* or will cease to exist.[156]

It is because imagination is the queen of the faculties that the model for painting should be sought among human fantasies rather than the oddities of prettinesses of "nature." But Breton's peremptory tone can be explained less by the distance he takes from the Western figurative tradition that came out of the Renaissance than from a wish to mark a decisive break with the whole contemporary avant-garde coming out of Impressionism. The only artist to escape this general indictment and be cited in the *Manifesto* along with Uccello (d. 1475?), Gustave Moreau (d. 1898), and Gauguin (d. 1903) was Georges Seurat (d. 1891)—and this was for reasons connected to one of the revolutions in taste characteristic of Surrealism. Seurat is like the natu-

ralist writers praised in *Les vases communicants* for being so much more "poets" than the Symbolists, so much more sensual and *honest*, and for achieving, by their endless, supposedly exhaustive descriptions, "total imprecision."[157] Georges Seurat is admired by Breton for paradoxically inventing a completely subjective universe by dint of trying to be scientific. Then, among living artists, Breton praises Henri Matisse, André Derain, Georges Braque, Picasso, Marcel Duchamp, Francis Picabia, Giorgio de Chirico, Paul Klee, Man Ray, Max Ernst, and André Masson.

Hans Arp, Man Ray, Max Ernst, and André Masson, following Duchamp and Picabia, had in fact proposed pictorial solutions to the problem of representation—solutions that went conspicuously further than those of the Impressionists and Cubists. Duchamp, always immediately and inevitably followed by Picabia, had gradually abandoned the principle of "retinal" and "olfactory" painting (the painter conditioned to paint by the smell of turpentine) to devote himself to a kind of painting which started from words and wordplay. The large plate glass *La mariée mise à nu par ses célibataires, même* ("The Bride Stripped Bare by Her Bachelors, Even") was definitively "unfinished" in 1923. Max Ernst had already invented "collage," juxtaposing preexisting iconographic elements in a diversion of meaning "analogous to that of the poetic image."[158] Man Ray had sought for the trace left by the most everyday objects on a sensitive photographic surface ("rayograms"). André Masson and Miró had pursued graphic automatism deeply during the years 1923–24.

With the formula of "the purely internal model," Breton offered a theory (or a shibboleth) to a Surrealist painting still in search of itself at a time when Surrealist writing had already found its own: automatism.

This key phrase also settled a debate within the group. From Max Morise's "Les yeux enchantés" (*La Révolution surréaliste*, no. 1, December 1924), Breton took an insight he found accurate: "What automatic writing is to literature, a Surrealist plastic art should be to painting, photography, everything made to be seen." In doing this, Breton was taking sides against the narrowly Marxist attitude of Pierre Naville, who, in the same review (no. 3) refused to allow Surrealist "painting" any existence of its own: "It is clear that neither pencil marks made by random gestures, nor an image retracing the figures in dreams, nor imaginative fantasies can be so described."

The "internal model" became evident thanks to the use of various techniques. This could also be a collective phenomenon, as in certain seances of

automatic writing. Now, among creative techniques, the ones trying to give rise to graphic automatism are always relayed by a hallucinatory research which assumes what one could call the *graphic signifier* as a *signified*.[159] In a third stage, the signified itself is sometimes recovered in an ethical network: perceived as objective chance. For the painter, it would have a cognitive function (cognition of oneself, of one's own desire). In this three-step model which I propose, we may recognize the direction of Breton's poetic quest, as well as Aragon's.

These three moments can be seen in Max Ernst's description of the discovery of "frottage." He dates the birth of frottage very precisely: a rainy day, August 10, 1925; and we know that it was at Pornic. Frottage consists of placing sheets of paper at random on a rough wooden plank and rubbing them with soft lead pencil to bring out the rills and dents. Some say this is an old Chinese technique; it is certainly a popular technique. The "sudden intensification of [his] visionary faculties" is unleashed, Ernst remarked in 1936, in a "hallucinatory succession of contradictory images, superimposing themselves on each other, with the persistency and rapidity characteristic of memories of love." The same technique adapted to painting he called "grattage."[160] But Ernst soon made use of these forms "to decipher a message in the tangle of these lines produced by chance—as opposed to the whole generation of abstract expressionists, automatists, and other 'abstract artists' who invaded this planet the morning after World War II." (José Pierre, *L'univers surréaliste*). Ernst's *ethical* will is made very clear in the way Breton quotes him in *L'amour fou* when he suggests using Leonardo's wall "in order to read his own future."[161]

As for collage, also invented by Max Ernst on the banks of the Rhine on a rainy day in 1919, we know that it consists in "composing" or combining two or more heterogeneous elements, originally taken from an illustrated catalogue that pictured objects for anthropological, microscopic, psychological, mineralogical, and paleontological demonstration! Ernst distinguishes two methods for inventing a collage: the Rimbaud method ("a will straining —out of love for clairvoyance—toward systematic confusion or *disordering of all the senses*")[162] and the aleatory method. There is no doubt that extreme concentration of the will gives some of the same phantasmic effects as the extreme liberty of a mind given to random choice. The hallucinatory effect is guaranteed by systematic disorientation. Within a few pages, Ernst uses these words, "the sudden intensification of the visionary faculties," to describe the effect of the absurdity of assemblage itself. The ethical limits of

the venture can be seen in Breton's massive use of quotation, which connects his narration of the two kinds of "invention."

The procedure passes from the visual to the written realm, and from the individual to the collective, in the game of "Exquisite Corpse," invented in late 1925 among Marcel Duhamel, Jacques Prévert, and Yves Tanguy, a happy band settled at 54 rue du Château. In this game, five people assign themselves the part of speech they are to propose (noun, adjective, etc.) in order to compose a sentence: as we know, the first sentence they got was "The exquisite corpse will drink the new wine." But the procedure then came back to the visual realm with drawn "exquisite corpses," each participant responsible for drawing a part of the body on a paper folded in such a way that no one involved could see the contribution of any of the others. As early as 1923, we have seen, Aragon related this technique to the invention of the metaphorical image.

Finally, although it involves a hallucinatory method rather than a pictorial technique (in René Passeron's sense), the "paranoiac-critical activity" set forth by Dali in 1929–30[163] has a very precise place in this lineage of ways to arouse a certain *internal model*. Max Ernst thought that such activity was just a kind of frottage, but there are many differences between them. Paranoiac-critical activity does not have the first stage of receptive passivity characteristic of frottage; it starts with readymade forms, and even from a signified—such as a photograph of an African hut— from which the obsessive image arises: turned the long way, the photograph becomes a Cubist face. What characterizes Dali's procedure is that the pictorial or graphic signifier comes afterward to "objectify," in a critical and systematic way, delirious associations and interpretations (this is thus an inverse movement from the signified to the signifier). Moreover, the purpose is heuristic rather than ethical. It is a question of establishing the basis for an irrational cognition, insofar as the contagiousness of such deliria can be confirmed. Dali claims to know and to make others know, whereas Max Ernst was trying to divine the signs of his *own* desire.

Dali thus went through photographs of real objects to reach what Breton called the "internal model." The existence of Dali's painting, like Magritte's or Chirico's (pre-1926) painting, forced Breton to modify this keynote of his policy. He did so in 1935, in a lecture delivered in Prague, "Situation surréaliste de l'objet, Situation de l'objet surréaliste":

[Painting] confronts this inner representation with that of the concrete forms of the real world, seeks in turn, as it has done with Picasso, to seize the object in its generality, and as soon as it has succeeded in so doing, tries to take that supreme step which is the poetic step par excellence: excluding (relatively) the external object as such and considering nature only in its relationship with the inner world of consciousness.[164]

This involves an essential clarification, and the introduction of a dialectical mechanism which would play between the internal model and the sign of the object.[165] Chirico and Magritte put into question once again the external world as it is, but without denying it altogether; they even occasionally describe it, in some of its aspects. Magritte's reflections are in any case extremely intellectualist.[166]

The whole question of pictorial automatism remained open. The pursuit of theory was faced with a problem, confronted by the existence of a strange, dreamlike kind of "trompe-l'oeil" illusion painting as well as by a kind of automatic painting that could be called "action painting." Nicolas Calas indicated three possibilities in his 1942 *Confound the Wise*. The first would be the "poetic direction," represented by Dali and Chirico, reflecting a "psychological automatism" (?), the model for which is the dream. The second direction would reflect an "objective" automatism: Calas describes frottage and grattage, and the process leading through free association to the way consciousness brings a latent content to the surface, in a mechanism analogous to that of objective chance. The third possibility would take place *between* the two preceding ones: this would be a "physiological" automatism, in which one would be present at the free movement of one's arm or one's hand (Arp, Tanguy, and Miró would be its champions). While this classification is inadequate in its analysis of the first direction, and unconvincing as to the inclusion of Miró and Arp in the third, it is interesting because it served as a pretext for the way action painting in the 1940s and afterward, particularly American action painting, rushed along this path mapped out for it with the good conscience of feeling "Surrealist" (Marcel Duchamp, cultivating his own irony, would confirm this to anyone who asked) without actually being Surrealist: there was no ethics, no quest for knowledge on the horizon of these paintings. Within Europe, *Cobra* was willing to be on the

main track, not always as easy as it looks, where everyone refuses to give what is called an *interpretation*, thus rediscovering the aims of a more classical aesthetics. Before meeting Degottex, Breton took no interest in this third path, which he saw as hardly either automatic or Surrealist; his tendency was to connect the first of these possibilities, the odd trompe-l'oeil, to automatism by focusing his attention on the *interrelationships* going on among these well-painted objects. For example, he says in *Le surréalisme et la peinture*:

> Certainly Magritte's initial concern is to reproduce the objects, sites and living creatures which make up our everyday world in order to reconstitute its appearances for us with absolute fiedlity. But far beyond this, Magritte is concerned to make us *conscious of the latent life* of all these components by drawing attention to the constant *fluctuation of their interrelationships*. . . . To distend and, if necessary, violate these relationships of size, position, lighting, alternation, substance, mutual toleration and gradual development is to introduce us into the heart of a secondary figuration. . . .[167]

In any case, just as the exercise of automatic writing requires us to avoid all the "rubbings" of consciousness, proper concentration on the emerging phantasmic visual element takes place thanks to

> a real *insulation*, thanks to which the mind, on finding itself ideally withdrawn from everything, can begin to occupy itself with its own life, in which the attained and the desirable no longer exclude one another, and can thereupon attempt to submit to a permanent and rigorous censorship whatever has constrained it hitherto.[168]

In 1944, Breton had made a synthetic statement that works for writing as well as for painting: poetic thought is "the sworn enemy of patina. . . . To remain what it should be—the conductor of mental electricity—it absolutely has to charge itself up in an isolated setting."[169] Consciousness thus reappears, with its function of distinguishing and separating what belongs to the *anecdotal* circumstances surrounding writing (or the presentation of forms on a canvas); what belongs to the mood of the *moment*; what would belong to an aesthetic or moral *project*; what would belong, within automatic

writing, to the visual image itself ("disorganizing," as he calls it in *Le message automatique*).

This constraining isolation is analogous to the "forced conduit" into which the human hand channels the waterfall to produce electricity. It is a question of *energy*. The "energetic" model has full play in the Surrealist conception of the imaginary. As Breton said,

> Once again, the question here is the whole problem of the transformation of energy. To distrust, as people do out of all proportion, the practical virtue of imagination is to be willing to deprive oneself at any cost of the help of electricity, in the hope of bringing hydroelectric power back to its absurd waterfall consciousness.
> The imaginary is what tends to become real.[170]

And Crevel will pick up the image, adding to it the idea that violence is suited to constrain and explode the discoveries of the imagination:

> To use a movement is to capture it. Violence is the source of energy. It is the only thing that can be. The twentieth century—that electrician—has picked up the torrent sung by the nineteenth and pocketed it. . . . The imagination is a great dowser.[171]

Points of Reference in the Philosophical and Psychoanalytical Debate

The relationship of Surrealism to Freud and psychoanalysis is so problematic that we first reassemble the scattered notes we have made so far.

As Jean-Bertrand Pontalis has powerfully demonstrated, the central intuition of Breton, as of Aragon and their friends, seems to have been *to dream true*. Reality *uses* and *abuses* its power, in the face of our subjectivity, and only an *excess* of imagination can neutralize this iniquitous effect. We must "under all circumstances establish the prerogatives of the mind, of the *possible*, faced with the death-machinery which reality basically is."[172] And Pontalis reminds us of the important experience at Saint-Dizier, when the ten-year-old André Breton met a "madman" who believed war was a simulacrum (see *Point du jour; Entretiens*). Faced with *reality*, we have to give in to

a kind of crazy, precarious, obstinate illusion, and keep ourselves there, in that place of *noncontradiction*.

This will to synthesis leads to a refusal of any separation between thought and language, in the invention of "the spoken thought," automatic writing; to a refusal of a separation between determinism and liberty, thanks to objective chance; and to a refusal of the difference between perception and the imaginary, laying claim to the error of the senses.

I am not sure this means that we have to talk about Surrealist *monism*, as Gérard Durozoi and Bernard Lecherbonnier systematically do, drawing on a single sentence of Breton's. Although their interpretation might find some support in that Breton takes into consideration the evolution of energy physics, which seems to give "mind" and "matter" the same status, our impression is rather that Breton was following here in the footsteps of Pierre Mabille, whose more audacious, and doubtless rasher, formulations deliberately took the side of the "realists" in the quarrel of the Universals. Mabille summarized this quarrel in *Egrégores ou la vie des civilisations* (1938): if concepts, schemas, and abstract ideas "are more or less arbitrary instruments forged by the mind, thought will find itself isolated from the object." If concepts are "contained in sensations and then in the objects which have aroused these sensations, consciousness allows for the discovery of laws and mechanisms which really are—and are outside ourselves." Mabille chose the latter hypothesis, thanks to which, according to him, humanity participates in the world. Jean-Louis Bédouin also makes this choice unhesitatingly, and so did many of the last generation of Surrealists. But for Breton, what is essential is a practical position: it is a question of giving oneself the means "to *maintain in a dynamic state* the system of comparison, unlimited in scope, which is at humanity's disposal. . . ."[173] And this position does not contradict phenomenology as a method of investigation: taking into account the human reading, writing, etc., and examining what comes to consciousness from the point of view of consciousness itself. In the philosophical debate, and the trial of idealism frequently laid to Breton's charge, we should not forget the (dialectical) materialist positions he formulated between 1925 and World War II. But I hope that room will *also* be made for the underlying current which breaks out during this period from time to time, without antinomy: the current of absolute nominalism, understood in its operative, not idealist sense. Surrealist reflection deals with the power of invention starting from a system of arbitrary forms; in this, it goes along with the scientific epistemology of the early twentieth century, though perhaps in a rather cavalier way.

Now, we come back to the encounter of Surrealism with Freudian analysis and its conceptual grid. Jean-Bertrand Pontalis has pointed out how Breton's syncretic and totalizing aim is diametrically opposed to "the *analytic* goal of Freud, whose whole thinking is centered on the *irreconcilable*, on the infinite capacity for conflict he detects within the psyche."[174]

This opposition has struck all the critics, to the point where the severity of nonpsychoanalysts toward Breton sometimes comes close to bad temper.[175] In the first place, we should say that no dialogue was possible between the Surrealists and Freud, and especially between Breton and Freud. Breton visited the Master in 1921: the sarcastic account of it he gave in *Littérature* (March 1922; reprinted in *Les pas perdus*) speaks his disappointment. The interview was not fruitful. In the *Manifesto*, in *Nadja*, in Aragon's *Traité du style*, in René Crevel's psychoanalysis by Dr. René Allendy, incidental remarks show interest but greater reservations. When Breton and Aragon celebrated the fiftieth anniversary of hysteria (*La Révolution Surréaliste*, no. 11, 1928) by making it a "supreme means of expression," they were thumbing their noses at Freud, whose theory came out of the attention he and Breuer paid to Anna O., and whose whole aim is therapeutic. For Breton and Aragon, hysteria is just one of many means of emancipation. In *Les vases communicants*, Breton takes a critical attitude toward the Freudian theory of the unconscious (unknown and unknowable) and also needles Freud about the analysis of his own dreams or—even worse—the omission of a German theoretician, Volkelt, in his bibliography. The resulting exchange of letters was published in the second edition of the book. As for Freud, while claiming that the Surrealists considered him their "patron saint," he considered them "absolutely mad"—"let's say 95 percent, like absolute alcohol" (letter to Stefan Zweig). But Breton's irritation masked a steady theoretical interest and personal respect. In March 1938, when Freud was "under observation" in Vienna, Breton added a protest to the proofs of the issue of *Cahiers GLM* ("Trajectoire du rêve") for which he was responsible, and if he "responds to" Freud in 1953 (see the questionnaire in *Médium*), it is with "profound deference."

As we know, Breton became acquainted with Freud's theories through Régis and Hesnard's book, *La psychoanalyse* (Alcan, 1914). Not enough attention, however, has been paid to the fact that Freud went on to develop secondary topics during the 1920s; Surrealism could not have accounted for or referred to Freudian theory as a body of clearly elucidated concepts.

All the same, as we have said, these are very different projects. The

Surrealist book closest to Freud, *Les vases communicants*, is certainly not Freudian. In the self-analysis to which Breton abandons himself in the first portion of the book, he takes into account only what Freud calls the "day's residues"—anchor points of a desire which remains unconscious. Self-analysis is "unsound." In automatic writing, once we admit that this Surrealist suggestion changed our collective sensibility historically and radically, we may well ask, as Pontalis does, whether "Surrealist techniques are capable of producing anything except a studied mimesis of an unconscious that is already representable and already put into words." At any rate, these techniques are close to the hypnosis Freud abandoned. In other words, the "unconscious," for Breton, is something like unconsciousness. Where Freud is trying to unveil the mechanisms of the unconscious to bring the actions of the analysand into harmony with the world as it is, Breton solicits the powers of our unconsciousness to reach a surreality.

The second major difference between Breton and Freud has to do with the concept of repression and the energy model used to construct the personality. Breton does not speak of the *process* of repression, but of *prohibitions* and *taboos;* he obscures the obliquities and reappearances of the mechanism. On the other hand, he always and immediately talks about action. Freudian research—descriptive, rationalizing, scientific—involves a slow interrogation about the primitive and the unconscious; Breton quickly turns this into a teleological perspective, into an indication of a plan for life, into a way of imagining his field for maneuvering. For example, Breton believes that the dream is the intermediary thanks to which one can *convert* the imagined "to the lived, or, more exactly, to what-ought-to-be-lived." Every impulse would be ultimately usable, by the direct conversion of energy, as the compulsion to live and to create. In this sense Breton really seems to find in psychoanalysis "less a scientific discovery than the pursuit of a philosophical and literary tradition which gives the faculty of imagination its full value."[176]

Finally, this opposition to Freud is focused on the relationship of the individual to society. In the energy and power to rebel aroused by impulse, Surrealism thinks it detects the mechanism of an avalanche: ultimately, a revolution. But for Freud, it seems as if all society is and will always be repressive, and that the end of the analytic cure is not disillusion, perhaps, but cynicism. The goal of the cure is to allow the patient to do better at *assuming* the world.

Breton's prudent attitude is justified in the long run by the inadequacy or difficulty of Freudian theory in dealing with sublimation and artistic crea-

tion. But like Breton, Freud is concerned with what certainly seems to be a *nexus* of the work of "sublimation" (a word Breton does not use): the point at which a partial impulse, destructive or self-destructive, changes into something like a compulsion to synthesize. As Freud said in *The Ego and the Id* (1923): "The forces utilizable for cultural work come largely from the repression of what we call the perverse elements of sexual arousal." In the *Second Manifesto*, speaking about the "short circuit" of the image and of the sovereign game of inspiration, Breton says explicitly:

> Surrealism . . . believes, and it will never believe in anything more wholeheartedly, in reproducing artificially this ideal moment when man, in the grips of a particular emotion, is suddenly seized by this something "stronger than himself" which projects him, in self-defense, into immortality.[177]

If the vocabulary is very different, the idea is closer than it may appear.

In any case, whereas psychoanalysis devotes us to metaphor (to the work of the psyche, the work of dream, the work of writing—that is, to a work of mourning), Surrealism, fascinated by the same work, leads us from metaphor (which is loss) to metonymy (which is connection). Here we should consider automatic writing as it is practiced by Breton; Aragon's novellas in *Libertinage*; *Fresh Widow*, an object constructed by Marcel Duchamp. Whatever the "versions" of Surrealism, whether emphasis is placed on metaphor or on metonymy, the direction is always the same: Surrealism tends to lead us to keep on searching better and better, to keep believing in finding the "lost object."

5

Conclusion:
Works of Art or Glacial Moraines?

Anyone who sees the degree to which the Surrealist "imaginary" remains the point of resource for all poetic activity (in the widest sense, without worrying about mode of expression or genre)—the yardstick by which everything is measured—would have reservations about devoting a few pages to a survey of the results. Such a survey could only deprive a work of its intentionality. A critique of the Surrealist spirit should avoid such reductiveness: the circumstances of a work should be carefully examined, and its intention evaluated on the ethical or political level as well as the aesthetic. Projections of a complex intentionality, objects of provocation, models fabricated for "understanding," these "works" are like moraines, glacial deposits that are relics of the passing of a great glacial adventure, faceted like crystal; they are the densest névé of the glacier, now partly volatilized into granular

snow. This is the case of the Surrealist exhibitions whose openings and installations have now become historic events, the traces of which we must hunt for.

Our critical reading would thus, if it could, model itself on that of the Surrealists:

> a criticism founded first on the deep feeling of the superiority of poetic language over even the most rigorous metalanguage . . . , a criticism which therefore tries to be an invitation to the pleasure of the text it is speaking about.[1]

As for Aragon's so-called "synthetic" criticism in *Sic* (1918–19), and Soupault's on the cinema in *Littérature*, we can say that they constitute prose poems or pastiches using metaphorical allusion, lyrical praise, and coded reservations. These are borderline cases. We recall Breton's suggestion: first of all, to love.[2] Every critical relationship which is not inaugurated, guaranteed, stimulated by such a global and intuitive seizure of the work, provoked by desire, is condemned to impotence or blindness.[3] Let us add, as does Roger Navarri, that this experience of aesthetic enjoyment is described and rigorously taken into consideration by the recent work of H. R. Jauss and the Konstanz school.

It is easy to make fun of the excesses of this criticism, as apologetics. Surrealism did not reject patience and scholarship, which respond to a different desire: to understand and to analyze. Examples might include Jean Ferry's critical devotion to the work of Raymond Roussel;[4] the work on Sade done by Maurice Heine and Gilbert Lely;[5] Breton's suggestion to Jean Suquet, to concentrate on the mirror-bright intricacy of Marcel Duchamp's *Grand verre*—and Suquet himself, working on this for thirty years, the best contemporary connaisseur of this work. These critiques are no less scientific for being devoted. In the name of an "open rationalism" ("limites non-frontières"), the Surrealists "set themselves apart from all theories and practices tending openly or surreptitiously to restore a theological conception of Art, which condemns the critic to subjectivism or to paraphrase."[6]

In any case, critics of Surrealism, misunderstandings apart, have often chosen to follow the search for intentionality without therefore refusing to analyze the space of a text or a canvas: neither to cut the intentional roots of the author, in a healthy phenomenology, nor to refuse the movement of our

phantasmic projection over these (often wild) texts, but perhaps not to be satisfied with it either; and on the other hand, not to keep on referring to the circumstances surrounding a production nor to *invoke*—by interpreting it—the intentionality founding it. In its widest sense, history must always be a rampart, though this rampart may be implicit. Criticism on Surrealism seems to me to be in its early stages: it is beginning to offer reliable documentation and to forge adequate conceptual tools. And while methodology of the study may be complex, it is neither inaccessible nor indefinable.

Surrealist works might be classified according to their mode of expression: on one hand, controllable historical acts and events which leave sociological traces (the visit to Saint-Julien-le-Pauvre, the Saint-Pol Roux banquet, activities of successive Surrealist groups, openings of exhibitions, and even Jean Benoît's celebration of Sade); on the other hand, written works, painted works, cinematographic works, whose intention is to some degree aesthetic.

Examples of the group's expressing itself in actions or events are the Surrealists' internal notes, lists of private conferences or talks, and especially the opening of exhibitions. We know that Surrealism constructed its history with international exhibitions since, after the "Eros" exhibition in 1959, labeled 8, they all bore a number (the last being 11, "L'écart absolu," 1965, in Paris). This numeration implies a glance backward and creates a direction and meaning to come: among all known exhibitions, those which mark this international circuit. (See the bibliography.) But "openings" became more and more ritualized, to the point of confusion with a unique theatrical event, as in the case of the exhibition "Eros" in 1960 (the banquet on the nude mannequin, etc.), coupled with the (private) ritual of Benoît's celebration of Sade. And the catalogues became increasingly copious with the years. In 1938, there was Breton and Eluard's "abridged" *Dictionnaire abrégé du surréalisme;* by 1947, a big volume accompanied the international exhibition *Le surréalisme en 1947,* responding to the collective interrogation about myth. This happened because exhibitions became, along with tracts and reviews, a collective echo to the call of events, and an occasion for the group to define itself.

But it would still be necessary to account for a Surrealist work by specifying the primary nature of the message sent: a referential function, "denotative," "cognitive" in narrations of dreams, autobiographical texts, replies to questionnaires, explanatory myths or models invented in order to

understand. There is a conative function in pamphlet texts (but the "theoretical" work responds also to these two functions, as we see in Pierre Mabille's *Thérèse de Lisieux*); a metalinguistic function (abundant); a poetic function.

Within this poetic function, the fundamental dichotomy of signs and objects seems to me to lay the foundations for Surrealism's doubly inventive quest. Our reading must account for this.[7] There is the quest that first intoxicates itself with plays on signifiers, perceived in their relative autonomy, and sometimes as arbitrary; there is the quest that concentrates primarily on places—conjunctions of space and the body—in which things (the signs of things) seem to begin to shift. Here, more often than is generally thought, reading must conceive of texts as symbolic. This is the case for the text *Il y aura une fois* (*Le SASDLR*, no. 1): a programmatic text, each line of which is explicable. It would be a mistake to try to find automatic writing in such a text.

Finally, we should probably add to this two-termed system the obverse, marginal to Surrealism: the belief that language is *not* at the origin of all invention, that even the body is an ideogram to be deciphered, and that the word arises only secondarily. Here I am thinking of Artaud, Hans Bellmer, and their posterity, who can be seen even in the "panic" theater of Arrabal, Topor, and Jodorowski.

Surrealism from an International Viewpoint

There remains the whole question of the spread of Surrealism beyond France, and its "encounter" with various avant-gardes. As opposed to Dadaism, which was born more or less simultaneously in several epicenters (New York, Zurich, Berlin, Cologne), Surrealism is a Parisian invention, even if Breton always made claims for its internationalism.

We have noticed in the course of our historical survey that although Surrealist-inspired groups and endeavors already existed in the 1920s in Belgium and Yugoslavia, it was during the 1930s that the Surrealist movement really exploded outside France in an undefined, sometimes widely scattered burst. Despite a certain slackening during the 1940s and even 1950s, there are hardly any countries in which some sort of group laying claim to Surrealism has not arisen. It is interesting to find painters and poets themselves insisting on establishing their own membership in Surrealism,

conceived as the entirety of the projects formulated by the reviews or texts of the group founded by Breton, in which the notions of "objective chance," the practice of automatic writing and collage, the life of the group are the crucial points of any definition. Bretonian "colonialism" is therefore not an adequate explanation; we must believe that Surrealism had a special place within the various international avant-gardes, perhaps because of its original way of considering the works of the past, and its attention to *desire*.

Should we be trying to find the diffusion pattern of Surrealism, its influence, the sometimes reciprocal ways it was influenced? Establish a series of theoretical requirements (without which there would be no Surrealism) and see if a given country embodies them at a specific moment? Assimilate Surrealism with all forms of subversion and pose the hypothesis of its "spontaneous" uprising? In the current state of Surrealist studies, only certain realms have been mapped out, sometimes in rich detail: I am thinking of the studies in French by José Vovelle on Belgian surrealism; on Portuguese and Spanish, by Pierre Rivas; on Serbian, by Hanifa Kapidzic-Osmánagic. We are still awaiting the work of Vera Linhartova on Surrealism in Japan, though there Yoshio Abé and Françoise Will have already shed some light. Here, in a word, is the front line of collective knowledge: future work will report its progress.[8]

Notes

NOTE: The place of publication is Paris, unless otherwise noted.

Chapter 1. Prohibition and Meaning

1. Michel Foucault, "The Discourse on Language," tr. Rupert Swyer, *Social Science Information* (April 1971), reprinted in *The Archaeology of Knowledge and the Discourse on Language*, ed. A. M. Sheridan Smith (New York: Pantheon, 1972), p. 216.
2. *Ibid.*, pp. 218–19.
3. André Breton, *Second manifeste du surréalisme*, tr. as *Second Manifesto of Surrealism* by Richard Seaver and Helen R. Lane in *Manifestoes of Surrealism* (Ann Arbor:

University of Michigan Press, 1969), p. 125. Tr. note: André Breton (1896–1966) was a founder of the Surrealist movement, influential through his theoretical *Manifestoes*, his poetry, his fiction, his criticism, and his personal influence in the formation of the Surrealist group. His many works include *Clair de Terre* (1923), *Poisson soluble*, (1924), *Nadja* (1928), and *L'amour fou* (1937).

4. Breton, "Il y aura une fois," *Le Surréalisme au Service de la Révolution* (July 1930), no. 1. This review will henceforth be called *Le Surréalisme ASDLR*. The text quoted is reprinted in *Clair de terre* (1966), p. 100.

5. Jean Starobinski, "Remarques sur l'histoire du concept d'imagination," *Cahiers Internationaux de Symbolisme* (1966), no. 11, p. 23.

6. Tr. note: Marcel Duchamp (1887–1968) was the creator of "readymades," presentations of manufactured objects found by the artist (*Bicycle Wheel*, 1913) and "optical machines" (a glass panel "To be looked at with one eye for almost an hour," 1918). He worked for some years on his *Large Glass: The Bride Stripped Bare by Her Bachelors, Even*, 1915–23 (see chapter 4, note 159). His punning pseudonym 'Rrose Sélavy" became part of the Surrealist repertoire (see chapter 3, note 78).

7. Pierre Naville, *Le temps du surréel* (Galilée, 1977), vol. 1, p. 135.

8. Tr. note: Georges Bataille (1897–1962) remained close to the Surrealists despite his differences with Breton. His writings included erotic tales *(Madame Edwarda, Ma mère)* and *L'érotisme*. André Masson, a member of the review *La Révolution Surréaliste*, was one of the first artists to work in a state of automatic trance, creating automatic drawings, sand paintings, and, later, "paroxysm paintings." Hans Bellmer constructed several incarnations of his erotic dream-object *Doll*, photographs of which appeared in *Minotaure* (1935) as *Variations on the Assembling of an Articulated Minor*. His later work continued to elaborate on the theme of remaking women's bodies.

9. Tr. note: The poet Robert Desnos (1900–1945) was involved with Breton in the trances described in the first *Manifesto*. Paul Eluard (born Eugene Grindel, 1895–1952) was a leader of the Surrealist movement, perhaps best known for his love poetry (*Capitale de la douleur*, 1926; *L'amour, La poésie*, 1929). He and Breton wrote *L'Immaculée Conception* together. Benjamin Péret (1899–1959) was one of the earliest practitioners of automatic writing and a close friend of Breton's. In addition to his collections of Surrealist poetry (*Le grand jeu*, 1928; *De derrière les fagots*, 1934), he published an anthology of myths and legends from America (1959). His best-known novel is *La brebis galante*. Julien Gracq wrote prose poems (*Liberté grande*, 1947), as well as the Surrealist novel *Au château d'Argol* (1938) and *Le rivage des Syrtes*.

10. Julien Gracq, *André Breton, quelques aspects de l'écrivain* (Corti, 1948), p. 34.

11. Michel Leiris, *Miroir de la tauromachie* (1938; reprinted Fata Morgana, 1981), p. 65. Tr. note: Leiris wrote poetry (*Haut mal*, 1943) as well as accounts of dreams (*Aurora*, 1946).

12. Frances Ponge, *Le grand recueil* (1961), vol. 2, p. 293. This is a conversation among Ponge, Pierre Reverdy, and Breton.

13. TR. NOTE: *Septembriseur* = September-breaker. Here, a radical; originally, an instigator of the September massacres of the French Revolution, 1972.

14. TR. NOTE: Antonin Artaud (1896–1948) directed the Bureau of Surrealist Inquiries (1925) before breaking with the group. He is best known for his work in the theater.

2. A Promethean and Totalizing Enterprise

1. Breton, "Preface for a Reprint of the *Manifesto*" (1929), in *Manifestoes of Surrealism*, p. x.

2. Breton, *Second Manifesto of Surrealism*, in *Manifestoes*, p. 129.

3. *La Révolution Surréaliste* (1929), no. 12, p. 76.

4. Breton, *Entretiens* (1952; reprinted Gallimard, 1969), p. 218. Breton wrote: "In France, for instance, the mind was then threatened by stagnation, whereas today [in the 1950s] it is threatened by disintegration."

5. Jean-Louis Bédouin, *Vingt ans de surréalisme* (Denoël, 1961), pp. 8–9.

6. Breton, "Speech to the Congress of Writers," *Position politique du surréalisme*, in *Manifestoes*, p. 219.

7. TR. NOTE: The artist Jacques Vaché (1886–1919) met Breton in a military hospital in 1916 and influenced his interest in black humor. According to Breton, his *Typewriter-Octopus* (1917) and other works "were evidently intended to start a family of various mechanical monsters." *Le surréalisme et la peinture* (Gallimard, 1965), tr. by Simon Watson Taylor as *Surrealism and Painting* (New York: Harper and Row, 1965), p. 191.

8. TR. NOTE: Saint-Pol Roux was a Symbolist poet whose work appealed to the Surrealists. In 1925 they held a banquet in his honor at the Closerie des Lilas during which fruit was thrown, the Surrealist Philippe Soupault swung from the chandelier, and various pro-German statements were made; a near-riot ensued.

9. Julien Gracq, "Pourquoi la littérature respire mal" (1960), reprinted in *Préférences* (Corti, 1961), p. 75. See also Philippe Audoin, "Nouvelle histoire de l'oeil ou le merveilleux préféré," *La Brèche* (October 1963), no. 5.

10. Breton, *Manifestoes*, pp. 26–27.

11. On Breton's "ideal library," see Pierre-Olivier Walzer, "Une bibliothèque idéal," in the collection *André Breton* (Neuchâtel: La Baconnière, 1970), pp. 81–93, and François Chapon, "La bibliothèque littéraire de Jacques Doucet," *Bulletin du Bibliophile* (1980), vol. 1, esp. pp. 68–81.

12. Paul Eluard, "D.-A.-F. de Sade, écrivain fantastique et révolutionnaire," *La Révolution Surréaliste* (December 1926), no. 8.

13. Robert Desnos, "De l'érotisme considéré dans ses manifestations écrites et du point de vue de l'esprit moderne" (1923), *Nouvelles Hébrides* (Gallimard, 1978), p. 134. On Surrealist readings of Sade, see J. Chénieux-Gendron, *Le surréalisme et le roman, 1922–50* (Lausanne; L'Age d'homme, 1983), pp. 110–11.

14. Breton, *L'amour fou* (1937); tr. by Mary Ann Caws as *Mad Love* (Lincoln: University of Nebraska Press, 1987), p. 94.

15. Breton, *Entretiens*, p.22.

16. Breton, "Avis au lecteur" (1929), *Point du jour* (reprinted Gallimard, 1970), p. 61. See also Breton's *Limites non frontières* . . . , *La clé des champs* (Le Sagittaire, 1953); "Situation de *Melmoth*," *Perspective cavalière* (Gallimard, 1970).

17. José Pierre, *L'univers surréaliste* (Somogy, 1983).

18. Breton, "Introduction aux *Contes bizarres*" (1933), in *Point du jour*.

19. For all these references to Surrealist admiration of painting, see José Pierre, *L'univers surréaliste*.

20. See Marc Eigeldinger, "André Breton révélateur de Germain Nouveau," *Studi Francesi* (Turin) (January–April 1981), no. 73.

21. Breton, "Le merveilleux contre le mystère" (1936), *Minotaure; La clé des champs*, p. 11.

22. TR. NOTE: Marcel Schwob (1867–1905) was a Symbolist writer whose *Le livre de Monelle* (1894) recounts disturbing fantasies.

23. TR. NOTE: Yves Tanguy (1900–1955), practices automatic drawing: his dreamlike landscapes characteristically involve ethereal "non-derivative object-beings," in Breton's phrase (*Surrealism and Painting*, p. 71). See *Four o'Clock in the Summer, Hope* (1929).

24. Breton, "Interview" (1950), *Entretiens* (1969, ed.), pp. 282, 285.

25. Kubin's *Die andere Seite*, published in France as *L'autre côté*, was translated by Denver Lindley as *The Other Side: A Fantastic Novel* (New York: Crown, 1967).

26. Aragon, "Pourquoi écrivez-vous ou le péril noir," a 1923 article incorporated in the 1924 preface to *Libertinage* (Gallimard, 1977), p. 278. TR. NOTE: Louis Aragon (1897–1982), an early member of the Surrealist movement, wrote theoretical works (*Traité du style*, 1928) fiction (*Le paysan de Paris*, 1926), and poetry (*Feu de joie*, 1920; *Mouvement perpétual*, 1926) before breaking with the group for political reasons.

27. Breton, *Manifestoes*, p. 27. TR. NOTE: Valéry's M. Teste prefers contemplating abstract possibilities to the imperfection of action. "Teste" means head, thus brain (*La soirée avec Monsieur Teste*, 1896).

28. Breton, "Flagrant délit" (1953), *La clé des champs*. See Louis Forestier, "Rimbaud et l'ambivalence," in *Etudes sur les "Poésies" de Rimbaud* (Neuchâtel: Baconnière-Payot, 1980).

29. André Masson, *Chefs-d'oeuvre du Musée de L'Homme* (Musée de l'Homme, 1965).

30. TR. NOTE: The poet and novelist Philippe Soupault was one of the founders of the Surrealist movement. He collaborated with Breton in writing *Les champs magnétiques* (1919). The American-born Man Ray began as a painter but is best known as a photographer and creator of Surrealist objects. In addition to his Surrealist camera photographs he created "rayograms," placing objects on light-sensitive plates. He also created objects in the "readymade" tradition, such as the nail-studded iron, *Cadeau* (1921). He worked on several films, including *Etoile de mer* (1928).

31. Breton, "Océanie" (1948), reprinted in *Poésie et autre* (1960), p. 281.

32. Breton, "Main première," *Perspective cavalière* (1970), pp. 221–25.

33. Breton, "Océanie" (1948), *Poésie et autre* (1960), p. 281.

34. Translated as "On Surrealism in Its Living Works" (1953), in *Manifestoes*, p. 298.

35. Jean Laude, *La peinture française, de 1905 à 1914, et l'art nègre* (Klincksieck, 1968), p. 2.

36. TR. NOTE: Leonora Carrington did paintings in which some have seen a Gothic influence (*At the Inn of the Dawn Horse*, 1942) and was also a writer of short stories ("The Oval Lady," 1939). Kurt Seligmann (1901–1962) was a painter and inventor of lithochronism, "fourth-dimensional" Surrealist objects.

37. *La Gazette des Beaux Arts* (New York) (September 1943), vol. 24, p. 175.

38. Breton, "Présent des Gaules" (1955), reprinted in *Le surréalisme et la peinture; Surrealism and Painting*, p. 335.

39. José Pierre, *L'univers surréaliste* (Somogy, 1983).

40. Frederic William Henry Myers, *Human Personality and Its Survival of Bodily Death* (London, 1904). [Translated into French as *La personnalité humaine, sa survivance, ses manifestations supranormales*, tr. Jankélévitch (Paris: Alcan, 1906).

41. Breton, "Le surréalisme et la tradition" (1956), *Perspective cavaliere*. TR. NOTE: *bâillon:* literally gag, muzzle.

42. Hans Jonas, *The Gnostic Religion: The Message of the Alien God and the Beginning of Christianity*, 2d ed., rev. (Boston: Beacon Press, 1970), p. 46.

43. Jules Monnerot, *La poésie moderne et le sacré* (Gallimard, 1945), p. 92.

44. TR. NOTE: This expression comes from *L'amour fou* (*Mad Love*, p. 8).

45. Breton, "Main première" (1962), *Perspective cavalière*, p. 44.

46. TR. NOTE: *bricolage:* making things out of whatever comes to hand. According to Lévi-Strauss himself, "The characteristic feature of mythical thought is that it expresses itself by means of a heterogeneous repertoire which, even if extensive, is nevertheless limited. It has to use this repertoire, . . . because it has nothing else at its disposal. Mythical thought is therefore a kind of intellectual 'bricolage.' . . ." *The Savage Mind*, 3d ed. (Chicago: University of Chicago Press, 1968), p. 17.

47. Breton, "Sur l'art magique" (1957), in *Perspective cavalière*, p. 144.

48. Benjamin Péret, "La parole est à Péret" (1942), reprinted in the introduction to *Anthologie des mythes, légendes et contes populaires d'Amérique* (Albin Michel, 1960), p. 23.

49. Breton, "Sur l'art magique" (1957), *Perspective cavalière*, p. 141.

50. Breton, *Arcane 17* (1944; reprinted UGE, 1965), p. 105. Author's emphasis.

3. *History of the Movement and Its Progressive Theorization*

1. TR. NOTE: Translated by David Gascoyne as *The Magnetic Fields*, 3d ed., rev. (London: Atlas, 1985).

2. Breton, *Entretiens* (1913–52), p. 218. Author's emphasis.

3. *Ibid.*

4. *Ibid.* p. 219.

5. For Breton, see note 3, chapter 1.

6. For Soupault, see note 30, chapter 2.

7. For Aragon, see note 26, chapter 2. TR. NOTE: "Rature" means "erasure," or "crossing out."

8. For Eluard, see note 9, Chapter 1.

9. TR. NOTE: Tristan Tzara (Sami Rosenstock, 1896–1963) wrote *Sept Manifestes Dada* (1924) as well as *L'homme approximatif*, an example of automatic writing.

10. TR. NOTE: Hans or Jean Arp (1887–1966) created collages (*Fatagaga*, with Max Ernst, 1920: "Fabrication of tableaux guaranteed to be gasometric"), *papiers déchirés* ("torn" papers, 1930), and sculptures. He also wrote poetry (*Le siège de l'air*, 1946; *Jours effeuillés*, 1966).

11. TR. NOTE: Francis Picabia (1878–1953) painted "orphic" images of women, created early examples of "mechanicist" art (*Child Carburetor*, 1917), and wrote (*Poésie ron-ron*, 1919; *Thalassa dans le désert*, 1945). He once tried to create a work of art involving a live monkey.

12. TR. NOTE: Georges Ribemont-Dessaignes (1884–1974) was an editor of the review *Bifur* and wrote *L'autruche aux yeux clos* (1924).

13. For a detailed account of this, see Michel Sanouillet, *Dada à Paris* (Pauvert, 1965; 2d ed., Université de Nice, 1980).

14. Breton, "Pour Dada," *La NRF* (August 1920), reprinted in *Les pas perdus* (Gallimard, 1979).

15. *Ibid.*

16. Tristan Tzara, "Lettre anonyme à Mme et M. Dada," *391* (March 1920), no. 12.

17. This text was written at the same time as the beginning of the "Cabaret Voltaire" (1916). It supposedly intends to "illuminate the breaking point between the

person Rimbaud was and the person he is about to become" (according to Henri Pastoureau, "Des influences dans la poésie présurréaliste d'André Breton," *André Breton*, ed. Marc Eigeldinger (Neuchâtel: Baconnière, 1970). For the divergence between the projects of Tzara and Breton, see José Pierre, "Le lyrisme exalté ou refusé: Breton et les dadaistes zürichois," *Bulletin de liaison du CAS* (June 1982), no. 16, and Pierre Prigioni, "Dada et surréalisme," *Le surréalisme* (Mouton, 1968).

18. Quoted by Marguerite Bonnet, *André Breton . . .* (Corti, 1975).

19. Aragon, Preface to *Libertinage* (1923; 1977 ed.), p. 276.

20. Bonnet, *André Breton . . .* , p. 267.

21. Aragon, *Je n'ai jamais appris à écrire ou les "incipit"* (Skira, 1969), p. 21.

22. TR. NOTE: René Crevel (1900–1935) wrote pamphlets and novels (*Babylon*, 1927). Roger Vitrac (1899–1952) wrote plays (*Victor ou Les enfants au pouvoir* (1928). Jacques Baron wrote poetry as well as his memoirs of the group, *L'an I du surréalisme* (1969). Georges Limbour (1900–1970) wrote poetry (*Soleils bas*, 1924) and fiction (*L'illustre cheval blanc*, 1930).

23. TR. NOTE: Pierre Naville, coeditor (with Péret) of *La Révolution Surréaliste*, was soon to challenge the Surrealists by posing the problem of the role of intellectuals in revolution: "What can Surrealists do?" (*La révolution et les intellectuels; Que peuvent faire les surréalistes?* 1926).

24. TR. NOTE: *Poisson soluble* has been translated as *Soluble Fish* in the Seaver-Lane edition of the *Manifestoes* (Ann Arbor: University of Michigan Press, 1969).

25. TR. NOTE: *Légitime défense* (1926) has been translated as "Legitimate Defense" by Richard Howard and is included in his translation of Maurice Nadeau's *The History of Surrealism* (London: Jonathan Cape, 1968).

26. TR. NOTE: The painter and sculptor Salvador Dali (b. 1904) creator of *The Persistence of Memory* (1931) and *The Ghost of Vermeer Which Can Be Used as a Table* (1934), developed his theory of "paranoiac-critical activity" as an attempt to use in artistic creation what had been learned from interpreting clinical paranoia. His "double image" technique can be seen in *The Metamorphosis of Narcissus* (1937). He also collaborated with Buñuel on *Un chien andalou* (1928).

27. TR. NOTE: *Le surréalisme et la peinture* has been translated by Simon Watson Taylor as *Surrealism and Painting* (New York: Harper and Row, 1965); this volume also includes "Artistic Genesis and Perspective of Surrealism" (1941) and various later essays on art by Breton.

28. TR. NOTE: René Char published several collections of poetry (*Arsenal*, 1929; *Artine*, 1930; *Le marteau sans maître*, 1934) while associated with the Surrealist movement.

29. Breton, *Manifestoes*, p. 123.

30. See the discriminating presentation of Pierre Daix, *Aragon, une vie à changer* (Seuil, 1975), pp. 255–64. The indictment of Aragon for the publication of the poem *Front rouge* ("Feu sur Léon Blum . . .") and Breton's defense of him in *Misère de la*

poésie are only a secondary aspect of this break, although Breton's text remains important for the definition of Surrealist aesthetics. The tracts *Certificat* (signed by Eluard) and *Paillasse* (a collaboration) were issued against Aragon's disavowal of Breton, published in *L'Humanité.* ·

31. Breton, *Manifestoes*, p. 23.
32. Breton, *Entretiens*, with André Parinaud, p. 81.
33. Aragon, *Je n'ai jamais appris à écrire ou les "incipit,"* p. 38.
34. Breton, "Le message automatique" (1933), *Point du jour* (1970), p. 185.
35. Breton, *Manifestoes*, p. 30.
36. *Ibid.*, p. 23.
37. *Ibid.*, p. 26.
38. *Ibid.*, p. 23.
39. *Ibid.*, p. 30.
40. *Ibid.*, p. 23.
41. Aragon, *Traité du style* (Gallimard, 1928; reprinted 1980), pp. 187, 192.
42. *Ibid.*, p. 187. Author's emphasis.
43. Robert Bréchon, *Le surréalisme* (Armand Colin, 1971), p. 34.
44. Quoted by Marguerite Bonnet, *André Breton*, p. 104.
45. Jean Starobinski, "Freud, Breton, Myers," *L'Arc* (1964), no. 34, reprinted in *La relation critique* (Gallimard, 1970).
46. François Will-Levaillant, "Signes de l'automatisme graphique: psycho-pathologie ou surréalisme?" *Psychologie médicale* (1981), vol. 13, no. 9.
47. Quoted in *ibid.*
48. Claude Abastado, *Le surréalisme* (Hachette, 1975), e.g. pp. 128–29.
49. I am using here the terms P. Vignaux uses in his various inquiries into nominalism.
50. Jean Largeault, *Enquête sur le nominalisme* (Paris and Louvain: B. Nauvelaerts, 1971), p. 426.
51. *Manifestoes*, p. 30.
52. Aragon, *Traité du style*, p. 190.
53. Aragon, *Je n'ai jamais appris à écrire ou les "incipit,"* p. 39.
54. Aragon, *Les communistes*, postface to *Le cycle du monde réel* (1966).
55. Breton, "Les chants de Maldoror," reprinted in *Les pas perdus*, p. 69.
56. Breton, "Réponse à une enquête," reprinted in *Les pas perdus*, p. 116.
57. Aragon, "L'homme coupé en deux," *Les lettres françaises*, May 9–15, 1968.
58. Bonnet, *André Breton . . .* , p. 193.
59. Michel Riffaterre, "Incompatibilités sémantiques dans l'écriture automatique," *La production du texte* (Seuil, 1979); tr. as *Text Production* by Terese Lyons (New York: Columbia University Press, 1985).
60. *Soluble Fish*, text 16, p. 75.

61. Aragon, *Le paysan de Paris* (1926; reprinted Gallimard, Livre de poche, 1966), p. 83. This quotation dates from 1924.

62. *Manifestoes*, p. 36.

63. *Ibid.*, p. 37.

64. TR. NOTE: Pierre Reverdy founded the review *Nord-Sud* and wrote poetry (*Les épaves du ciel*, 1924; *Flaques de verre*, 1929).

65. TR. NOTE: All this quotation from Reverdy except the last sentence is quoted by Breton in the first *Manifesto* (*Manifestoes*, p. 20).

66. Georges Duhamel, " 'Alcools' de Guillaume Apollinaire," *Mercure de France*, June 16, 1913. Quoted by E.-A. Hubert in the notes to Pierre Reverdy, *Nord-Sud, Self defence et autres écrits sur l'art et la poésie (1917–26)* (Flammarion, 1975).

67. Jules Romains, "La poésie immédiate," *Vers et prose* (October–November–December 1909).

68. See Etienne-Alain Hubert, "Autour de la théorie de l'image de Pierre Reverdy," *Sud*, "Bousquet, Jouve, Reverdy" (1981).

69. "Espace," *Sources du Vent* (Gallimard, 1971). Translated by Folkenflik.

70. E.-A. Hubert, "Autour de la théorie."

71. "Thought is the penetrating mind, dream is the mind letting itself be penetrated." *Nord-Sud, Self defence et autres écrits*, p. 106.

72. E. A. Hubert, "Autour de la théorie."

73. Breton, *Manifestoes*, p. 37.

74. *Ibid.*, p. 38.

75. *Ibid.*, p. 38.

76. See the analysis of this image by Jean-François Lyotard, *Discours, Figure* (Klincksieck, 1971), pp. 289–91.

77. All the following references are from the first *Manifesto, Manifestoes*, pp. 38–39.

78. TR. NOTE: Tr. by Folkenflik. Rrose Sélavy is pronounced "Eros, c'est la vie": "Rrose" = Eros (the letter *R* is pronounced "Er"). Rrose Sélavy was a pseudonym of Marcel Duchamp. "Dwarf" *(nain)* and "bread" *(pain)* rhyme in French, as do "well" *(puits)* and "night" *(nuit)*.

79. Jean Paulhan wrote *Entretiens sur des faits divers* (1930) and *Les fleurs de Tarbes* (1941) as well as editing the *NRF* (1925–40).

80. Nicole Boulestreau, ". . . comme une langue commune, Eluard à l'école de Paulhan," *Littérature* (October 1977), no. 27.

81. Paul Eluard, "Conduite intérieure," *La vie moderne* (March 4–11, 1923).

82. Some conference papers were later published under the title "L'évidence poétique," and others were reprinted in *Premières vues anciennes* (Pléiade, 1968), vol. 1, p. 538; see especially the transcript of the conference, p. 1490.

83. *Au-delà de la peinture*, reprinted in Max Ernst, *Ecritures* (Gallimard, 1970).

TR. NOTE: Max Ernst's interest in collage included the collage-novel *La femme 100 têtes* (1929). He went on to create the automatic rubbings of frottage and grattage (see chapter 4, note 160).

84. Aragon, "Max Ernst, peintre des illusions," *Les collages* (Hermann, 1965).

85. See Wolfgang Babilas, "Le collage dans l'oeuvre critique et littéraire d'Aragon," *La Revue des Sciences Humaines* (July –September 1973), no. 151.

86. Aragon, "A quoi pensez-vous?" *Les écrits nouveaux* (August–September 1921), vol. 8, nos. 8–9.

87. Ferdinand Alquié, *Philosophie du surréalisme* (1955), tr. by Bernard Waldrop as *The Philosophy of Surrealism* (Ann Arbor: University of Michigan Press, 1965), p. 125.

88. And Breton distinguishes himself from Baudelaire: "The time of Baudelairean 'correspondences' . . . is past. For my part, I refuse to see in them anything but the expression of a transitional idea, a timid enough one in any case. . . . Oneiric values have once and for all succeeded the others." Breton, "Exposition X . . . Y . . ." (April 1929), reprinted in *Point du jour*. This has been translated by David Gascoyne in his volume *What Is Surrealism?* a collection of Breton's writings (London: Faber and Faber, 1936), p. 25.

89. This speech was reprinted in *Position politique du surréalisme* (1935); an English translation of it is available in *Manifestoes*, pp. 245–46.

90. TR. NOTE: This text has been translated as "On the Time When the Surrealists Were Right," *Manifestoes*, pp. 243–54.

91. Breton, *Arcane 17*, p. 117.

92. Pierre Mabille (1904–1952) was a doctor who invented the psychological "village test."

93. According to the analysis of José Pierre, *Le surréalisme* (Lausanne: Rencontre, 1967), p. 57.

94. TR. NOTE: The sculptures of Alberto Giacometti (1901–1966) included *The Suspended Ball* (1930), *The Palace at 4 P.M.* (1932), and *The Invisible Object* (1934–35).

95. TR. NOTE: The painter Méret Oppenheim constructed Surrealist objects such as the *Déjeuner en fourrure*, a cup, saucer, and spoon covered in fur (1936). Valentine Hugo, who illustrated many Surrealist texts and reviews, constructed one of the earliest Surrealist objects in 1931. Her drawings of women are delicate and erotic.

96. TR. NOTE: Victor Brauner (1903–1966) developed "picto-poetry" in his native Romania before joining the Surrealists in Paris; after painting dismembered eyes he lost an eye in a quarrel. He painted chimeras (*Psychological Space*, 1939), worked with automatic drawings made with candle smoke (*fumages*), and invented other experiments as a result of his interest in magic.

97. TR. NOTE: Oscar Dominguez (1906–1957), was much involved with automatism. For a description of his "decalcomania of desire," folding and peeling paper spread with gouache, see Breton, *Surrealism and Painting*, tr. Simon Watson Taylor (New York: Harper and Row, 1965), pp. 128–29.

98. TR. NOTE: Wolfgang Paalen (1907–1959) painted *Saturnine Princes* (1938) and other disturbing fantasy figures as a result of his automatic experiences (*Articulated Cloud*, 1938).

99. TR. NOTE: Roberto Matta Echaurren, originally an architect, was inspired by the Surrealists to devote himself to painting (*The Earth Is a Man*, 1943).

100. TR. NOTE: René Magritte (1898–1967) explored the relationship between representation and trompe-l'oeil, meaning and figuration in such paintings as *This Is Not a Pipe* and *The Therapeutist* (1937). E.L.T. Mesens (1903–1970) did collages as well as writing poetry (*Alphabet sourd aveugle*, 1933), and collaborated with Magritte in publishing two reviews *(Oesephage, Marie)*. Jindrich Styrsky (1899–1942) was inspired by his dreams to create collages and paintings of great erotic intensity. The artist Marie Germinova, called Toyen, did dreamlike paintings such as *The Sleeping Girl* (1937) and *Hide, War* (1944) as well as collages, photographs, and drypoints (*Neither Wings nor Stones: Wings and Stones*, 1954).

101. Lucien Scheler, *La grande espérance des poètes, 1940–45* (Temps actuels, 1982). The published letters restore the attractive figure of Louis Parrot. See also Louis Parrot, *L'intelligence en guerre, Panorama de la pensée française dans la clandestinité* (La Jeune Parque, 1945). For the maturation of the Surrealist spirit, see the abundant dossier assembled and published by Michel Fauré, *Histoire du surréalisme sous l'Occupation* (La Table ronde, 1982); it is, perhaps involuntarily, pitiless, but the texts cited show this development clearly.

102. Faure, *Histoire du surréalisme*, pp. 15, 263 ff.

103. This is a 1937 addition to the questionnaire on chance occurrences appearing in *Minotaure* (December 1933); *L'amour fou (Mad Love*, pp. 23–24).

104. Aragon, "Le sentiment de la nature aux Buttes-Chaumont," second part of the *Paysan de Paris*, published in magazine form in 1925.

105. Breton, "Equation de l'objet trouvé," *Documents 34; L'amour fou*, text 3 (*Mad Love*, p. 25).

106. Breton, "La beauté sera convulsive," *Minotaure* (1934), no. 5; *L'amour fou*, text 1 (*Mad Love*, p. 13). TR. NOTE: In *Mad Love*, Breton developed his earlier statement, "Beauty will be convulsive or it will not be" *(Nadja)* as "Convulsive beauty will be veiled-erotic, fixed-explosive, magic-circumstantial, or it will not be" (p. 19).

107. Pierre Mabille, "L'oeil du peintre," *Minotaure* (1939) no. 12–13.

108. Breton, *L'amour fou (Mad Love*, p. 30).

109. Jacqueline Chénieux-Gendron, *Le surréalisme et le roman* (L'Age d'homme, 1983). Whereas the event is usually represented to our imagination as a point on a timeline, for Surrealism it is a right-angle segment in which the words designating it confuse the direction of the temporal vector. It is like a whirlwind: in the course of several days or several hours, all the words around me designate this important event that is happening to me.

110. Breton, "La nuit du Tournesol," *Minotaure* (June 1935), no. 7; *L'amour fou*, text 4 (*Mad Love*, p. 39).

111. Breton, *Nadja* (1928; revised text, 1964), p. 20.

112. Breton, "Le château étoilé," *Minotaure* (1936), no. 8; *L'amour fou*, text 5 (*Mad Love*, p. 126).

113. Aragon, *Le paysan de Paris*, p. 168.

114. Breton, *L'amour fou*, text 5 (*Mad Love*, p. 87).

115. Breton, *L'amour fou*, text 3 (*Mad Love*, p. 25).

116. Breton, "Il y aura une fois," *Le Surréalisme ASDLR*, (July 1930), no. 1.

117. Breton, *L'amour fou*, text 1 (*Mad Love*, p. 16).

118. *Ibid.* (p. 15).

119. TR. NOTE: Sigmund Freud's *Der Witz und seine Beziehung zum Unbewussten* was published in Vienna in 1905.

120. Translated as "Surrealist Situation of the Object," *Manifestoes*, p. 268. The following sentence is taken from the same paragraph.

121. *Ibid.*, p. 266. TR. NOTE: Alfred Jarry (1873–1907) wrote the deliberately shocking play *Ubu Roi* (1896) and other works of poetry and fiction (*L'amour absolu*, 1899; *Le surmâle* (1902). His pseudo-science of "pataphysique" aimed at the destruction of commonsense statements.

122. Breton, *Manifestoes*, pp. 266–67.

123. Hegel, *The Philosophy of Fine Art*, tr. by F. P. B. Osmaston (London: G. Bell, 1920), vol. 2, p. 386.

124. Annie Le Brun, "L'humour noir," *Entretiens sur le surréalisme* (Paris and the Hague: Mouton, 1968), p. 102.

125. Tr. Folkenflik. *Charnière* = hinge. For Rrose Sélavy, see above, note 78.

126. See Alain and Odette Virmaux, *Les surréalistes et le cinéma* (Seghers, 1976).

127. See Edouard Jaguer, *Les mystères de la chambre noire* (Flammarion, 1982). Also Rosalind Krauss, *L'Amour Fou: Photography and Surrealism* (New York: Abbeville, 1985).

128. Tr. as "Prolegomena to a Third Surrealist Manifesto or Not," *Manifestoes*, pp. 285, 293.

129. See Marguerite Bonnet and Jacqueline Chénieux-Gendron, *Autour d'André Breton, 1948–1972* (New York: Kraus, 1982) for the introductory notices to each collection of reviews. This book offers an examination of all collaborations, with a general index.

130. José Pierre has collected these under the title *Surréalisme et anarchie* (Plasma, 1983).

131. See José Pierre, *Tracts surréalistes . . .* (Losfeld, 1982), vol. 2. See also Jean-Louis Bédouin's *Vingt ans de surréalisme, 1939–59*, which Breton would have liked to see partly rewritten.

132. Tr. NOTE: Tr. by Folkenflik. NEO = Neon: the final N is not sounded as fully in French as in English.

133. Tr. NOTE: In this game, the person who is "it" leaves the room and chooses an object to "be," while the people remaining in the room choose a different object for him to identify himself with. He must describe himself to them so that the image of the object he has chosen superimposes itself on the one they have chosen for him.

134. Jean Schuster, "Raison sociale décousue main" (1965), *Archives 57–68* (Losfeld, 1969), p. 73.

135. See Jean-Michel Place's republication of the review *Cobra*, 1948–51.

136. Tr. NOTE: The events of May were the student rebellions in Paris during May 1968, calling for widespread reforms and supported by some other sectors of the population; they involved confrontation with the police.

137. Tr. NOTE: The word allegory comes from the Greek *allos*, "other" + *ago-reuein*, "to speak."

138. Jean-Paul Valabrega, *Phantasme, mythe, corps et sens* (Payot, 1980), p. 150.

139. Aragon, *Le paysan de Paris* (1926, 1966), pp. 141–42. This quotation dates from 1925.

140. *Ibid.*, pp. 142, 145.

141. Breton, *Position politique du surréalisme* (1935), tr. *Manifestoes*, p. 210.

142. *Ibid.*, pp. 230–31. Tr. NOTE: The poet Pierre-Jean Jouve wrote *Les mystérieuses noces* (1928) and *Sueur de sang* (1935), among other works.

143. Breton, *Prolégomènes* (1942), tr. *Manifestoes*, pp. 287–88.

144. Georges Bataille, *Les Cahiers de Contre-Attaque* (May 1936), no. 1, reprinted in *Oeuvres complètes* (Gallimard, 1970), vol. 1, p. 428.

145. Bataille, *L'apprenti sorcier* (1938); *Oeuvres complètes*, vol. 1, p. 535.

146. Breton, "Devant le rideau," *La clé des champs* (1953), p. 95.

147. *Rupture inaugurale*, reprinted in José Pierre, *Tracts surréalistes et déclarations collectives* (Losfeld, 1982), vol. 2, p. 36.

148. "Le texte est de 1942," written in Mexico; reprinted in the introduction to *L'anthologie des mythes, légendes et contes populaires d'Amérique* (Albin Michel, 1960).

149. Breton, *Manifestoes*, p. 293.

150. Breton, *Manifestoes*, p. 294. Tr. NOTE: On the same page, Breton describes Emile Duclaux as "a former director of the Pasteur Institute (1840–1904)."

4. High Stakes and Their Actualization

1. Breton, *Les pas perdus*, p. 85.

2. Breton, "Introduction au discours sur le peu de réalité" (1924), *Point du jour*, pp. 14, 8.

3. Aragon, Preface to *Libertinage* (1920, text).

4. Breton, *Manifestoes*, p. 9.

5. Aragon, *Traité du style* (1928), p. 167.

6. Breton, *Manifestoes*, pp. 136–37.

7. Marcel Duchamp, *Duchamp du signe, écrits*, ed. by Michel Sanouillet (Flammarion, 1926); *Notes* (Centre national d'Art et de Culture Georges-Pompidou, 1980).

8. Breton, "Introduction au discours sur le peu de realité," *Point du jour*, p. 15.

9. Breton, *Manifestoes*, p. 26.

10. Breton, *Position politique de l'art d'aujourdhui*, tr. as "Political Position of Today's Art," *Manifestoes*, p. 230.

11. Breton, *Manifestoes*, pp. 11–13.

12. Robert Desnos, "Le rêve et le cinéma" (1923), *Cinéma* (Gallimard, 1966). See Sarane Alexandrian, *Le surréalisme et le rêve* (Gallimard, 1974).

13. Breton, *Manifestoes*, p. 14.

14. Breton, *Les vases communicants* (1970 ed.), pp. 10–11.

15. Robert Desoille, *Exploration de l'affectivité subconsciente par la méthode du rêve éveillé* (D'Artrey, 1938). And see esp. Rogert Dufour, *Ecouter le rêve* (Laffont, 1978).

16. Aragon, *Le paysan de Paris*, p. 164.

17. TR. NOTE: This Surrealist game involves "five players writing in turn subject, adjective, verb, object, complement, each folding over the paper so that the next player could not see what had been already written." José Pierre, *A Dictionary of Surrealism*, tr. W.-J. Strachan (London: Eyre Methuen, 1974), pp. 71–72. Breton himself describes this game in "The Exquisite Corpse, Its Exaltation" (*Surrealism and Painting*), pp. 288–90. The name refers to "the first phrase obtained in this manner: 'The exquisite—corpse—shall drink—the young—wine.'" (In French, the adjective "young" would follow "wine.")

18. Breton, "Exposition X . . . Y . . ." (1929), *Point du jour*, p. 56.

19. TR. NOTE: The principle of "psychophysical isomorphism" in Gestalt theory suggests that "experience as such exhibits an order *which is itself experienced.* . . . Experienced order in space is always structurally identical with a functional order in the distribution of underlying brain processes. . . . Experienced time must have a functional counterpart in brain events just as experienced space has." Wolfgang Köhler, *Gestalt Psychology* (New York: New American Library, 1959), pp. 38–39.

20. Breton, *L'amour fou*, text 6 (*Mad Love*, p. 106). TR. NOTE: This is the title of a picture by Cézanne as well as a reference to an actual experience of Breton's (described on pp. 102–4 of the same text).

21. Breton, "Il y aura une fois," *Le Surréalisme ASDLR*, (July 1930), no. 1.

22. Breton, "La beauté sera convulsive" (1934); *L'amour fou*, text 1 (*Mad Love*, p. 6).

23. Jean Starobinski, "Remarques sur l'histoire du concept d'imagination," *Cahiers Internationaux du Symbolisme* (1966), no. 11.

24. Tr. note: *Märchen:* German tales, particularly folk or fairy tales.

25. Breton, *Manifestoes*, pp. 9–10.

26. Octavio Paz, "André Breton ou la recherche du commencement," *L'Arc* (1967), no. 32 (Georges Bataille).

27. Breton, "Introduction au discours sur le peu de réalité" (1924), *Point du jour.*

28. I differ here from Claude Abastado, *Le surréalisme* (Hachette, 1975), pp. 126ff.

29. Tr. note: Merleau-Ponty's *Signs* has been translated by Richard C. McCleary (Evanston: Northwestern University Press, 1964).

30. Elisabeth Lenk, *Der springende Narziss, André Bretons poetischer Materialismus* (Munich: Rogner and Bernhard, 1971).

31. Georges Bataille, "Catechisme de Dianus," *Oeuvres complètes*, vol. 5, p. 405.

32. Georges Bataille, *L'érotisme* (1957; 1965 ed.), p. 302.

33. Wilhelm Worringer, *Abstraktion und Einfühlung* (1907).

34. Michel Deguy, "Du 'Sphinx vertébral' au 'Signe ascendant,' " *Poétique* (April 1978), no. 34.

35. Breton, "Francis Picabia," *Les pas perdus*, p. 135.

36. Breton, *Manifestoes*, p. 125.

37. René Crevel, *Les pieds dans le plat* (1933; Pauvert, 1974), pp. 204ff.

38. Breton, *Arcane 17* (1944; UGE, 1965), p. 75.

39. Breton, "Silbermann" (1964), *Surrealism and Painting*, p. 408.

40. Xavière Gauthier, *Surréalisme et sexualité* (Gallimard, 1971).

41. Aragon, *Les aventures de Télémaque* (1966 ed.), pp. 59, 61. This text dates from 1920.

42. Aragon, *Le paysan de Paris*, p. 82. This text dates from 1924.

43. Marcel Duchamp, note to *Boîte verte*, reprinted by Michel Sanouillet in *Duchamp du signe, écrits* (Flammarion, 1976), p. 47.

44. Tr. note: Translated by Jean-Pierre Cauvin and Mary Ann Caws, *Poems of André Breton: A Bilingual Anthology* (Austin: University of Texas Press, 1982), p. 39.

45. René Crevel, *Les pieds dans le plat*, pp. 182–83.

46. Breton, *L'amour fou*, text 1 (*Mad Love*, p. 11).

47. Aragon, "Une vague de rêves," *Commerce* (1924), no. 2.

48. Tr. note: Benjamin Constant's novel *Adolphe*, written in 1807, published in 1816, provides some remarkable examples of psychological analysis in fiction by its narrator and its author.

49. Aragon, *Le paysan de Paris*, pp. 209, 211.

50. *Ibid.*, pp. 130, 132.

51. Paul Eluard, "La dame de carreau," *Les dessous d'une vie, Oeuvres complétes*, vol. 1, pp. 202–3.

52. Breton, "Introduction" (1924), *Point du jour*, p. 10.

53. Breton, "Max Walter Svanberg" (1961), *Surrealism and Painting*, p. 242.

54. Octavio Paz, *Deux transparents, Claude Lévi-Strauss et Marcel Duchamp* (Gallimard, 1970).

55. TR. NOTE: The French word falcon, *faucon*, sounds like *faux* (false) + *con* (cunt).

56. Benjamin Péret, *Anthologie de l'amour sublime*.

57. Desnos, *La liberté ou l'amour!* pp. 49–50.

58. Breton, *Les vases communicants* (1970), p. 84.

59. Breton, *L'amour fou*, text 1, (*Mad Love*, p. 7).

60. Breton, *Les vases communicants*, p. 85.

61. Breton, *L'amour fou*, text 6 (*Mad Love*, p. 97).

62. Péret, *Anthologie de l'amour sublime*.

63. Breton, *L'amour fou*, text 5 (*Mad Love*, p. 76).

64. TR. NOTE: Joyce Mansour also published several volumes of poetry, including *Cris* (1952) and *Les gisants satisfaits* (1958).

65. Breton, Introduction to the "Contes bizarres" (1933), reprinted in *Point du jour*.

66. Catalogue for the Victor Brauner exposition, MNAM (June–September 1972), p. 96.

67. François Rigolot, *Poétique et onomastique* (Droz, 1977); Martine Broda, "L'objet du poème lyrique," *Action Poétique*, no. 86.

68. Breton, *Arcane 17*, pp. 118–19.

69. Lenin, translated into French as *De l'émancipation de la femme* (1937), p. 74.

70. Arthur Rimbaud, letter to Paul Demeny, May 15, 1871.

71. Breton, "Prolégomènes," *Manifestoes*, p. 285.

72. Breton, *Arcane 17*, pp. 62–63.

73. TR. NOTE: Lissagara Varo, called Remedios (1913–1963), painted fantasies such as *Solar Music* (1955). Judit Reigl's paintings include *They Have an Undying Thirst for the Infinite* (1950) and *Incomparable Sensual Delight* (1953). Frida Kahlo was described by Breton as "situated at that point of intersection between the political (philosophical) line and the artistic line" (*Surrealism and Painting*, p. 144); its "surreality" combined elements of Mexican folk art with social consciousness. On Mimi Parent's work he has only one sentence: "In Mimi's thistle eyes shine Armida's enchanted gardens at midnight" (p. 391). Yahne Le Toumelin painted inhabited landscapes, in which, Breton said, "precedence is given to beings that 'transform' electricity," and empty landscapes, "the product (as though the residue) of an inner air-pump designed to obtain, beyond the 'absence of self,' the *transparency* which gives access to the unrevealed worlds and establishes *objective chance*" (*Surrealism and Painting*, p. 253).

74. Nora Mitrani, "Des esclaves, des suffragettes, du fouet," *Le Surréalisme, Même* (1957), no. 3.

75. Breton, Introduction to the "Contes bizarres," *Point du jour*.

76. Maurice Blanchot, *Lautréamont et Sade* (1949); Georges Bataille, *L'érotisme* (1957).

77. Blanchot, *Lautréamont et Sade*, p. 259.

78. Bataille, *Oeuvres complétes*, vol. 6. p. 454.

79. TR. NOTE: Pierre Molinier characteristically painted women beautifying themselves as the objects of desire.

80. Jean-Bertrand Pontalis, preface to Xavière Gauthier's *Surréalisme et sexualité*.

81. TR. NOTE: The word "poetic" comes from the Greek *poetikos*, inventive, from *poiein*, to make.

82. Breton, *Manifestoes*, p. 9.

83. Quoted by Breton, *Perspective cavalière* (1970), p. 28, with a typographical omission in the second sentence that distorts Mascolo's statement.

84. Victor Crastre, *André Breton* (Rodez: Arcanes, 1952), p. 39.

85. Breton, *Arcane 17*, pp. 14, 16.

86. Breton, "Caractères de l'évolution moderne," in *Les pas perdus*, p. 170.

87. Breton, "La Claire Tour," reprinted in *La clé des champs*.

88. Péret, *Le déshonneur des poètes*, 1945.

89. Jean Schuster, "Les bases théoriques du surréalisme" (1967), *Archives 57–68*, p. 146.

90. Aragon, *Traité du style* (1928), p. 222, pp. 234–35.

91. This text is reprinted in José Pierre, *Tracts surréalistes* (1980), vol. 1.

92. Breton, *Arcane 17*, pp. 15–16. Author's emphasis.

93. Jean-Paul Sartre, "Qu'est-ce que la littérature?" (1947), *Les temps modernes* (1947); reprinted in *Situations II*. Translated by Bernard Frechtman, *What Is Literature?* (New York: Philosophical Library, 1949).

94. Breton, *Les vases communicants*, pp. 148, 168.

95. Breton, "Légitime défense," tr. Richard Howard, *The History of Surrealism*, p. 252.

96. Eluard, "L'evidence poétique," originally a lecture (1936); *Oeuvres complètes* (Pléiade, 1968), vol. 1, p. 520.

97. For example, see Crevel, *Le clavecin de Diderot* (1932; 1966 ed.), pp. 44, 174; "Au carrefour de l'amour, la poésie, la science et la révolution" (1935), *L'esprit contre la raison* (Tchou, 1969), p. 129; the whole last chapter of the novel *Les pieds dans le plat* (1933). For Mabille, see *Thérèse de Lisieux* (Corti, 1937).

98. Breton ["La barque de l'amour"], 1930, *Point du jour*.

99. Breton, *Entretiens*, p. 119. See Marguerite Bonnet, "Trotsky et Breton," postface to Leon Trotsky, *Lénine* (Presses Universitaire de France, 1970).

100. Breton ["La barque de l'amour"].

101. Reprinted in *La clé des champs* and signed by the painter Diego Rivera instead of Trotsky, for tactical reasons of Trotsky's own. TR. NOTE: This text has been translated by Dwight Macdonald as "Manifesto: Towards a Free Revolutionary Art,"

Partisan Review (Fall 1938); it is reprinted in *Leon Trotsky on Literature and Art*, ed. Paul N. Siegel (New York: Pathfinder Press, 1970).

102. Jean Schuster, "L'axe invisible" (1965), *Archives 57–68* (Losfeld, 1969).

103. Breton, *La clé des champs*, p. 39.

104. *Ibid.*, p. 40.

105. *Ibid.*, p. 38.

106. *Ibid.*, p. 36.

107. *Ibid.*, p. 40.

108. Breton, *Manifestoes*, p. 155.

109. Emile Zola, in *Le Figaro* (1881); *Oeuvres complètes* (Cercle du livre précieux, Tchou), vol. 14, p. 667.

110. Péret, "La parole est à Péret," *Anthologie des mythes, légendes et contes populaires d'Amérique* (Albin Michel, 1960), p. 30.

111. Breton, *Manifestoes*, p. 156.

112. Breton, "Prolégomènes," *Manifestoes*, p. 345.

113. TR. NOTE: Charles Fourier (1772–1837) proposed that society be organized in cooperative phalanges of 100 families, sharing their profits, labor, and sexual partners. Two of his works were the *Traité de l'association domestique et agricole* (1822) and *Le Nouveau Monde industriel* (1829–30).

114. José Pierre, *Position politique de la peinture surréaliste* (Le musée de poche, 1975), pp. 45–48.

115. See Jean Schuster, "Les bases théoriques du surréalisme" (1967), *Archives 57–68*, pp. 159–60. TR. NOTE: In his speech to the Congress of Writers, 1935, Breton combines the watchwords of Marx and Rimbaud: "'Transform the world,' Marx said; 'change life,' Rimbaud said. These two watchwords are one for us." *Manifestoes*, p. 241.

116. Breton, *L'amour fou*, text 1 (*Mad Love*, p. 8).

117. *Ibid.*, p. 8.

118. Breton, "Political Position of Surrealism" (1935), *Manifestoes*, p. 222.

119. Aragon, *Le paysan de Paris*, p. 81. This quotation dates from 1924.

120. Breton, *Manifestoes*, p. 4.

121. Aragon, *Le paysan de Paris*, p. 61.

122. Lautréamont, "Poésies," *Oeuvres complètes* (Garnier and Flammarion, 1969), p. 291. But the expression is ambiguous, as Marguerite Bonnet says in her introduction to this edition, pp. 28–29.

123. TR. NOTE: In French, the letters "LHOOQ" can be sounded like the words for "She is hot in the tail" (L = *elle*, HO = *a chaud*, O = *au*, Q = *cul*).

124. Breton, *Manifestoes*, p. 161.

125. *Ibid.*, p. 16.

126. *Ibid.*, p. 14.

127. Aragon, *Je n'ai jamais appris à écrire ou les "incipit"* (Skira, 1969), p. 45.

128. *Ibid.*, p. 14.

129. Breton, *L'amour fou*, text 1 (*Mad Love*, p. 19).

130. *Ibid.*, p. 11.

131. Aragon, *Traité du style*, pp. 189–90. The previous quotation from Aragon is on the same page.

132. Eluard, *Oeuvres complètes*, vol. 1, p. 516.

133. Catalogue for the Marcel Duchamp exposition at the Musée national d'Art moderne (Centre Georges-Pompidou, 1977), vol. 2, *L'oeuvre*, p. 81. The following quotation is from the same page.

134. TR. NOTE: "Avida Dollars" means "eager for dollars." The title, originally in English, of the anti-Dali tract is a reference to a Dali painting of a Madonna, included in the exhibition and titled "The Anti-Matter Ear." See André Breton, *What Is Surrealism?* tr. by Franklin Rosemont (New York: Monad Press, 1978), p. 348.

135. Breton, "Du poème-objet" (1941); translated as "The Object-Poem," *Surrealism and Painting*, p. 284.

136. TR. NOTE: Breton's "Crise de l'objet" had been translated by Simon Watson Taylor as "Crisis of the Object," and "Genèse et perspective artistiques du surréalisme" as "Artistic Genesis and Perspective of Surrealism," both in *Surrealism and Painting*. See the Seaver-Lane translation of the *Manifestoes* for "Surrealist Situation of the Object."

137. Renée Riese-Hubert, "Du tableau-poème à la poésie concrète," *Ecritures II* (Le Sycomore, 1984).

138. "We must seek the great reality of this century in *Les mystères de New York* and in *Les vampires*. Beyond fashion. Beyond taste." Aragon and Breton, "Le trésor des Jésuites," *Variétés* (June 1929).

139. Surrealist taste in 1966 was reviewed by Charles Jameux at Cerisy-la-Salle in *Le surréalisme* (Mouton, 1968), p. 419. Note the admiration for the early (animated) films of Valerian Borowczyk, and for Richard Lester's films, in which the theme of disorder prevails. We should not forget the sequences inspired by Max Ernst and Marcel Duchamp in Hans Richter's *Dreams That Money Can Buy*, 1947.

140. Georges Ribemont-Dessaignes, *Dada and Dada II* (Champ libre, 1974, 1978), texts and bibliography edited by Jean-Pierre Begot.

141. Man Ray, "Cinémage," *L'age du cinéma* (August–November 1951), nos. 4–5.

142. Breton, "Comme dans un bois," *Ibid.*; reprinted in *La clé des champs*, pp. 241–46.

143. For this disappointment, see Marguerite Bonnet, "L'aube du surréalisme et le cinéma," *Etudes cinématographiques* (1965), nos. 38–39.

144. Breton, "Silence d'or" (1944), *La clé des champs*, pp. 79–80.

145. André Souris, "Discussion générale," *Le surréalisme* (Mouton, 1968), p. 526. We should recall the condemnation of 1925 and Breton's provocative discussion of

"auditive images" in *Le surréalisme et la peinture:* "musical expression . . . the most deeply confusing of all forms. Auditive images, in fact, are inferior to visual images not only in clarity but also in strictness, and, with all due respect to a few melomaniacs, they are not destined to strengthen the idea of human greatness." *Surrealism and Painting,* p. 1.

146. According to the suggestions of Souris himself, *Le surréalisme,* p. 527. See also Souris, *Conditions de la musique et autres écrits* (Université de Bruxelles and Centre National de la Recherche Scientifique, Paris, 1976).

147. François-Bernard Mâche, "Surréalisme et musique, Remarques et gloses," *La NRF* (December 1974), no. 264.

148. Eluard, *Oeuvres complètes,* vol. 1, pp. 1387–88.

149. TR. NOTE: Breton's "Tournesol" (Sunflower) is a poem published in *Clair de terre* (1923). For an English translation, see *Poems of André Breton: A Bilingual Anthology,* translated by Jean-Pierre Cauvin and Mary Ann Caws (1982).

150. See the chapter "Deux modes de l'invention" in my book *Le surréalisme et le roman* (Lausanne: L'Age d'homme, 1983).

151. Breton, "Signe ascendant," *Néon* (1948), no. 1; then *Signe ascendant* (Gallimard, 1968) p. 12.

152. Michel Deguy, "Du 'Signe ascendant' au 'Sphinx vertébral,' *Poétique* (April 1978), no. 34.

153. Breton, *Manifestoes,* pp. 21–22.

154. *Ibid.,* p. 30.

155. I believe that it is inaccurate to think of Aragon as Surrealist in a limited sense; see Petr Kral in *Dictionnaire du surréalisme* (Presses Universitaires de France, 1982). *Je n'ai jamais appris à écrire ou les incipit* (published in 1969, to be sure) is evidence to the contrary.

156. Breton, *Surrealism and Painting,* pp. 3–4. Emphasis added.

157. Breton, *Les vases communicants,* pp. 96, 124.

158. Aragon, "Max Ernst peintre des illusions," *Les collages* (Hermann, 1965), p. 30.

159. René Passeron gives about thirty technical inventions, which he classes according to medium: graphic, plastic, photographic, *Histoire de la peinture surréaliste* (Gallimard, Le livre de poche, 1968), p. 193. The inventions listed in these last two categories are not Surrealist. In the first, we should note that the *stoppage-étalon* (standard-stop) is a hapax. TR. NOTE: To make the three standard-stops, Duchamp dropped pieces of thread one meter long onto canvas, fixed them in place with varnish, and cut rulers to reproduce the resulting shape (1913–14). In *The Bride Stripped Bare by Her Bachelors, Even,* these threads become the capillary tubes carrying the bachelors' sperm.

160. Max Ernst, "Au-delà de la peinture," *Cahiers d'art* (1936), nos. 6–7; *Ecritures*

(1970), pp. 242ff. TR. NOTE: In "grattage," Ernst placed canvas over the material and used paint instead of rubbing with pencil.

161. Breton, *L'amour fou*, text 5 (*Mad Love*, p. 87).

162. TR. NOTE: The expression "dérèglement de tous les sens" comes from Rimbaud's letter of May 15, 1871.

163. Salvador Dali, "L'âne pourri," *Le Surréalisme ASDLR* (1930), no. 1. Reprinted in *OUI I* (Denoël/Gonthier, 1979).

164. Breton, "Surrealist Situation of the Object," *Manifestoes*, p. 260.

165. José Pierre emphasizes this in *Position politique de la peinture surréaliste* (le Musée de Poche, 1975), p. 48. Raymond Queneau shows that Hegel had been discovered largely thanks to A. Kojeve after 1930; but nineteenth-century translations were available. "Premières confrontations avec Hegel," *Critique* (1963), nos. 195–96.

166. See José Vovelle, *Le surréalisme en Belgique* (Brussels: De Rache, 1972); and Michel Foucault, *Ceci n'est pas une pipe* (Fata Morgana, 1973).

167. Breton, "René Magritte" (1961), *Painting and Surrealism*. pp. 269–70. Author's emphasis.

168. *Ibid.*, p. 4.

169. Breton, *Arcane 17*, p. 8.

170. Breton, "Il y aura une fois," *Le Surréalisme ASDLR* (1930), no. 1.

171. René Crevel, "L'enfance de l'art," *Minotaure* (1933), no. 1.

172. J.-B. Pontalis, "Les vases non communicants," *La NRF* (March 1, 1978), no. 302, p. 34.

173. Breton, *Arcane 17*, p. 105. Author's emphasis.

174. Pontalis, "Les vases non communicants," p. 36.

175. Jean-Bertrand Pontalis cites Jean-Louis Houdebine; *La Nouvelle Critique* (February 1970), no. 31, and especially *Tel Quel* (Summer 1971), no. 46. Jean-Pierre Morel gives a very different account in "Aurélia, Gradiva, X . . . : Psychanalyse et poésie dans 'Les Vases communicants,'" *Revue de Littérature comparée* (1972), no. 1.

176. Morel, *ibid.*, p. 79.

177. Breton, *Manifestoes*, pp. 161–62.

5. Conclusion: Works of Art or Glacial Moraines?

1. Roger Navarri, "Critique synthétique, critique surréaliste, aperçus sur la critique poétique," *RHLF* (April–May 1979), p. 216.

2. André Breton, "Main première," *Perspective cavalière*.

3. See Roger Navarri, "Au grand jour / à la grande nuit, ou la double postulation de la critique surréaliste," *L'Information littéraire* (March–April 1981).

4. Jean Ferry is himself a writer of fantasies such as *Le mécanicien et autres contes* (Gallimard, 1953). His study of Raymond Roussel, "finished" in 1948, published in 1953 (Arcanes), was a starting point for the better-known criticism of Michel Foucault (1963) and Bernard Caburet (1968).

5. Maurice Heine and Gilbert Lely can be considered the first French editors of Sade, in the complete version of his work.

6. Roger Navarri, "Au grand jour / à la grande nuit," p. 66.

7. I have discussed this double "version": "Versants et versions du surréalisme français," *Revue des Sciences humaines* (1981), vol. 4, no. 184.

8. Readers may consult various publications of our group at the Centre National de la Recherche Scientifique: "CAS," Champs des activités surréalistes. See also the *Dictionnaire général du surréalisme et de ses environs* (Presses Universitaires de France, 1982), and the *Transactions of the International Colloquium on Comparative Literature* (New York, 1982).

Selective Bibliography

The place of publication is Paris, unless otherwise noted.

General History of Surrealism in France

Bédouin, Jean-Louis. *Vingt ans de surréalisme, 1939–59.* Denoël, 1961.

Nadeau, Maurice. *Histoire du surréalisme*, followed by *Documents surréalistes.* Seuil, 1965. Translated by Richard Howard, *The History of Surrealism.* New York: Macmillan, 1965.

Pierre, José. *Tracts surréalistes et déclarations collectives.* Losfeld. Vol. 1 (1922–39), 1980; vol. 2 (1940–69), 1982. (While this work does not offer a historical narrative,

like the two preceding books, its detailed critical apparatus contributes to a new and precise history of Surrealism.)

Surrealist and Related Periodicals

These have become accessible through facsimile reprints and indexed bibliographies.

SURREALIST PERIODICALS

Littérature. 1919–21 (first series); 1922–24 (second series). Reprinted J.-M. Place, 1978.

La Révolution Surréaliste. 1924–29, nos. 1–12. Reprinted J.-M. Place, 1975.

Variétés (Brussels). 1929. "Le surréalisme en 1929." Special issue.

Le Surréalisme au service de la Révolution. 1930–33, nos. 1–6. Reprinted J.-M. Place, 1976.

Minotaure. 1933–39, nos. 1–12. Reprinted Flammarion, 1981.

Documents 34 (Brussels). 1934. "Intervention surréaliste." Special issue. Reprinted *L'Arc*, no. 37.

V.V.V. 1942–44, nos. 1–4.

Néon. 1948–49, nos. 1–5.

Médium, "Informations surréalistes." 1952–53, Nos. 1–8.

Médium, "Communication surréaliste." 1953–55, nos. 1–4.

Le Surréalisme, Même. 1956–59, nos. 1–5.

Bief, "Surrealist connection." 1958–60, nos. 1–12.

Front Unique (Review). 1959–60, nos. 1–2.

La Brèche, "Surrealist action." 1961–65, nos. 1–8.

L'Archibras. 1967–69, nos. 1–7.

Coupure. 1969–72, Nos. 1–7. (After the disintegration of the Surrealist group.)

NOTE: See the bibliographic study by Marguerite Bonnet and Jacqueline Chénieux-Gendron, *Autour d'André Breton, 1948–1972* (New York: Kraus, 1982), covering the last nine periodicals, together with special Surrealist issues of *La Nef* ("Almanach surréaliste du demi-siècle," 1950), *L'Age du Cinéma* (1951), and *La Rue* (1952). This work contains an examination of each article and illustration, with a brief analysis of content, and various indices.

PERIODICALS RELATING TO SURREALISM

Adventure. 1921–22, nos. 1–3.
L'Oeuf dur. 1921–24, nos. 1–16. J.-M. Place.
Dés. 1922, no. 1. Reissued in one volume, J.-M. Place, 1975.
Le Grand Jeu. 1928–30, nos. 1–3. J.-M. Place (with no. 4, which remained in proofs), 1977.
Documents. [1929] nos. 1–7; 1930, nos. 1–8; 1933, no. 1, ser. 3; 1934, no. 1, ser. 4. (The last two issues were not edited by Georges Bataille.)
Les Cahiers de Contre-Attaque, 1936, no. 1.
Acéphale, 1936–39, nos. 1–5. J.-M. Place, 1980.
NOTE: See *Autour de Georges Bataille, 1929–39,* an analysis of these three last collections published by the "CAS" group (Champ des activités surréalistes) at the CNRS (Centre National de la Recherche Scientifique).
Clé. 1939, nos. 1–2. Monthly bulletin of the FIARI, led by André Breton.

DURING AND AFTER THE WAR

Le Cheval de Quatre. 1940.
Dédale. 1940.
La Main à Plume. 1941.
Quatre-vingt et Un. June 1943.
Le Surréalisme Encore et Toujours. August 1943.
L'Avenir du Surréalisme. January 1945.
La Révolution la Nuit. 1945, nos. 1–2.
Les Deux Soeurs. 1946–47, nos. 1–3.
Le Surréalisme Révolutionnaire. March–April 1948.
Cobra. 1948–51, nos. 1–10. Reprinted J.-M. Place.
Phases. 1954– .
NOTE: *Cobra* was published partly in French; there are other Surrealist or near-Surrealist reviews published outside France, not listed here. We might mention, in French, the Belgian reviews *Correspondance, Oesophage, Marie, Distances, Variétés, Rupture, Phantomas,* published in Brussels or La Louvière.

Group Exhibitions of the Surrealists

1925: Paris, Galerie Pierre.
1928: Paris, Le Sacre du Printemps.
1929: Zurich, Kunsthaus.

1931: Hartford, Connecticut.
1932: New York, Julien Levy Gallery.
1934: Brussels, Palais des Beaux-Arts.
1935: Copenhagen, Den Frie Udstillung Bygning, "Cubism-Surrealism." ("First" international exhibition.)
1935: Santa Cruz de Tenerife, Canary Islands.
1936: La Louvière, Belgium.
1936: Paris, Charles Ratton.
1936: London, New Burlington Galleries. (Second International exhibition.)
1936: New York, Museum of Modern Art, "Fantastic Art, Dada, and Surrealism."
1937: Tokyo, Ginza Galleries.
1937: London, London Gallery.
1938: Paris, Galerie des Beaux-Arts, ("Third") "Exposition internationale du surréalisme."
1938: Amsterdam, Galerie Robert, "Exposition internationale du surréalisme.
1940: Mexico, Galerie de Arte Mexicano, ("Fourth") "Exposicion internacional del surrealismo."
1942: New York, Coordinating Council of French Relief Societies, ("Fifth") "Surrealist Exhibition."
1945: London, Arcade Gallery.
1947: Paris, Galerie Maeght, ("Sixth") "Exposition internationale du surréalisme."
1947: Prague, ("Seventh") "Exposition internationale du surréalisme."
1948: Santiago, Chile, Galeria Dédalo.
1959–60: Paris, Galerie Daniel Cordier, "Huitième Exposition internationale du surréalisme" ("Eighth"), *Eros.*
1960–61: New York, D'Arcy Galleries, "Surrealist Intrusion in the Enchanters' Domain." ("Ninth" international exhibition.)
1961: Milan, Galerie Schwarz, "Mostra internazionale del surrealismo" ("Tenth").
1965–66: Paris, Galerie L'Oeil, "Onzième Exposition internationale du surréalisme" ("Eleventh"), *L'écart absolu.*
1965–66: Galerie Le Ranelagh, "Collages, dessins, gravures surréalistes."

Bibliographies of Principal Surrealists Writing in French

NOTE: I refer to the most scholarly bibliography, when there is one; it is often at the end of a critical study.

Aragon, Louis. See Crispin Geoghegan, *Louis Aragon, essai de bibliographie.* London: Grant and Cutler, 1979. Vol. 1: *Works;* vol. 2: *Criticism.*

——*Jours effeuillés*. Gallimard, 1966. (Contains almost all the French-language texts.)

Arp, Hans. *Unsern täglichen Traum*. Zurich: Verlag der Arche, 1955. (Collects poetry and essays in German, 1914–54.)

Artaud, Antonin. *Oeuvres complètes*. 25 vols. Gallimard, in preparation.

Baron, Jacques. *L'allure poétique*. 1924.

——*Charbon de mer*. 1935; Gallimard, 1982.

——*Miss Lucifer*. P. Trémois, 1945.

——*Le noir de l'azur*. Bateau ivre, 1946.

——*L'an I du surréalisme*, followed by *L'an dernier*. Denoël, 1969.

NOTE: Radio plays and poems published in reviews have not been collected.

Breton, André. See Michael Sheringham, *André Breton, a bibliography*. London: Grant and Cutler, 1972. Marguerite Bonnet, *André Breton, naissance de l'aventure surréaliste*. Corti, 1975.

Carrington, Leonora. *Le cornet acoustique*. Garnier and Flammarion, 1983. (Introduction and bibliography by Jacqueline Chénieux-Gendron.)

——*Pigeon vole, contes retrouvés*, followed by *Histoire du petit Francis*. Cognac: Le temps qu'il fait, 1986.

Césaire, Aimé. *Cahier d'un retour au pays natal*. 1939.

——*Les armes miraculeuses*. 1946.

——*Et les chiens se taisaient*. 1946.

——*Soleil cou coupé*. 1948.

——*Corps perdu*. 1949.

——*Ferrements*. 1960.

——*Noria*. 1976.

Char, René. *Oeuvres complètes*. Gallimard, Pléiade, 1983.

Crevel, René. See Etienne-Alain Hubert, "René Crevel, bibliographie." *Bulletin du Bibliophile*. 1983, vol. 4; 1984, vol. 1.

Dali, Salvador; *Visages cachés*. Stock, 1972.

——*Oui 1*. Denoël-Gonthier, 1979.

——*Oui 2*. Denoël-Gonthier, 1979.

Desnos, Robert. See Marie-Claire Dumas, *R. D. ou l'exploration des limites*. Klincksieck, 1978.

Duprey, Jean-Pierre. See Jean-Christophe Bailly, *Jean-Pierre Duprey*. Seghers, 1973.

Eluard, Paul. *Oeuvres complètes*, ed. Lucien Scheler and Marcelle Dumas. 2 vols. Gallimard, Pléiade, 1968.

Ernst, Max. *Ecritures*. Gallimard, 1970.

Ferry, Jean. *La société secrète*. Fontaine, 1946.

——*Le voyageur avec bagages*. Fontaine, 1947.

——*Le tigre mondain*. Saint-Maurice d'Etelan: P. Bettencourt, 1950.

——*Le mécanicien et autres contes*. Les cinéastes bibliophiles, 1950. (Preface by Breton.)

Fourré, Maurice. *La nuit du Rose-Hôtel*. Gallimard, 1950. (Preface by Breton.)

Terry, Jean. *La marraine du sel.* Gallimard, 1955.
——*Tête-de-Nègre.* Gallimard, 1960.
——*Le caméléon mystique.* Quimper: Calligrammes, 1981.
Gracq, Julien. See Peter Hoy, *Julien Gracq, essai de bibliographie.* London: Grant and Cutler, 1973. (For the years 1938–72).
Hardellet, André. See Hubert Juin, *André Hardellet.* Seghers, 1975.
——*Radovan Ivsic.*
——*Airia.* Pauvert, 1960.
——*Le Roi Gordogane.* Surréalistes, 1968.
——*Autour ou dedans.* Maintenant, 1974.
Le Brun, Annie. *Sur-le-champ.* Surréalistes, 1967. (Illustrated by Toyen.)
——*Les mots font l'amour.* Losfeld, 1970.
——*Les pâles et fiévreux après-midi des villes.* Maintenant, 1972.
——*Tout près, les nomades.* Maintenant, 1972. (Illustrated by Toyen.)
——*Les écureuils de l'orage.* Maintenant, 1974.
——*Annulaire de lune.* Maintenant, 1977.
——*Lâchez tout.* Sagittaire, 1977.
——*Les Châteaux de la subversion.* Garnier for J-J. Pauvert, 1982.
Legrand, Gérard. *Des pierres de mouvance.* Surréalistes, 1953.
——"*Poésies*" *d'Isidore Ducasse,* first annotated edition, in collaboration with Georges Goldfayn. Terrain vague, 1960. (Isidore Ducasse was the original name of the comte de Lautréamont.)
——*Marche du lierre.* Losfeld, 1969.
——*Pour connaître la pensée des présocratiques.* Bordas, 1970.
——*Préface au système de l'éternité.* Losfeld, 1971.
——*Le retour du printemps.* Soleil noir, 1974.
Leiris, Michel. See Louis Yvert, "Bibliographie des écrits de Michel Leiris, 1924–1974." *Bulletin du bibliophile,* 1974, pp. 8–49, 271–314.
Limbour, Georges. See "Limbour l'irréductible," *Critique,* (August–September 1976), nos. 351–52. (Not a complete bibliography of the art criticism.)
Mabille, Pierre. See Rémy Laville, *Pierre Mabille: un compagnon du surréalisme.* Faculté des Lettres et Sciences Humaines, Université de Clermont-Ferrand. Vol. 2, part 1, 1983.
Mansour, Joyce. *Cris.* Seghers, 1953.
——*Déchirures.* Minuit, 1955.
——*Jules César.* Seghers, 1956.
——*Les Gisants satisfaits.* Pauvert, 1958.
——*Rapaces.* Seghers, 1960.
——*Carré blanc.* Soleil noir, 1966.
——*Les damnations.* Visat, 1967.
——*Le bleu des fonds.* Soleil noir, 1968.

——*Phallus et momies*. Daily Bul, 1969.

——*Ça*. Soleil noir, 1970.

——*Histoires nocives*. Gallimard, 1973.

Mayoux, Jehan. *Traînoir*. 1935.

——*Mais*. 1937.

——*Le fil de la nuit*. 1938

——*Ma tête à couper*. 1939.

——*Au crible de la nuit*. 1948.

——*A perte de vue*. 1958.

Péret, Benjamin. *Oeuvres complètes*. Losfeld, in preparation. Three volumes have already appeared, 1969, 1971, 1979.

Pichette, Henri. *Les épiphanies*. 1948. Gallimard, 1969.

——*Rond-point*, followed by *Joyce au participe futur* and *Pages pour l'arc-en-ciel*. Mercure de France, 1950.

——*Lettres arc-en-ciel*. L'Arche, 1950.

——*Le point vélique*. Mercure de France, 1950.

——*Nucléa*. L'Arche, 1952.

——*Les revendications*. Mercure de France, 1958.

——*Odes à chacun*. Gallimard, 1961.

——*Tombeau de Gérard Philipe*. Gallimard, 1961.

——*Dents de lait dents de loup*. Gallimard, 1962.

Pierre, José. *D'autres chats à fouetter*. Losfeld, 1968.

——*Théâtre*. Denoël, 1969.

——*Le testament d'Horus*. Losfeld, 1971.

——*Qu'est-ce que Thérèse? — C'est les marronniers en fleurs*. 1974.

——*Gauguin aux Marquises*. Flammarion, 1982.

See also his art criticism, below.

Prassinos, Gisèle. See bibliography, J. Chénieux-Gendron, *Le surréalisme et le roman*. Lausanne: L'Age d'homme, 1983.

Rigaut, Jacques. *Papiers posthumes*, Au sans pareil, 1934.

——*Oeuvres*, Gallimard, 1970.

Rodanski, Stanislas. *La victoire à l'ombre des ailes*. Soleil noir, 1975. (Preface by Julien Gracq.)

Schuster, Jean. *Archives 57–68*. Losfeld, 1969.

Soupault, Philippe. See bibliography, *Action Poétique* (December 1978), no. 45.

Suquet, Jean. *Miroir de la Mariée*. Flammarion, 1973.

——*Le guéridon et la virgule*. Christian Bourgois, 1976.

Tzara, Tristan. *Oeuvres complètes*, ed. Henri Béhar. Flammarion, in preparation. Five volumes appeared in 1982.

Unik, Pierre. *Le Théâtre des nuits blanches*. Corti, 1934.

——*Chants d'exil*. Editeurs français réunis, 1972.

Unik, Pierre. *Le héros du vide.* Editeurs français réunis, 1972.
Vaché, Jacques. *Lettres de guerre.* Losfeld, 1970.
Vitrac, Roger. *Connaissance de la mort.* Gallimard, 1926.
——*Humoristiques.* Gallimard, 1927.
——*Cruautés de la nuit.* Cahiers du Sud, 1927.
——*Georges de Chirico.* Gallimard, 1927.
——*Jacques Lipchitz.* Gallimard, 1929.
——*Dés-lyre.* Gallimard, 1964. (Complete poetry.)
——*Théâtre.* 4 vols. Gallimard, 1946–64.
NOTE: Works related to Surrealism should also be considered, such as those of René Daumal, Roger Gilbert-Lecomte, Pierre Naville, Jacques Prévert, Raymond Queneau, Georges Ribemont-Dessaignes.

Selected Critical Bibliography

GENERAL WORKS

Abastado, Claude. *Le surréalisme.* Hachette, 1975.
Alexandrian, Sarane. *Le Surréalisme et le rêve.* Gallimard, 1975.
Alquié, Ferdinand, *Philosophie du surréalisme.* Flammarion, 1955. Translated by Bernard Waldrop, *The Philosophy of Surrealism.* Ann Arbor: University of Michigan Press, 1965.
Audoin, Philippe. *Les surréalistes.* Seuil, 1975.
Balakian, Anna. *André Breton: Magus of Surrealism.* New York: Oxford University Press, 1971.
Bancquart, Marie-Claire. *Paris des surréalistes.* Seghers, 1972.
Bonnet, Marguerite. *André Breton, naissance de l'aventure surréaliste.* Corti, 1975.
Brechon, Robert. *Le surréalisme.* Armand Colin, 1971.
Carrouges, Michel. *André Breton et les données fondamentales du surréalisme.* Gallimard, 1950. Translated by Maura Prendergast, *André Breton and the Basic Concepts of Surrealism.* University: University of Alabama Press, 1974.
Caws, Mary-Ann. *The Poetry of Dada and Surrealism.* Princeton: Princeton University Press, 1970.
——*The Inner Theater of Recent French Poetry.* Princeton: Princeton University Press, 1972.
Chénieux-Gendron, Jacqueline. *Le surréalisme et le roman, 1922–50.* Lausanne: L'Age d'homme, 1983.
Durozoi, Gérard, and Bernard Lecherbonnier. *Le surréalisme, théories, thèmes, techniques.* Larousse, 1971.
Gracq, Julien. *André Breton, quelques aspects de l'écrivain.* Corti, 1948.

Monnerot, Jules. *La poésie moderne et le sacré*. Gallimard, 1945.

Riffaterre, Michael. *La production du texte*. Seuil, 1979. [Translated by Terese Lyons, *Text Production*. New York: Columbia University Press, 1985.]

Schuster, Jean. *Archives 57/68*. Losfeld, 1969.

Vovelle, José. *Le surréalisme en Belgique*. Brussels: De Rache, 1972.

COLLECTIVE WORKS AND SPECIAL ISSUES OF PERIODICALS

"André Breton et le mouvement surréaliste." *La NRF* (April 1967), no. 172. Special issue.

Le surréalisme. "Entretiens de Cérisy-la-Salle, sous la direction de Ferdinand Alquié." Paris and the Hague: Mouton, 1968. [Proceedings of conferences at Cérisy-la Salle, ed. Ferdinand Alquié.]

Les critiques de notre temps et André Breton. Garnier, 1974. Introduction by Marguerite Bonnet.

Le surréalisme dans le texte. "Actes du colloque organisé à Grenoble par Daniel Bougnoux et Jean-Charles Gateau." Université des Langues et Lettres de Grenoble, 1978. [Proceedings of the conference organized at Grenoble by Daniel Bougnoux and Jean-Charles Gateau.]

Théorie, tableau, texte, de Jarry à Artaud. Le siècle éclaté. No. 2. Minard, Lettres modernes, 1978.

Mélusine. Cahiers du Centre de recherches sur le surréalisme de Paris, no. 3. Lausanne: L'Age d'homme, 1980– .

"André Breton." *Revue des Sciences humaines*, 1982/4, no. 184. Special issue.

Dictionnaire général du surréalisme et de ses environs, ed. Adam Biro and René Passeron. Presses Universitaires de France, 1982.

"Surréalistes," *Revue des Sciences Humaines*, 1984/1. Special issue.

Pleine Marge, ed. Jacqueline Chénieux. 1985– . Cognac: Le temps qu'il fait; Ivry s/ Seine: "CAS," Centre National de la Recherche Scientifique.

Du surréalisme et du plaisir. "Actes du colloque international organisé à l'abbaye de Royaumont," ed. J. Chénieux-Gendron. Corti, 1987. [Proceedings of the international conference at the Abbaye de Royaumont.]

L'objet au défi, ed. J. Chénieux-Gendron and M. C. Dumas. Coliartco and Presses Universitaires de France, 1987.

ARTICLES OR CHAPTERS ABOUT SURREALISM IN GENERAL

Bataille, Georges. "Le surréalisme et sa difference avec l'existentialisme." *Critique* (July 1946), no. 2.

Blanchot, Maurice. "Réflexions sur le surréalisme." In *La part du feu*. Gallimard, 1949, 1980.

Decottignies, Jean. "L'oeuvre surréaliste et l'idéologie." *Littérature* (1971), no. 1.

Deguy, Michel. "Du 'Signe ascendant' au 'Sphinx vertébral.'" *Poétique* (April 1978), no. 34.

Morel, Jean-Pierre. "Aurélia, Gradiva, X. . . , Psychanalyse et poésie dans 'Les vases communicants.'" *Revue de Littérature Comparée* (January–March 1972), no. 1.

Navarri, Roger. "Au grand jour / A la grande nuit, ou la double postulation de la critique surréaliste." *L'Information Littéraire* (March–April 1981).

Pontalis, Jean-Bertrand. "Préface" to Xavière Gauthier, *Surréalisme et sexualité*. Gallimard, 1971.

——"Les vases non communicants." *La NRF* (March 1, 1978), no. 302.

Riffaterre, Michael. "La métaphore filée dans la poésie surréaliste"; "Incompatibilités sémantiques dans l'écriture automatique"; "Surdétermination dans le poème en prose (Julien Gracq)," in *La production du texte*. Seuil, 1979. [Translated by Terese Lyons, *Text Production*. New York: Columbia University Press, 1985.]

Rosolato, Guy. *Essais sur le symbolique*. Gallimard, 1969.

WORKS AND ARTICLES ABOUT A SINGLE ASPECT OF
SURREALISM PAINTING

Hubert, Renée Riese. *Surrealism and the Book*. Berkeley and Los Angeles: University of California Press, 1988.

Passeron, René. *Histoire de la peinture surréaliste*. Livre de Poche, 1968.

Pierre, José. *Le surréalisme*. Lausanne: Rencontre, 1967. Translated by Paul Eve, *Surrealism*. London: Heron, 1970.

——*André Breton et la peinture*. Lausanne: L'Age d'homme, 1986.

Smejkal, Frantisek. *Le dessin surréaliste*. Cercle d'art, 1974.

Vovelle, José. *Le surréalisme en Belgique*. Brussels: De Rache, 1972. (This goes far beyond the subject indicated.)

PHOTOGRAPHY

Jaguer, Edouard. *Les mystères de la chambre noire*. Flammarion, 1982.

Krauss, Rosalind. *L'amour fou: Photography and Surrealism*. New York: Abbeville, 1985.

SELECTIVE BIBLIOGRAPHY

THE THEATER

Béhar, Henri. *Essai sur le théâtre dada et surréaliste.* Gallimard, 1967, 1979.
Gouhier, Henri. *Antonin Artaud et l'essence du théâtre.* Vrin, 1974.
Orenstein, Gloria F. *The Theater of the Marvelous.* New York: New York University Press, 1975. (Deals with the period since 1945.)
NOTE: See also the accounts given by Georges Durozoi and Bernard Lecherbonnier, *Le surréalisme,* Larousse, 1971; and Robert Abirached, *La crise du personnage dans le théâtre moderne,* Grasset, 1978.

THE NOVEL

Chénieux-Gendron, Jacqueline. *Le surréalisme et le roman, 1922–1950.* Lausanne: L'Age d'homme, 1983.

MUSIC

Souris, André. "Paul Nougé et ses complices." In *Le surréalisme.* Mouton, 1968.
——*Conditions de la musique et autres écrits.* Université de Bruxelles and Centre national de la recherche scientifique, 1976.

Critical Works on the Principal Surrealist Writers

NOTE: These are a few important studies of the last fifteen years.

Aragon

Daix, Pierre. *Aragon, une vie à changer.* Seuil, 1975.
Melzer, Helmut. *Das Frühwerk Louis Aragons: eine kritische Darstellung seiner Enttschung und Bedeutung.* Doctoral thesis, University of Leipzig, 1978.

Breton

Bonnet, Marguerite. *André Breton, naissance de l'aventure surréaliste.* Corti, 1975.

Char

Matthieu, Jean-Claude. *La poésie de René Char ou le sel de la splendeur*. Vol. 1: *La traversée du surréalisme*. Corti, 1984.

Desnos

Dumas, Marie-Claire. *R. D. ou l'exploration des limites*. Klincksieck, 1978.

Eluard

Boulestreau, Nicole. *La poésie de Paul Eluard: La rupture et le partage, 1913–1936*. Klincksieck, 1985.
Gateau, Jean-Charles. *Paul Eluard, 1910–1930*. Geneva: Droz, 1982.

Gracq

Amossy, Ruth. *Le rivage des Syrtes*. Sedes, 1982. *Colloque*, Université d'Angers. Presses de l'Université, 1981. (Colloquium under the direction of Georges Cesbron.)

Index